100
WAYS TO TAKE BETTER
LANDSCAPE
PHOTOGRAPHS
GUY EDWARDES

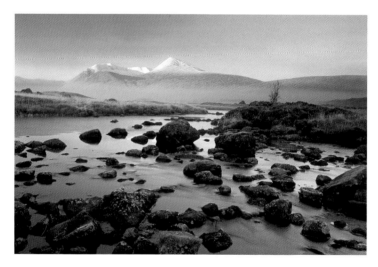

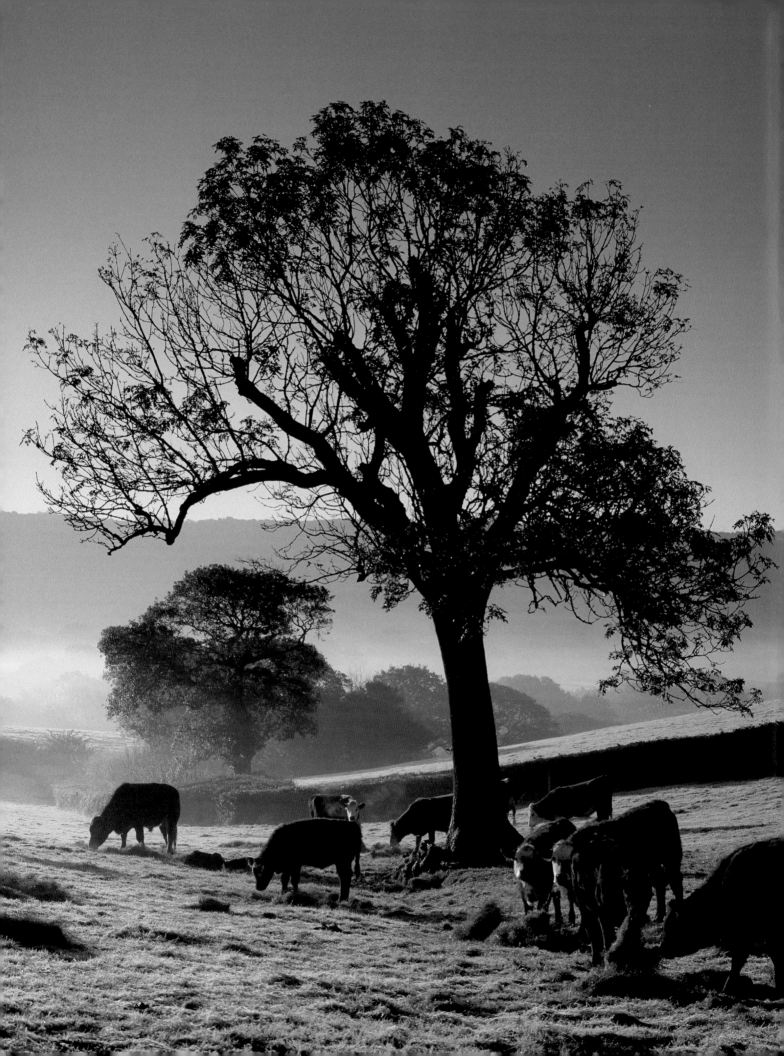

100
WAYS TO TAKE BETTER
LANDSCAPE
PHOTOGRAPHS
GUY EDWARDES

D&C
David and Charles

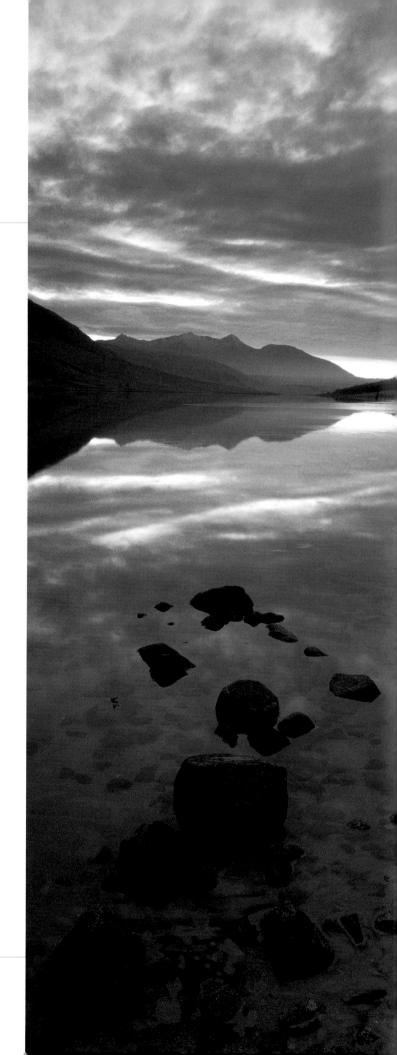

A DAVID & CHARLES BOOK

David & Charles is a subsidiary of F+W (UK) Ltd.,
an F+W Publications Inc. company

First published in the UK in 2005

Distributed in North America
by F+W Publications, Inc.
4700 East Galbraith Road
Cincinnati, OH 45236
1-800-289-0963

A catalogue record for this book is available from the British Library.

ISBN 0 7153 1997 3 hardback
ISBN 0 7153 1993 0 paperback

Printed in China by SNP Leefung
for David & Charles
Brunel House Newton Abbot Devon

Commissioning Editor Neil Baber
Desk Editor Lewis Birchon
Art Editor Mike Moule
Designer Jodie Lystor
Production Controller Kelly Smith

Visit our website at www.davidandcharles.co.uk

David & Charles books are available from all good bookshops;
alternatively you can contact our Orderline on (0)1626 334555
or write to us at FREEPOST EX2 110, David & Charles Direct,
Newton Abbot, TQ12 4ZZ (no stamp required UK mainland).

www.guyedwardes.com

Contents

Introduction

Simply recording the landscape with a camera is easy, but to take great landscape photographs requires a totally different approach. In fact, landscapes are one of the most difficult subjects to capture successfully in a photograph. It isn't easy to catch the drama, depth, colour and atmosphere of a magnificent landscape scene, as these attributes, which make the scene so special at the time, can be lost in the photograph itself. It's not always a question of what to include in the composition; more often it is what to exclude in order to concentrate attention on the most important part of the scene before you.

'Point and shoot' photography will never produce consistently high quality results when photographing the landscape because image sharpness is critical, particularly if you intend to make large prints or to have your photographs published – in fact, every image in this book was taken with the camera firmly supported either by a sturdy tripod or by a beanbag. A methodical approach is required, and a great deal of thought needs to be put into each composition. Too many landscape photographs are taken from the roadside or a well trodden path, often leading to duplicated and two-dimensional compositions.

This book will encourage you to spend a little more time on each shot, to step off the path, and to let your creativity steer you towards a more dynamic composition. The points covered apply to any camera format, and to both film and digital capture.

> **This book will encourage you to spend a little more time on each shot and to let your creativity steer you towards a more dynamic composition.**

Starting with the fundamentals of good photographic technique, each chapter covers a different area of the genre, covering all the most commonly encountered situations and revealing the secrets of good landscape photography: how to recognize scenes with photographic potential and make the most of them with good composition and atmospheric lighting; the different approaches required for various inland and coastal landscape locations at different times of the day and the year; the relative merits of wideangle and telephoto lenses and the techniques required to get the best from both; and how to turn the textures, patterns and details abundant in the landscape into creative and original images.

Photography is a very subjective art, and in no way should this book be taken as a definitive guide on how you should photograph the landscape: as a landscape photographer you will need to develop your own ideas on what makes a successful image, and take time to consider exactly what makes a landscape photograph work for you. There is no better way to improve your skills than to get out into the countryside with your camera as often as possible. *100 Ways to Take Better Landscape Photographs* provides a reference that I hope will help and inspire you to make striking, atmospheric and technically proficient landscape photographs on a consistent basis.

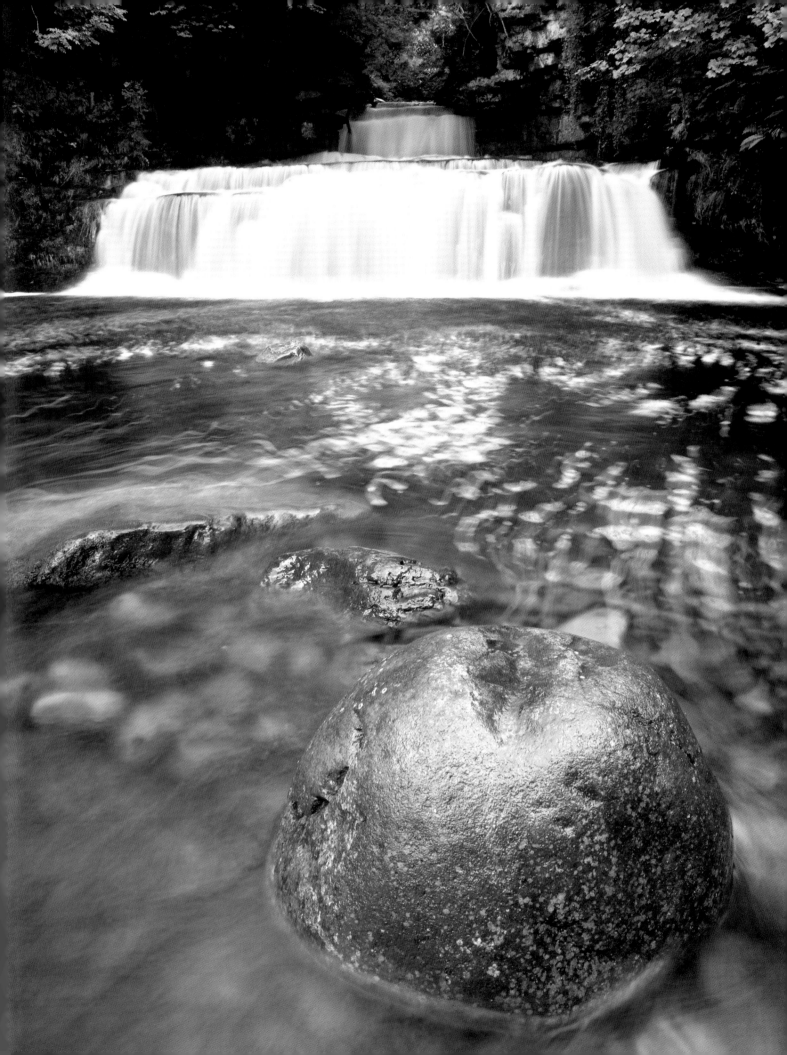

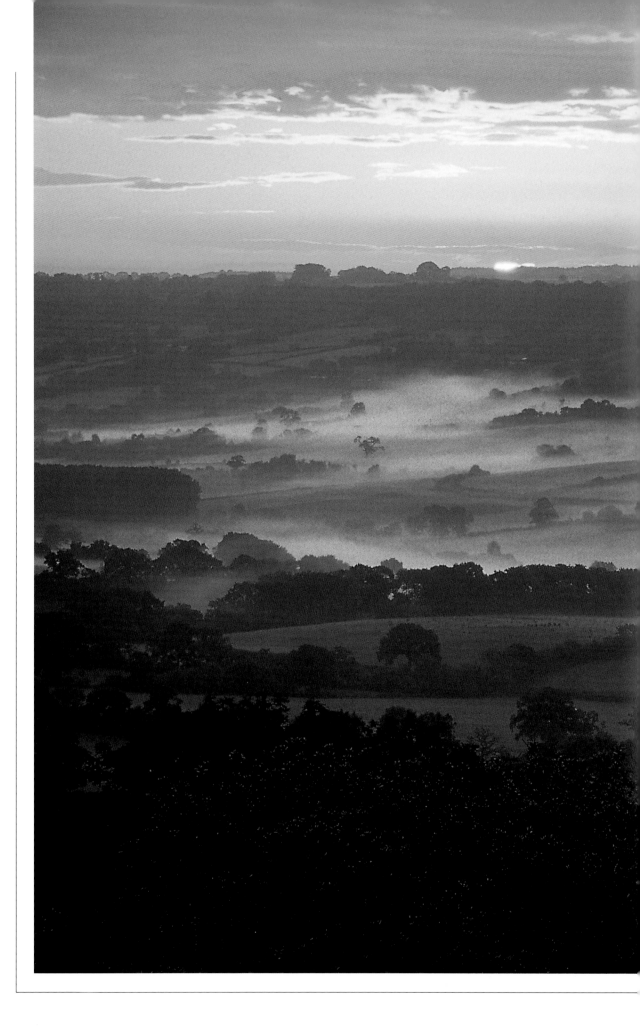

Landscape photography basics

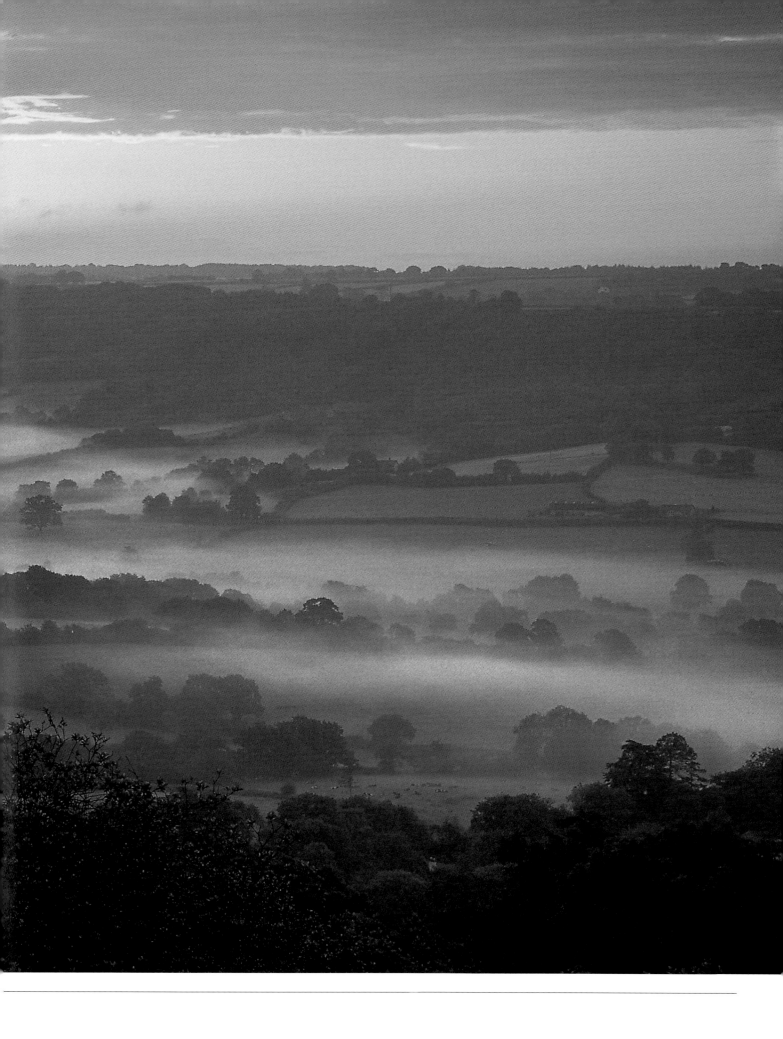

1 Keep your equipment portable

When travelling long distances on foot, it is best to keep your photographic kit as light and compact as possible, so that it neither hampers you nor deters you from traversing difficult ground. It is easy to be tempted into replacing or adding to your camera system with the very latest, and reportedly better, cameras, lenses and accessories. However, you should consider carefully how these upgrades and new items might benefit your photography, and whether they will help you to produce better images. They may very well provide little more than additional ballast to your camera bag! Good-quality modern zoom lenses can replace several prime lenses, saving both weight and cost without sacrificing image quality. However, as many landscape images require the use of a small aperture for sufficient front-to-back sharpness, heavy and expensive fast zoom lenses are both unnecessary and rather impractical.

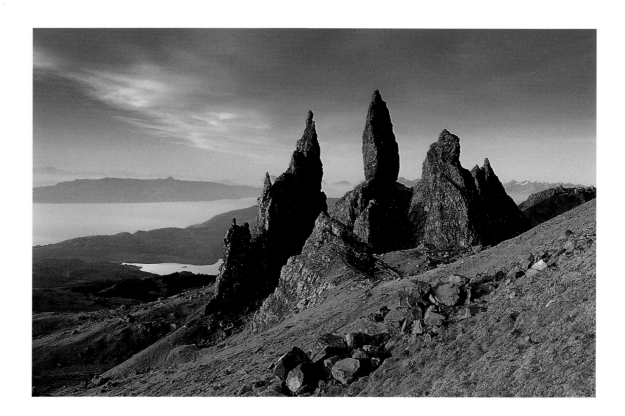

The Storr

When travelling longer distances by foot over rough ground, I take only a basic camera set-up. On this occasion, I had only one camera body, a wide-angle zoom lens and a telephoto zoom lens, a basic filter system, spare batteries, film and a carbon-fibre tripod. The total weight of a little over 6kg (13lb) meant that I wasn't deterred from climbing the steep 300m (1,000ft) ascent in pre-dawn light in order to reach the top of a rocky outcrop in the Scottish Highlands in time for sunrise. The backs of these rocky pinnacles on the Isle of Skye are lit by beautiful warm light only in early summer, when the sun rises at the easternmost point of its yearly cycle.

Canon EOS 5, 28–105mm lens, polarizer filter, 1-stop neutral density graduated filter, Fujichrome Velvia, 1/2sec at f/11

2 Get to know your camera

It is surprising how many photographers are not totally familiar with the functions and operation of their camera. Landscape photography doesn't require a great many of the functions available on a modern SLR, but you must familiarize yourself with those that are necessary. Find out how to set the different metering modes, and learn how the metering system reacts to different lighting conditions. Set the custom functions that you might need and make a list of ones that you access regularly. Know how to replace the battery. Practise attaching the remote release and setting the camera up for long exposures. Learn how to set the mirror lock-up and self-timer function. Order your filters and adaptor rings in one easily accessed and well-labelled wallet. Memorizing these functions and procedures will help you to work quickly in order to catch moments of transient light. It will also allow you to work far more efficiently in low light situations.

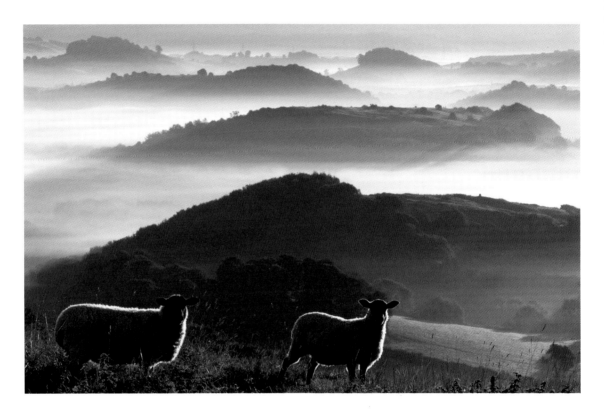

Inquisitive sheep

I was returning to my car after shooting a sunrise over this mist-filled valley when a flock of sheep ran along the ridge past me. The last two paused inquisitively against a wonderful backdrop. I hurriedly set my tripod down and changed to a longer focal length lens, composed the scene, focused, metered the exposure, set an aperture small enough to record the background sharply, set mirror lock-up and self timer and hit the shutter. Without knowing exactly how to set the functions on my camera I would almost certainly have missed this shot as I managed to fire off only two frames before the sheep decided to catch up with the rest of the flock.

Canon EOS 1Ds, 70–200mm lens, ISO 100, 1/30sec at f/22

3 Include a sense of scale

It is often essential, although not always easy, to illustrate scale in a landscape photograph. Take, for example, California's Giant Sequoia forest: without including an easily recognizable object, it would be impossible to show just how massive these magnificent trees are in reality. The same is true of many other subjects – towering cliffs, vast sandy beaches, waterfalls and the like. The easiest option may be to include a human figure within your composition. If this doesn't appeal to you, or if it simply isn't practical, then look for another easily recognizable object that will fit naturally within the scene – perhaps a building, an animal or a plant. Whatever you use to illustrate scale must be placed close to the main subject, otherwise the effects of perspective may counteract your efforts. A wide-angle lens used close to a foreground element can exaggerate scale very effectively and will often result in a very dramatic and eye-catching image.

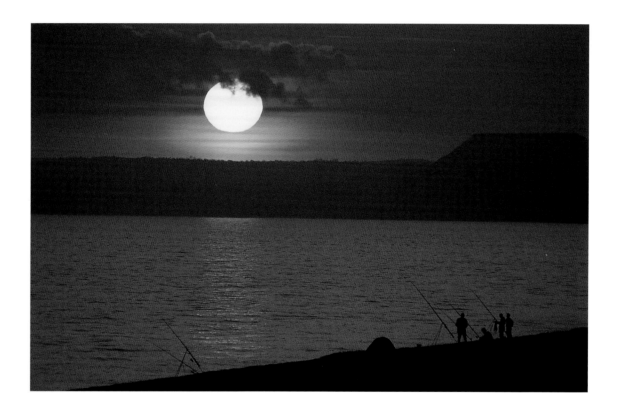

Fishermen at sunset

The fishermen on the beach exaggerate the size of the sun due to the compressing effect of a 400mm telephoto lens. This may look a little unnatural, as it is not the way we would see the scene in reality. However, the compressing effect produces an image with far more impact than would have been possible had I shot the same scene with a 50mm lens. In breezy condi-

tions I used a beanbag to support the lens. I placed a second bag on top of the lens and used the mirror lock-up function, along with a cable release, to minimize the chances of vibration spoiling the final image.

Canon EOS 5, 400mm lens, Fujichrome Velvia, 1/15sec at f/16

4 Invest in a tripod

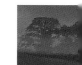

A sturdy tripod is an essential piece of equipment for landscape photography. Some shots are impossible to achieve without one, but every image will benefit from the use of one. Unfortunately not all tripods are up to the job, and those that are, tend to be quite expensive. Try not to be lured by cheap lightweight models even if you shoot with a basic 35mm camera system. Look for one that extends to at least head height and also allows ground-level shooting by splaying the legs at right-angles. Again, you must buy a high quality head if it isn't to become a weak link in your set-up. Although less versatile than a ball and socket head, a three-way pan and tilt head will offer independent adjustment of each axis, which can be a great help in fine tuning composition. It is easy to miss moments of transient light when you are fumbling to screw your camera on to a standard tripod head. A quick-release head will cost a little more, but the benefits over years of photography make the initial investment worthwhile.

Dawn from Eggerdon Hill

I spotted this distant scene from a roadside gateway. The crops inside the gate were so tall that I had to extend the legs of my tripod to maximum height in order to gain a clear vantage point. Although my tripod has no centre column I still needed a small stepladder to be able to see through the viewfinder. Centre columns are a weak link in any tripod set-up and should only be used when there is no other option. It is perhaps best to buy a tripod that doesn't have a centre column – then you won't be tempted to use it!

Canon EOS 3, 400mm lens, Fujichrome Velvia, 1/4sec at f/16

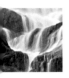

5 Learn good tripod technique

A sturdy tripod will help to ensure consistently sharp results, but only when combined with good technique. Never extend the leg sections of the tripod any further than necessary, and make sure that all tripod controls are fully tightened before making your exposure. Position your tripod on firm ground or push the legs into softer ground. Matted grass, moss and woodland debris all act like springs under the legs of a tripod, amplifying any vibration. Hanging a beanbag, or even your camera bag, from the tripod as additional ballast can be quite effective when using longer focal length lenses. By using your camera's mirror lock-up feature, in combination with a cable release or self timer, the vibration caused by the action of the mirror can be allowed to die away before the exposure is made.

Waterfall

There are many situations in which it would be impossible to obtain a sharp image without using a tripod to support your camera. This shot of a waterfall in Briksdal, Norway, was taken in overcast light with a telephoto lens, a combination that always calls for the use of a tripod. I also wished to record movement in the water, for which an exposure time of 1/4sec was required. Fortunately I was able to set up on a firm surface, and I placed a beanbag on top of my lens to help minimize the effects of any shutter-induced vibration. I also locked the mirror up before making the exposure – mirror lock-up is a camera feature that I could not live without.

Canon EOS 5, 400mm lens, Fujichrome Velvia, 1/4sec at f/11

6 Research your destination

Whenever you travel to an unfamiliar place it is vital to carry out as much research as possible before you depart if you intend to make the most of the photographic opportunities available. The internet is perhaps the best source of information prior to departure. Maps are the landscape photographer's best friend so buy the best you can find with as much information on them as possible, ideally before departure so that you have a chance to study them carefully. Those that accurately show the lie of the land can be used to predict lighting conditions – such as which side of a valley will be in shade at a certain time of day. Upon arrival, head for the nearest tourist information centre for inspiration. You are certain to find postcards, calendars and guidebooks depicting local landmarks and characteristic views of the area. This will provide further insight into the region's photographic potential and may reveal more locations that could be worth exploring. In poor weather use your time constructively to search out and explore new sites. Try to find compositions that would be worth returning to in good light and consider precisely when to revisit – morning or afternoon, or at high or low tide, for example.

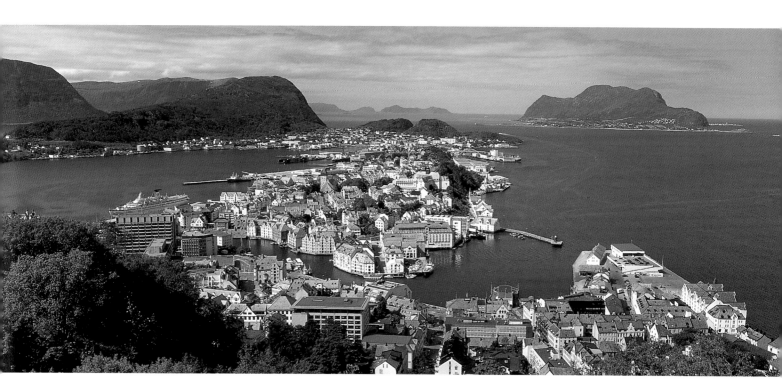

Ålesund

The panoramic view from this hilltop just outside the town of Ålesund on the Norwegian coast is depicted in just about every tourist brochure and guidebook about the region. Even though the prospects of getting a unique shot are relatively slim at a location that is this well photographed, a visit is still worthwhile even if it is just a matter of getting your first shots 'in the bag'.

A clear haze-free day is essential when you are photographing distant, highly detailed scenes. Here I used a polarizing filter to intensify the colours and remove reflections from the foliage and rooftops.

Hasselblad XPan, 45mm lens, polarizer, centre-spot filter, Fujichrome Velvia, 1/15sec at f/11

7 Use a polarizing filter

The polarizer is a very important filter for the landscape photographer. On sunny days, it can be used to deepen the colour of blue skies, accentuate clouds and saturate other colours within a scene. This can reduce the contrast between land and sky and increase the overall impact of the shot. A polarizer is most effective when used at right-angles to the sun and when the sun is low in the sky; however, it isn't always necessary to apply the full amount of polarization – a half turn of the filter may be all that is required. A polarizer can also be helpful on overcast days (see page 27) when it can be used to remove unwanted reflections from grass, foliage, rocks and other surfaces, thereby improving colour saturation and the definition of fine detail. Polarizers reduce the amount of light reaching the film by 1–2 stops. In-camera TTL exposure systems will take this into account, but you will need to compensate for this if you are using a hand-held light meter.

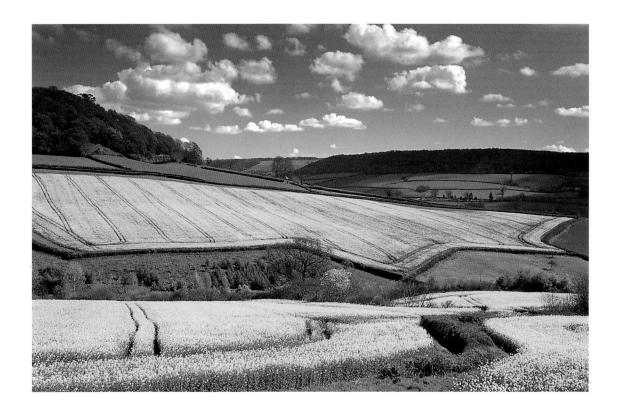

Oil-seed rape fields

White clouds set in an otherwise clear blue sky provide the perfect opportunity to exploit the effects of a polarizing filter. The blue sky becomes highly saturated, making the clouds stand out clearly. The filter has also removed reflections from the vegitation and saturated the colours throughout the image. I normally avoid using a polarizing filter on wide-angle lenses when photographing scenes that include blue sky, as I dislike the uneven darkening of the sky that can result.

Canon EOS 5, 50mm lens, warm-tone polarizer, Fujichrome Velvia, 1/45sec at f/16

8 Search for the best vantage point

One of the most important lessons in landscape photography is not to arrive at a location and instantly fix your camera to your tripod. A tripod-mounted camera is very restrictive and discourages you from moving very far or from altering the height from which you shoot. This often results in images that lack both depth and an interesting or well-conceived foreground. Always explore the location first. Step off the path and walk around, keeping an eye out for interesting foreground elements or lead-in lines. Once you have found a likely shooting position hold your camera up to your eye and consider how to compose the scene. Try both vertical and horizontal format to see which might work best. Only once you are happy with what you see should you reach for your tripod, which then becomes a perfect aid for fine-tuning your chosen composition.

Seaton Bay at sunset

Upon arriving at this pebble beach at Axmouth, in Devon, England, I walked up and down the shoreline with my camera in hand, searching for the best position from which to shoot. This was obviously a wide-angle shot so I was looking for a nice arrangement of boulders to include in the foreground. The freedom of movement that a hand-held camera provides allowed me to quickly find the best position and height from which to shoot before setting the tripod in place. This technique both speeds up the image-taking process and can also increase the compo-sitional impact of your shots. On this occasion, the clouds overhead reflected the colours of the setting sun. A layer of haze in front of the sun prevented any problems with flare. I selected a small aperture to ensure sufficient depth of field, and added a 2-stop neutral density filter to increase the exposure time to help smooth out the surface of the sea and to record the movement of the swirling water in the foreground.

Canon EOS 3, 24mm lens, 2-stop neutral density filter, 2-stop neutral density filter, Fujichrome Velvia, 10sec at f/16

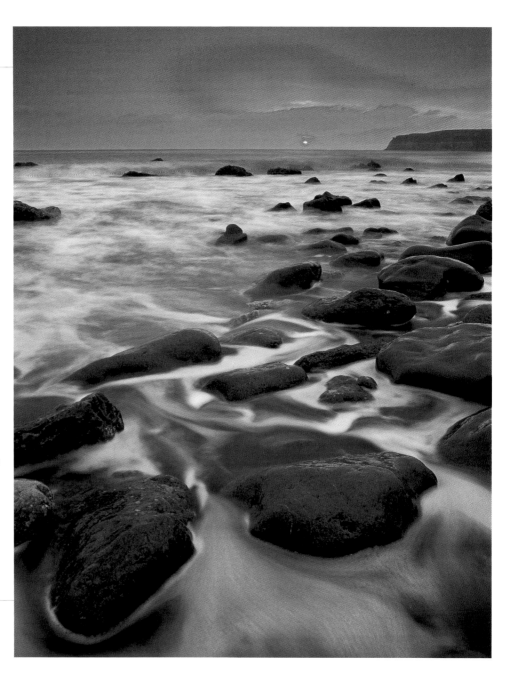

9 Learn to use neutral density graduated filters

Neutral density graduated filters (also known as ND grads) are an indispensable tool for the landscape photographer. Neither film nor digital capture is able to record the same range or brightness that we can see with our own eyes, and if you ignore this limitation you are likely to be disappointed with many of your landscape photos. We can decipher detail within a brightness range of about 13 stops, whereas transparency film can only record detail within a range of 5 stops (a little more with digital) before either highlights burn out or shadows block up. Therefore, if you photograph a scene that includes a broad range of brightness and expose for the highlights, the shadows will lack detail; if you expose for the shadows, the highlights will burn out. Expose for somewhere in between and the whole image is likely to look wrong. This is where neutral density graduated filters come in. Their 50/50 split of clear and grey (neutral density) glass or optical resin allows us to reduce the contrast between light and dark areas (often the difference between the sky and the landscape itself), helping to retain a full range of detail in our images. If there is more than a 5-stop difference between the correct exposure for the brightest highlights and the deepest shadows, you will need to control this contrast in order to preserve detail throughout the image. Even if the scene is within the 5-stop range, you will probably wish to reduce the contrast for a more balanced result. To aid precise positioning of the filter, set your shooting aperture and hold down your camera's depth-of-field preview button (if it has one). The viewfinder image will be dark, but it will show the transition line of the filter more clearly. Slide the filter up and down in the holder to achieve perfect positioning. Remember that the smaller the aperture you use, the sharper the transition line of the filter will appear in your image. Neutral density graduated filters come in different strengths (normally 1, 2 and 3 stops) and in both hard- and soft-edged versions. Hard-edged filters are most useful when photographing a scene with a relatively straight horizon, such as a seascape, whereas soft-edged filters are of more use when the horizon is interrupted by hills, trees or buildings.

Loch Tummel

Part of this Scottish scene was illuminated by late afternoon sunlight, but the rocks that I wanted to use to provide foreground interest were in the shadow of the hillside behind me. I took a spot-meter reading (with a polarizing filter in place) of 1/15sec at f/16 from a mid-toned area of the sunlit hills, and another reading of 1sec at f/16 from the foreground rocks. This difference of 3 stops meant that I needed to position a neutral density graduated filter across the top half of the image in order to record sufficient detail throughout.

I decided to use a 2-stop ND grad in order to maintain some contrast between the two areas. When you are using an ND grad to hold back a bright sky always make sure the sky records as a lighter tone than the foreground, otherwise the resulting image will tend to look unnatural. There is nothing to stop you combining two or more neutral density graduated filters to help retain detail in a very high-contrast scene, or perhaps to hold back both the sky and the foreground when shooting a snow scene.

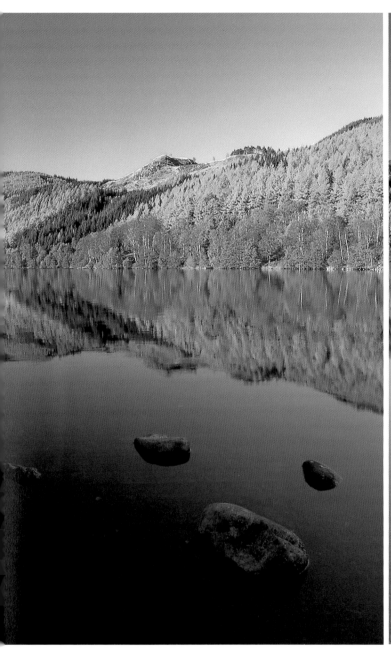

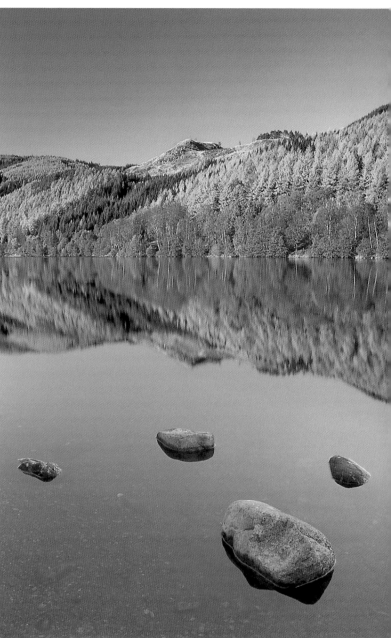

Canon EOS 3, 24mm lens, polarizer,
Fujichrome Velvia, 1/15sec at f/16

Canon EOS 3, 24mm lens, polarizer,
2-stop neutral density graduated filter,
Fujichrome Velvia, 1/4sec at f/16

10 Understand reciprocity

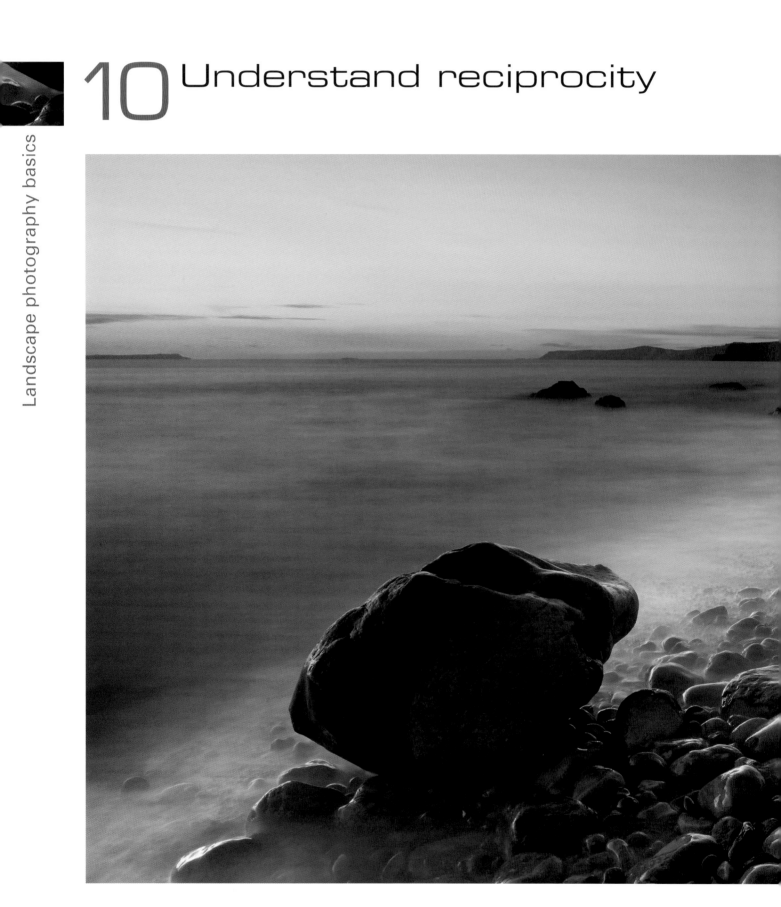

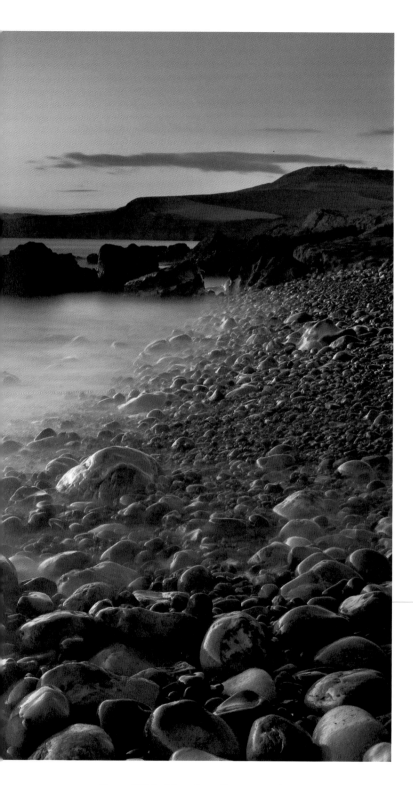

Reciprocity is the relationship between shutter speed and aperture and the way they both affect the exposure of film. Your choice of shutter speed affects the exposure of your image, as does your choice of aperture, and by the same amount. A 1-stop increase in either shutter speed or aperture would reduce the exposure of your image by 1 stop, and vice versa. You can rely upon this reciprocal relationship between shutter speed and aperture settings working in unison to allow the right amount of light to reach the film for the metered exposure to be correct. However, during very long exposures, this relationship begins to breakdown. This break down is known as reciprocity failure and the result is an underexposure of the image. Reciprocity failure only occurs in exposures of over 2 seconds, in which case the film will need to be exposed for slightly longer than your meter reading suggests in order to compensate for the film's reduced light sensitivity during extended exposure times. Some films may also require a colour-correction filter to be used to compensate for the colour shifts that can also occur. Until you're confident in the way your chosen film handles long exposures you would be wise to bracket your shots to ensure a good result.

Jurassic Coast sunset

It was worth the effort it took to reach this rather inaccessible section of Dorset coastline as I discovered this small west-facing pebble beach – a perfect location for a sunset shot. I use Fujichrome Velvia whenever I need to set a long exposure. I have learnt how this film reacts to extended exposure times and how much compensation is required to make up for the effects of reciprocity failure. I find that it needs less compensation than Fuji suggest; about + 1/2 stop at 10sec, + 1 stop at 20sec and, as on this occasion, + 1 1/2 stop at 1min. I have often exposed it for up to 15min (at + 2 1/2 stops) with no adverse effects. When shooting sunsets I never try to filter out any colour shifts that occur as they often enhance the mood of the image.

Canon EOS 3, 24mm lens, 2-stop neutral density graduated filter, Fujichrome Velvia, 1min at f/16

Light and the landscape

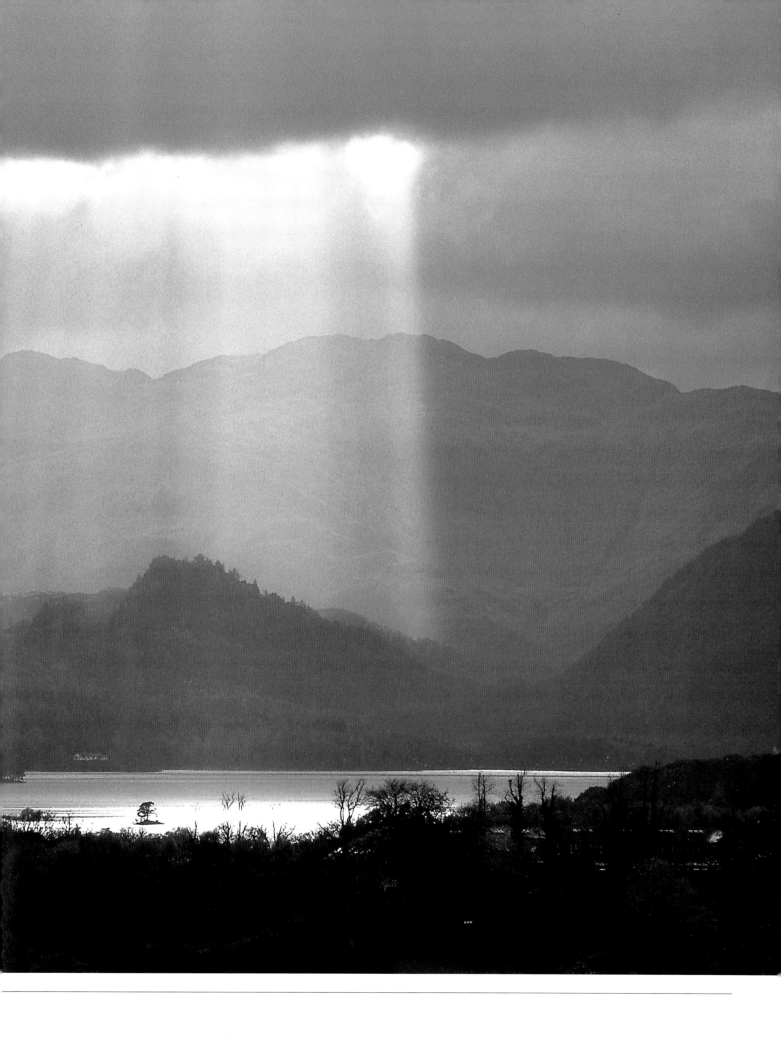

11 Shoot stormy weather

Stormy weather can be the perfect time to make dramatic landscape images. Head to an accessible location where you can include elements that will help to capture the atmosphere on film. Look for windblown foliage, bending trees or blowing sand. One of the best locations is the coast, where the landscape is exposed to the full force of the elements. A telephoto lens can be used to compose an image from a safe distance, but use a sturdy tripod and weight it down with additional ballast. Position your body to shield the camera from the buffeting wind. If your camera has a motordrive use it to take three consecutive shots – the second frame will often be the sharpest. Be prepared for spectacular lighting effects as the storm clears, when rays of sharp sunlight illuminate the landscape – a strong contrast with the dark clouds above.

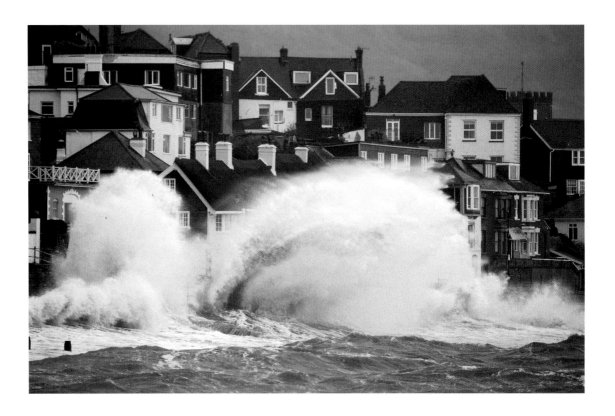

Storm

When this winter storm was predicted, I tried to make sure that I was well prepared. My tide tables showed me that high tide was at midday, so this was when the waves would be crashing most ferociously against the sea wall at Lyme Regis, Dorset, England. My main aim was to exaggerate the town's seemingly precari-ous coastal position. Much of the sea-front here is protected by a high harbour wall, so I had no trouble finding a safe position from which to shoot. Using a 300mm telephoto lens enabled me to compose tightly around the main area of interest. This also had the effect of compressing perspective, thus making the sea front buildings appear much closer to the breaking waves. Even though I was using a sturdy tripod, the constant buffeting of the wind combined with low light levels would have made obtaining a sharp image very difficult without the aid of an image-stabilized lens.

Canon EOS 5, 100–400mm lens, Fujichrome Provia 400F (uprated to ISO 800), 1/125sec at f/5.6

12 Make the most of the golden hour

When the sun is high its light is neutral but the closer it gets to the horizon the warmer its rays become. Some of the best lighting conditions for landscape photography occur early and late in the day. The light during the hour after sunrise and before sunset paints the landscape with warm, low-contrast light. This is beneficial to scenes that include a lot of detail, as the soft light enables film and digital sensors to record this in all areas of the image. The low angle of the sun also casts soft shadows, which reveals the shapes and textures of the land. The changes that occur during this brief period can have a profound effect upon the landscape and the way it records on film. Spend the harsh daylight hours searching for the right spot from which to shoot later in the day or the following morning.

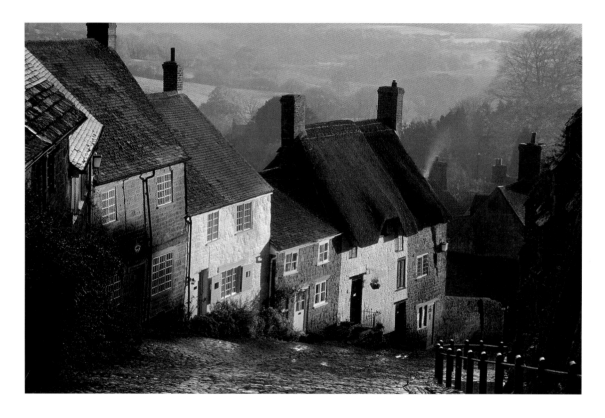

Gold Hill

Shooting late on an autumn afternoon enabled me to make use of the warm, low-angled sunlight striking this row of attractive cottages in Dorset. The angle of the light also helped to reveal the textures of the stone, thatched roof and cobbles. The lighting effect on this occasion was amplified by the fact that it was pouring with rain as the image was made. The raindrops have been illuminated by the warm light of the sun, but haven't recorded on film due to the long exposure. The light reflecting off the wet surface of the cobbles also helps to brighten the foreground considerably. This combination of heavy rain and late afternoon sunlight is an unusual occurrence, but was highly effective in injecting additional atmosphere into the scene.

Canon EOS 5, 28–70mm lens, polarizer, Fujichrome Velvia, 1sec at f/22

13 Utilize low light

The hour before sunrise and after sunset can be a magical time for landscape photography, as the soft light and pastel colours create an atmosphere of calm and tranquillity. On overcast days, a cool blue colour cast will result, but on cloudless days the colour will vary from yellow to magenta. Search for locations such as lakes, rivers and beaches, where the colour of the sky can be reflected into the foreground of your image. In mountainous areas, watch out for alpenglow, which can paint the higher peaks with soft red light. Metering can be tricky, as the electronic exposure systems of many modern cameras can only be set up to 30 seconds. This means that you will have to resort to the old-fashioned method of timed exposures (using the bulb setting) with a cable release and illuminated stopwatch. Exposure times can extend into several minutes, so a sturdy tripod becomes even more essential.

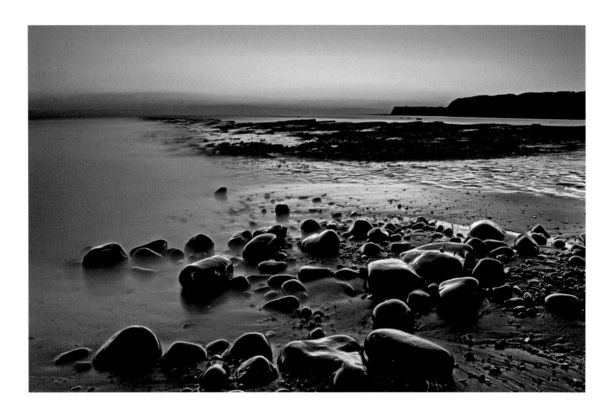

Kimmeridge Bay

As the tide was rising, I knew that the pebbles on this beach would have dried off during the day. For this reason, I took a watering can along so I could damp down the area I intended to use as foreground. The wet pebbles reflect the colour of the sky and brighten the foreground. This shot was taken in mid-December, about 30 minutes after sunset. I placed the camera low to the ground so that the foreground pebbles would add depth to the shot. The small aperture that was required for sufficient depth of field, together with the very low light levels and slow-speed film, resulted in an exposure time of 4min. I didn't use a colour-correcting filter to remove the blue cast, as I wanted to maintain the colour contrast with the warm orange afterglow along the horizon. 1 and 1/2 stops of extra exposure were required to compensate for reciprocity failure.

Canon EOS 5, 28–70mm lens, 3-stop neutral density graduated filter, Fujichrome Velvia, 4min at f/16

14 Make use of overcast days

Although some photographers regard overcast days as unsuitable for landscape photography, some scenes lend themselves to these conditions. Try to tackle subjects that don't work well in direct sunlight. A cloudy sky acts as a diffuser, creating low-contrast, even illumination that records colour accurately and reveals detail. Such conditions are ideal for shooting detailed, colourful scenes, such as woodlands in spring and autumn, and wildflower meadows in early summer. Colour variations will play a big part in the composition of your image. A bland sky will often detract from the main subject, so it is best excluded. A polarizing filter is vital on overcast days, as it can revive the colours of flowers and foliage that were previously muted by reflected light. A well-saturated transparency film will also enhance the natural colours of the scene.

Lupins

Many of the roadside verges along the west coast of Norway are transformed by a brilliant display of wild lupins during early May. Their vibrant colours appear washed out in all but the weakest sunlight, making overcast conditions a necessary requirement for recording them accurately. I was struck by the sheer variety of colours among this display on the island of Runde. In persistent drizzle, I searched a stretch of roadside verge for the best composition, finally settling upon this section of colourful blooms. The vertical format was rather dictated by the arrangement of the flowers, but helps to emphasize the conical shape of the individual flower spikes. Once I was happy with the general composition, I spent time carefully checking the edges of the frame and recomposing to avoid too many neighbouring blooms intruding into the picture. A polarizing filter removed reflections from the wet leaves and revived the vibrant colours.

Canon EOS 3, 28–70mm lens, Fujichrome Velvia, 6sec at f/16

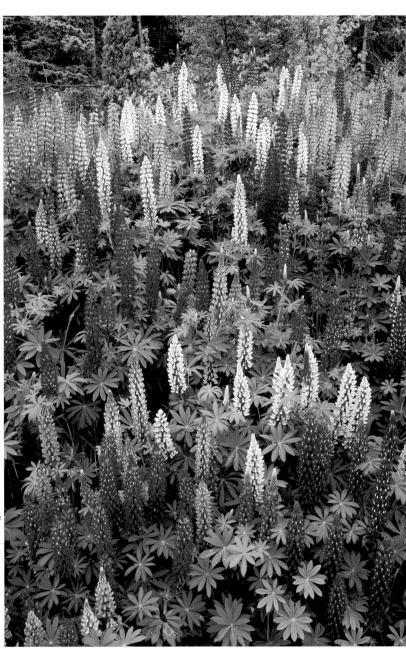

15 Keep an eye on the sky

The sky is a hugely important element in many landscape photographs. However, it should only be included if it adds a positive element or improves the composition. As landscape photographers prefer to shoot early and late in the day in order to catch the best light, we tend to witness some of the most spectacular skies – rapidly changing, with sudden bursts of colour and shafts of light. It is vital that we keep an eye on these developments in order to exploit every opportunity. As the sky is generally brighter in tone than the landscape or foreground of any scene, the use of a neutral density graduated filter will often be necessary to help control contrast as, otherwise, your film may be unable to record sufficient detail. A polarizing filter can also be used to control contrast, as well as to enhance cloud formations and saturate colour.

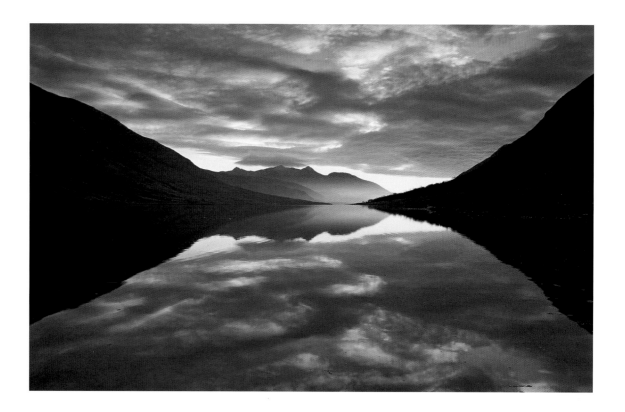

Loch Etive

When I arrived at this location in Scotland, late in the afternoon, the sky was clear and blue. However, within half an hour, broken cloud began to appear from the east and soon covered the sky above me. It was now just before sunset and the last rays of the sun began to add a little subtle colour to the encroaching clouds. Fortunately, the air was still and the surface of the loch was perfectly calm, providing a mirror image of the colourfully patterned sky above. A scene like this would be impossible to capture accurately on colour slide film without the help of a neutral density graduated filter. On this occasion, I used a 2-stop hard-edged filter positioned with the transition line directly upon the distant horizon. When photographing reflections, it is vital to choose the correct density of filter, as the image in the reflection should never appear brighter than its source.

Canon EOS 3, 28–70mm lens, 2-stop hard-edged neutral density graduated filter, Fujichrome Velvia, 2sec at f/11

16 Be prepared for transient light

Some of the most memorable landscape images are made when fleeting glimpses of light break through an otherwise overcast sky. Some of the best opportunities occur around sunrise and sunset, when passing weather fronts allow the sun to briefly appear close to the horizon – often leading to spectacularly colourful skies. The best way to record transient light is to plan your shot. Choose a location, research lighting angles and select a composition in advance. A spot meter is best for metering for a scene in transient light. Take a reading from an area within the pool of sunlight and assign it a tonal value (see page 33). Set this reading on your camera, re-compose the scene and fire away! The sunlit areas will then be correctly exposed whilst the unlit areas will record as a dark tone, capturing the drama that initially attracted you to the scene.

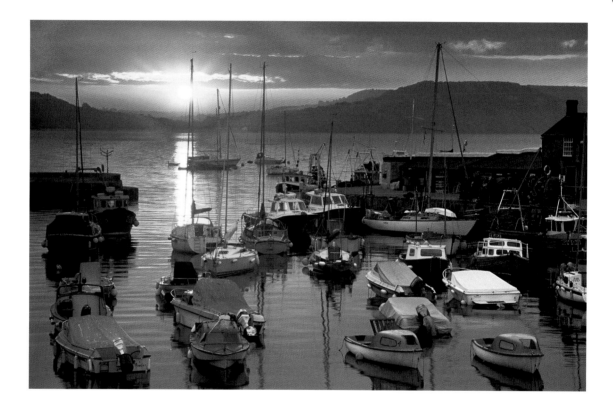

Harbour sunrise

This particular day in early summer dawned cloudy, still and rather uninspiring. Nevertheless, I made my way down to the harbour at Lyme Regis at 5am in the hope of catching a colourful sunrise. I noticed a thin strip of orange sky along the horizon to the east and immediately began to set up my camera in a predetermined position on the harbour wall. It wasn't long before the fiery disc of the sun began to appear, casting a beautiful clear light across the scene. However, within five minutes it had risen behind the encroaching clouds and remained hidden for the rest of the day. My main concern with this shot was to avoid flare – not easy with the sun included in the frame. I minimized the chances of flare occurring by using a prime lens. Fortunately, as the sun had only just broken the horizon, the contrast levels were not that great, and the film was able to record the scene exactly as I had remembered.

Canon EOS 5, 50mm lens, 2-stop neutral density graduated filter, Fujichrome Velvia, 1/2sec at f/16

17 Control flare

Shooting into the light can dramatically increase the atmosphere in your pictures. Zoom lenses are more prone to flare, making prime lenses favourable. Optical surfaces should be kept spotlessly clean and filter use kept to a minimum. Lens hoods are ineffective if the sun is included in the frame. With a tripod-mounted camera it is best to shade the lens with your hand or a piece of card. When using telephoto lenses, you should cast a shadow across the front element from as far away as possible – the further from the lens you are, the sharper and more accurately placed the line of the shadow will be. If the sun is included in the frame you could try to partially conceal it behind a tree or similar element within the image. Take great care to prevent the sun from striking the front element of your lens, or any filters that you have in place.

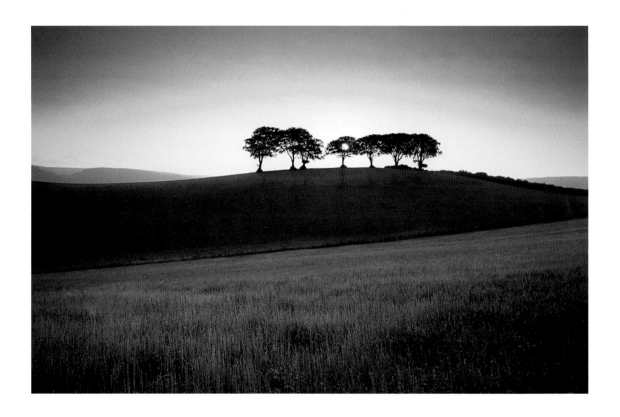

Beech trees at sunrise

This row of hilltop beech trees on the northern edge of the Exmoor National Park in Somerset, England, was a scene that I had considered photographing many times. Although there was the potential for a good shot in favourable light, the view never really inspired me. However, I noticed that at sunrise a more atmospheric image might be possible by shooting into the light. I decided to return in mid-June, when the sun would rise roughly behind the line of trees. In fact, the sun appeared directly behind the centre tree. Not only did this help to balance the composition, it was also a great help in preventing flare from spoiling the image. I used a prime wide-angle lens with a 3-stop hard transition neutral density graduated filter to help retain detail in the foreground field without losing detail in the bright sky. I had only a minute or two to get the shot, because once the sun had risen above the tree line the effects of flare became unavoidable.

Canon EOS 3, 35mm lens, 3-stop neutral density graduated filter, Fujichrome Velvia, 1/4sec at f/16

18 Develop a workflow

There is a lot to think about when taking a landscape photograph; technical and aesthetical decisions have to be made, and often quite quickly. It is easy to forget a vital point, which may lead to the loss of an image. All photographers eventually develop a natural workflow but initially it is worthwhile making a simple list to follow. The fundamental factors of composition, focusing, exposure, filtration and camera set-up should be noted in the order you are most comfortable with. You should familiarize yourself with the layout of your camera bag so that you can find any item quickly. After finding the optimum position from which to shoot, run through your workflow to make sure that you've remembered everything. These steps will soon become second nature and you will be able to concentrate fully on capturing the scene before you.

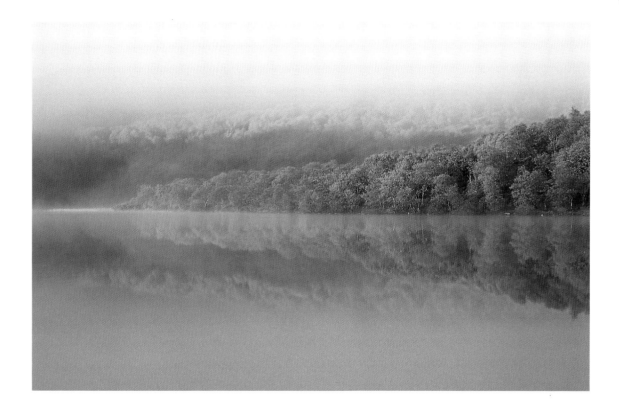

Woodland reflections

When walking along the shore of this small Scottish lochan on a very foggy early summer morning, I kept catching tantalizing glimpses of the opposite shoreline reflected in the calm water as the mist began to clear. I knew that the effect would not last long because, as the sun rose higher, the fog would begin to burn off and the breeze would pick up, destroying the reflections. It was essential to work quickly in order to capture the atmosphere of the moment. Having a basic workflow to follow provides an added safeguard that might just prevent disappointment when an opportunity like this arises. The main area of interest was quite distant, so I needed to use a telephoto lens to compose an image without too much blank space. Once I had set up my camera, using a polarizing filter to saturate the fresh spring foliage, I only needed to wait a few seconds before the mist cleared just enough to reveal sufficient contrast in the distant trees.

Canon EOS 5, 100–400mm lens, polarizer, Fujichrome Velvia, 1/15sec at f/11

19 Take control of exposure

Control of exposure is fundamental to successful landscape photography. All reflected light meters will give the correct reading to expose whatever they are pointed at as a mid-tone in the prevailing lighting conditions – even a white or black object would be recorded as a mid-tone grey if you used the setting suggested by your camera. This can be used to your advantage if you learn exactly how much compensation your camera meter requires in order to record white subjects as white and black subjects as black. Pure white subjects generally require 2 stops more exposure than the light meter will suggest, whilst pure black subjects need 2 stops less exposure. By using these extremes as a guideline you can work out how much compensation is required throughout the whole range of tones you are likely to encounter in the field.

Glen Lyon

It is important to work within the limitations of film and digital capture. I like to keep the range of tones in any scene within roughly 3 stops whenever possible, as this produces a more balanced result with plenty of detail throughout the image. I normally achieve this by shooting in low-contrast lighting conditions, or by using neutral density graduated filters to reduce contrast within the image. If I ever need to sacrifice detail in harsh lighting conditions in order to capture a specific scene, I always opt to lose detail in the shadows, as the human eye accepts dense shadows more naturally than blown highlights. This frosty shot of Glen Lyon, in Scotland, in winter was taken in very soft light. There was only a 3-stop brightness range in this scene, so the film has been able to record plenty of detail in both shadow and highlight areas.

Canon EOS 3, 24mm lens, Fujichrome Velvia, 1sec at f/16

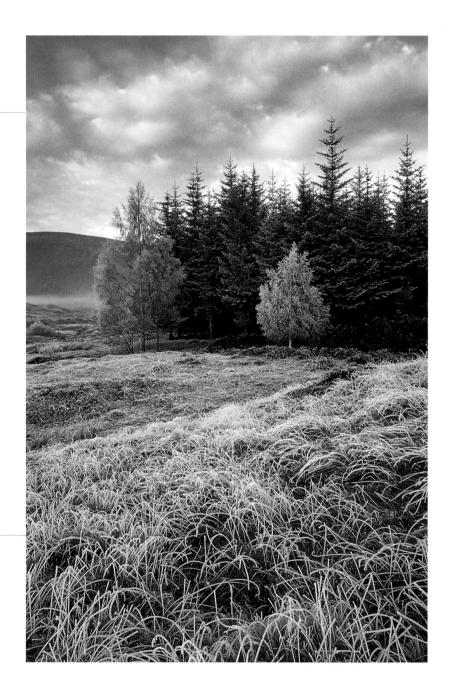

20 Master your metering technique

You shouldn't rely on your camera's standard metering system. You will achieve better results by taking a spot meter reading directly from the most important tones in the scene. If your camera doesn't have a spot-meter, attach a telephoto lens and fill the frame with the area you want to meter from. Once you have metered the most important tone in the scene and worked out an exposure setting that will record this tone at its correct brightness level on film (see page 32), meter other areas of the scene to make sure they are within the 5-stop brightness range that transparency film and digital sensors can handle. If certain parts of the scene, such as the sky, are outside this range, you might be able to reduce the contrast by using a neutral density graduated filter. You will have more control if you use your camera in manual mode. Handheld exposure meters are another option and many incorporate a spot meter.

Larch sapling

I discovered this lone larch sapling on the edge of a spruce plantation. Its bright yellow autumn foliage contrasted vividly with the monotonous green surroundings. Even though the overcast light provided soft and even illumination, the predominance of dark tones in the scene would still have fooled most in-camera metering systems into overexposing the image. I had two options: to take a spot meter reading directly from the yellow larch and increase the metered exposure by one stop to place it as a light tone on film; or, meter from an evenly lit section of green spruce and reduce the metered exposure by one stop so that it recorded as a dark tone. In such even light, both methods would have resulted in the same end exposure value.

Canon EOS 5, 100–400mm, polarizer, Fujichrome Velvia, 1/2sec at f/22

33

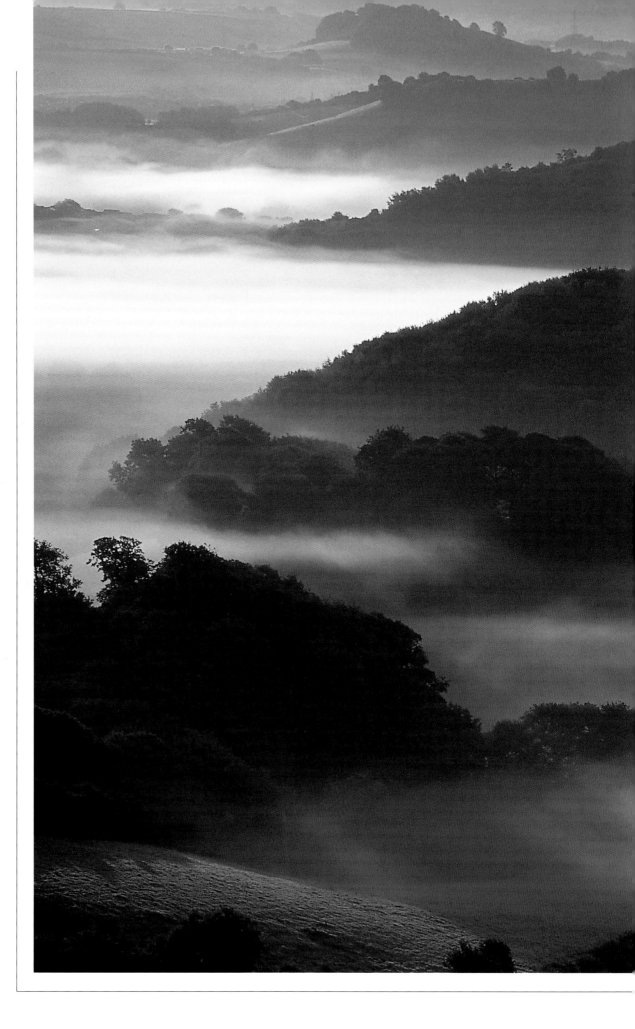

Capturing atmosphere

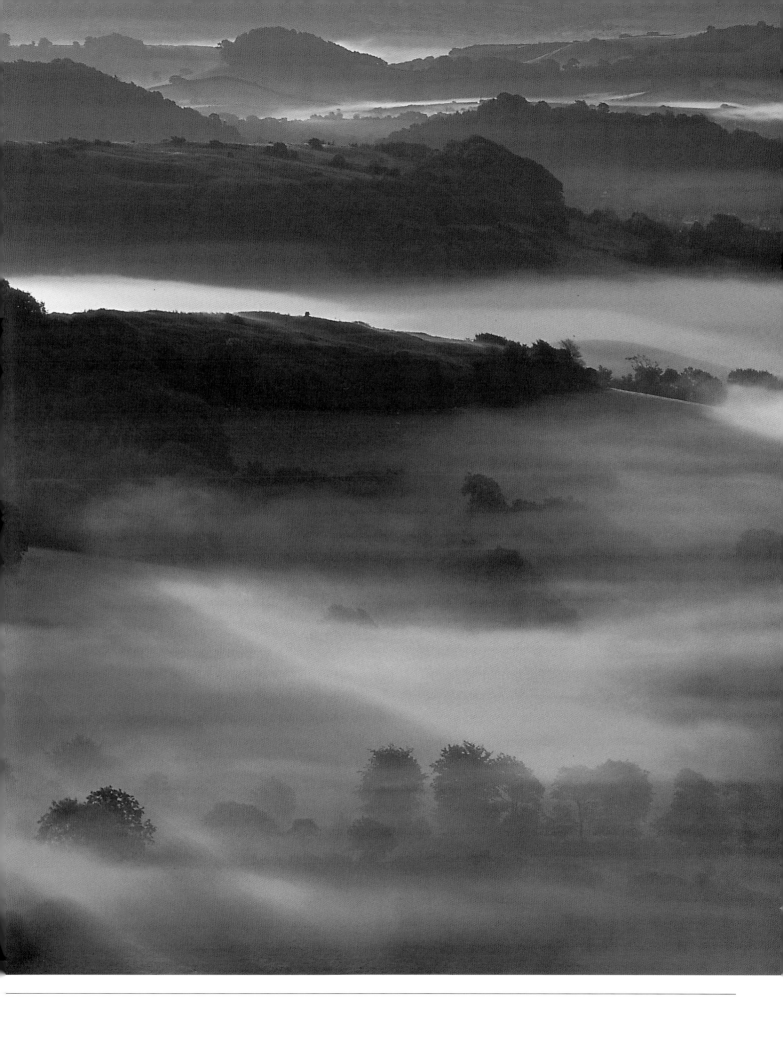

21 Add warmth to your images

There are times when you might want to add a little extra warmth to your images. Under a cloudless sky, shaded areas will reflect the blue and record this cool tone on film. A warm-up filter can be used to counteract this colour cast. Weak warm-up filters can also be used to enhance warm light early and late in the day, and provide a lift on overcast days. If the sky is included in your image, a graduated warm-up filter will add warmth to the foreground without altering the colour of the clouds. Don't over-use warm-up filters; only use them when absolutely necessary. Images with a warm tone tend to have a more positive feel, but the effect of a strong warm-up filter can be rather sickly. An 81A or 81B filter will be sufficient in most situations, although the more subtle range of coral filters produces a more pleasing and natural effect.

Neist Point

For this shot of Neist Point light-house in the Isle of Skye, I used a weak graduated coral warm-up filter upside down to add warmth to the foreground rock without affecting the colours in the rest of the scene. Positioning these subtle filters accurately can be difficult, but by pressing the depth-of-field preview button on your camera, the transition line of the filter becomes more apparent when looking through the viewfinder. There was a strong wind blowing across the clifftop, so I set my tripod up quite low to the ground and weighed the legs down with beanbags and boulders. I tripped the shutter whilst shielding the camera with my jacket.

Canon EOS 5, 24mm lens, polarizer, Coral 1 graduated warm-up filter, Fuji-chrome Velvia, 1/2sec at f/22

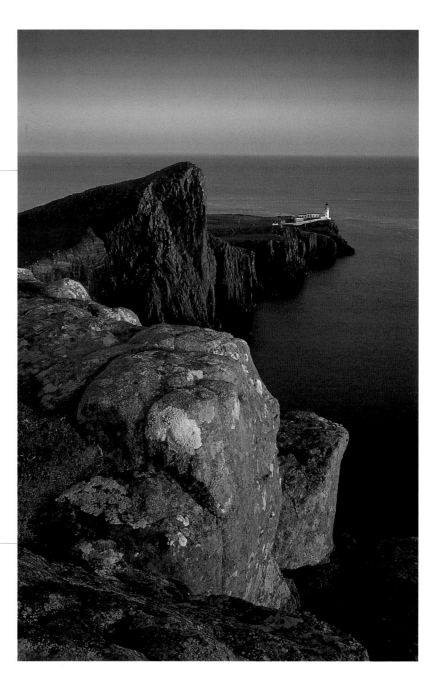

22 Capture subtle colours

Direct sunlight isn't always necessary in landscape photography. The subtle pastel colours that occur shortly before sunrise and after sunset bring with them a feeling of calm and serenity that can benefit certain landscape images. These soft tones often occur at their best in the opposite direction to the sun where clouds and haze are illuminated with various shades of colourful light, even though the sun is below the horizon. These colours look great when reflected in still water, and the low-contrast, even illumination helps to reveal detail throughout the scene. Keep your compositions simple and uncluttered and allow the colours themselves to form the basis of the image. A well-saturated, fine-grain film will help you to bring the most out of situations like this.

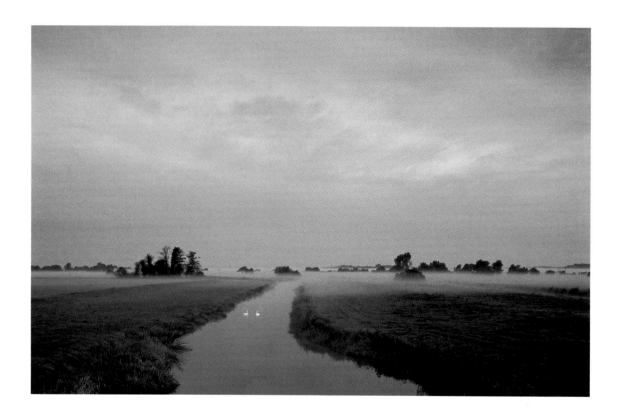

Swans on King's Sedgemoor

This misty early autumn morning on the Somerset Levels provided plenty of opportunities for atmospheric photography. I had been photographing the scene in the opposite direction to the image above when I noticed the colour developing behind me. I quickly changed my position. High cloud was being illuminated by the rising sun, even though it had yet to break the horizon. The clouds reflected this very soft red light across the landscape and on to the tranquil surface of the river. The two swans may be distant, but they form an important focal point within the composition.

Canon EOS 5, 28–70mm lens, 1-stop neutral density graduated filter, Fujichrome Velvia, 1sec at f/16

23 Create an image with depth

Composing a scene that includes distinct foreground, middle distance and background elements will help to create a three-dimensional feel. This can be achieved very effectively by including interesting elements in the foreground. Try to ensure that the general scale of elements within the scene gradually diminishes from the immediate foreground to the horizon – for example, placing a very large boulder in the middle distance would break this gradual recession and confuse the impression of depth that you are trying to create. A wide-angle lens can help to emphasize perspective and the scale of elements in your shot – get in close to foreground features to make them appear larger than they are in reality. Lighting will also affect the feeling of depth in an image. On overcast days, when there are no shadows, the landscape will look quite flat and featureless. The same is true on clear days when the sun is high in the sky. However, when the sun is low in the sky, it creates long shadows across the landscape, revealing textures and contours and helping to make certain features more distinct. The contrast of light and shadow will cause some sections of the landscape to become more prominent than others, leading to a far more three-dimensional effect.

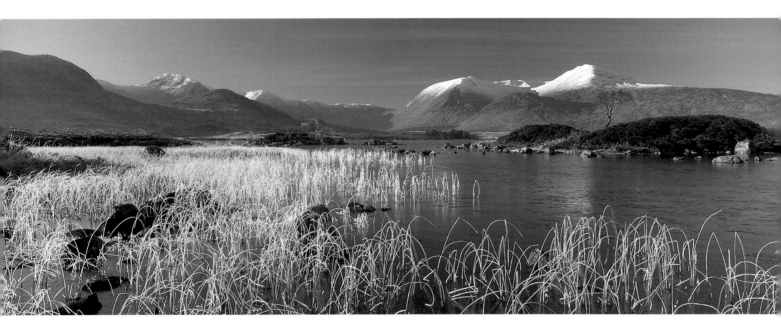

Rannoch Moor

By positioning my camera at a low angle very close to the frosted reeds in the foreground of this Scottish scene, and at a height that clearly shows the grasses receding into the distance, I was able to create a feeling of depth that would have been lacking had I shot the same scene from head height.

I used a polarizing filter to increase the contrast in the image by darkening both the sky and the lake.

This added further depth to the composition by making the reeds stand out sharply against the water and ice. I focused the lens using the engraved hyperfocal distance scale to ensure sufficient front-to-back sharpness.

Hasselblad X-Pan, 45mm lens, polarizer, Fujichrome Velvia, 1sec at f/22

24 Make the most of mist

Misty conditions tend to be quite predictable. A showery day followed by a clear night will often cause mist to form as the temperature drops. A cold night following a hot sunny day can also result in the formation of mist as the land radiates its heat. Lakes and river valleys are prone to mist, but fens, marshes and dry valleys can also harbour mist around dawn. Get to know where mist regularly forms and search out the best vantage points. A high viewpoint with an open aspect can be very rewarding – look for layers of hills or treetops emerging from a fog bank. Some of the most effective misty landscape images are made looking into the light, increasing contrast and adding drama to your shot. To expose a misty scene, take a spot-meter reading from the brightest area of the image and assign it as a very light tone by increasing the reading by between 1 and 2 stops. Misty conditions don't last long, so be in position well before sunrise.

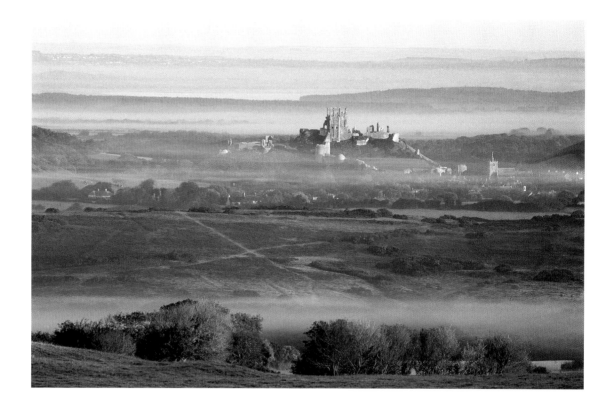

Corfe Castle

The elevated position of Corfe Castle in Dorset, England, allowed it to stand proud of the mist that had formed in the valley below. I chose to take this image from a considerable distance away, which allowed me to emphasize the layers of mist surrounding the castle by compressing perspective with the use of a telephoto lens. The mist also helped to conceal many unwanted elements in the composition such as telegraph poles, cars and houses.

This scene was sidelit and, as such, reacted well to the use of a polarizing filter, which saturated the colours and increased the contrast in the scene. I took spot-meter readings from all over the scene and then calculated an exposure that would maintain the subtle, pale tones in the mist.

Canon EOS 5, 100–400mm lens, polarizer, Fujichrome Velvia, 1/8sec at f/11

25 Photograph fog

Foggy conditions tend to be thought of as rather depressing. However, certain subjects work well in foggy conditions, such as woodland interiors, which can take on a magical atmosphere. Try using a telephoto lens to compress perspective, filling the frame with tree trunks receding into the mist. Alternatively, look for landscape details closer to you, where the softening effect of the mist will be less apparent and the even light will be perfect for recording fine detail. When using a wide-angle lens, try filling the foreground with textural or colourful subjects, such as fallen leaves or bright green fern fronds. If the sun begins to break through, try shooting into the light to increase the impact of the shot. Experiment with different films, and if you wish to increase contrast and colour saturation try uprating your film a stop or two.

Lighthouse

This shot was taken early on a damp, drizzly and very foggy morning. The fog-horn was blaring and the air was filled with sea spray. After a long drive in the dark, I was determined to take some pictures. I noticed how well defined the beams of the light were as they circled through the fog. In order to record the shape of each beam on film, I needed to use a relatively fast shutter speed. I uprated my film to ISO 200 to gain an extra stop and set my lens to a wide aperture, which gave me 1/30sec. I used a cable release to fire the shutter when the beams were in the best position. To enhance the beams further, I used a blue filter to provide a stronger contrast than would have resulted from shooting against a white sky.

Canon EOS 5, 28mm lens, 80A filter, Fujichrome Sensia 100 (uprated to ISO 200), 1/30sec at f/4

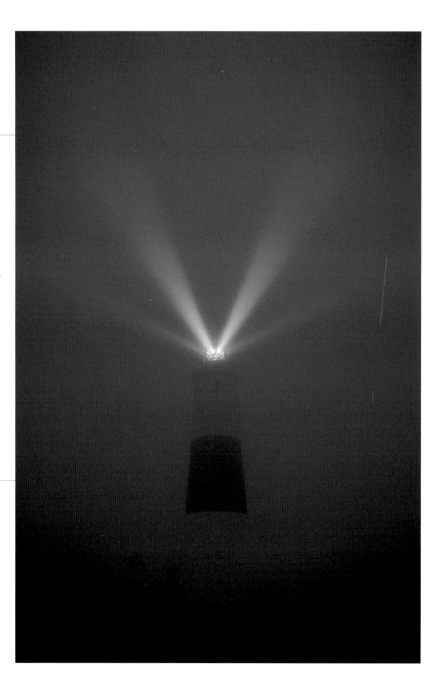

26 Shoot reflections

What could be better than doubling the impact of a beautifully lit landscape scene by including its mirrored reflection upon the still surface of a pond or lake? For perfectly mirrored reflections calm weather is an obvious requirement, with the best chances occurring early or late in the day. This is one of the few types of landscape image where a 50/50 split composition can be very effective. There is often a difference in brightness between the sky and its reflected image that isn't always readily apparent to the naked eye, so to prevent an unbalanced result you may need to use a neutral density graduated filter positioned over the sky. The strength of filter used is important, as, for a natural result, the reflection should never appear brighter than its source. In hilly or mountainous regions try using a longer focal length lens to eliminate the sky altogether – select interesting sections of the landscape, such as colourful trees, textural hillsides or interesting buildings that reflect in the water. A perfect reflection isn't always necessary; by using a strong neutral density filter to increase your exposure time to several seconds, it is even possible to record a soft reflection in rippling water.

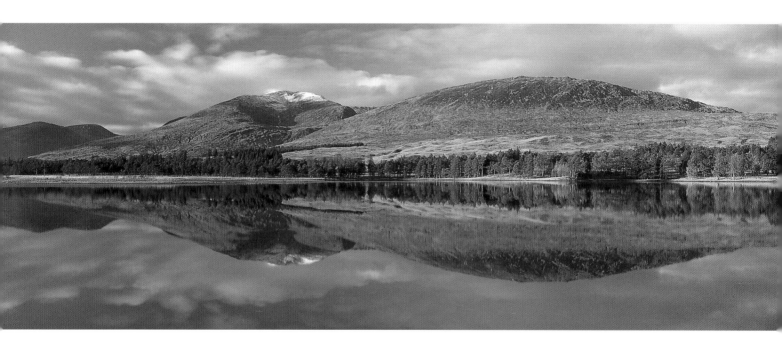

Loch Tulla

Late in the day, the surface of this remote Scottish loch reflected the surrounding landscape perfectly. The loch's surface was actually frozen over, but a thin layer of water coated the ice. Shallow water is far less prone to ripple, so even when a light breeze passed over the surface, the water fell calm again almost immediately. I decided to place the shoreline in the very centre of the composition in order to maximize the impact of the reflected image. By including the mountain tops, along with the sky, anything other than a 50/50 split would have made the composition look rather awkward.

Hasselblad X-Pan, 45mm lens, polarizer, centre-spot filter, Fujichrome Velvia, 1/2sec at f/11

27 Record movement in the landscape

Try to work with the prevailing weather conditions rather than against them. In windy weather, it is usually better to allow vegetation and other mobile elements to blur during a long exposure, rather than resorting to a wide aperture to obtain a shutter speed fast enough to freeze the motion – which will always be at the expense of valuable depth of field. In fact, recording the movement of rivers, waves, grasses and foliage can bring an otherwise dull landscape image to life. Movement can add both atmosphere and interest to the image. Fields of swaying arable crops or wildflowers can produce pleasing patterns as the breeze sweeps through them. The amount of blur is controlled by the selected shutter speed – anything from 1/15sec to several seconds can be effective. This technique works especially well on overcast days when the light levels are low, but can be equally effective in sunlight. If there is too much light to allow a slow shutter speed to be set, consider using a neutral density filter or a polarizer to reduce the amount of light reaching the film.

Beech avenue

If a long enough exposure is made, it can be possible to simplify a busy composition by blurring large areas of foliage, thus isolating static objects such as tree trunks. On this occasion, there was a strong wind blowing both the foliage on the trees and the ground flora; however, the substantial trunks and limbs remained static. I used a polarizing filter both to saturate the vibrant colour of the spring foliage and to increase the exposure time to 1sec.

Canon EOS 5, 70–200mm lens, polarizer, Fujichrome Velvia, 1sec at f/22

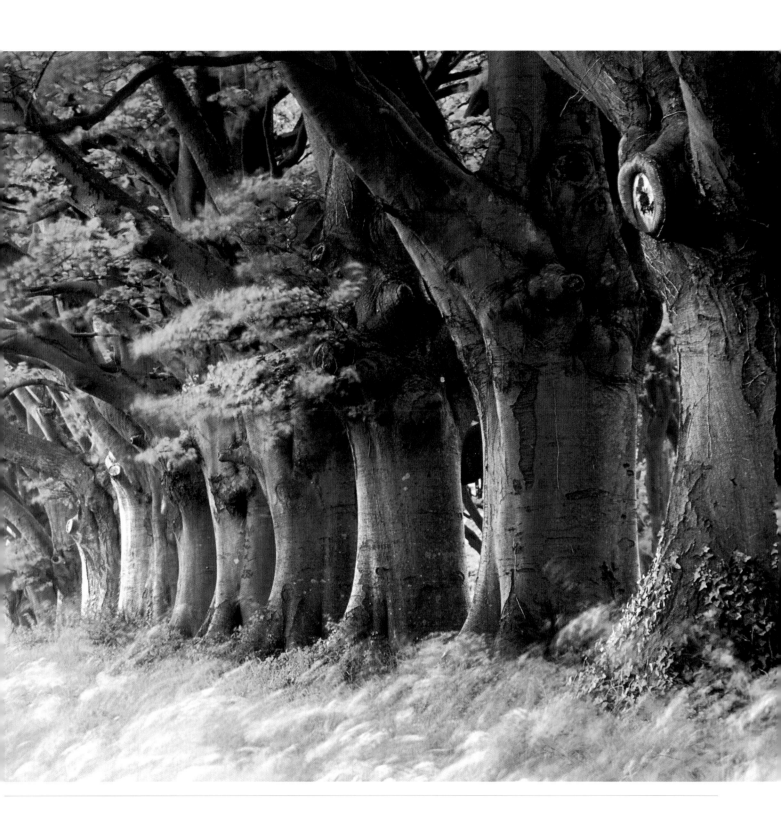

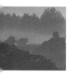
28 Shoot into the light

Shooting into the light can produce dramatic and atmospheric images. Results vary greatly according to the intensity of light and the exposure. Neither film nor digital capture can handle the brightness range in most backlit situations, so do not expect a backlit scene to record exactly as you see it. You need to choose between making a dark, moody image by exposing for the highlights and allowing the shadows to form a solid silhouette, or making a high-key image by exposing for shadows at the expense of highlight detail. The subject matter will often dictate which method is more appropriate. It can be worth bracketing exposures to see the range of different moods. Backlit scenes can fool in-camera metering systems, so work in manual mode and follow the principle of assigning a tone to the most important area. Flare will be a concern when shooting into the light, so take care to prevent it spoiling your image.

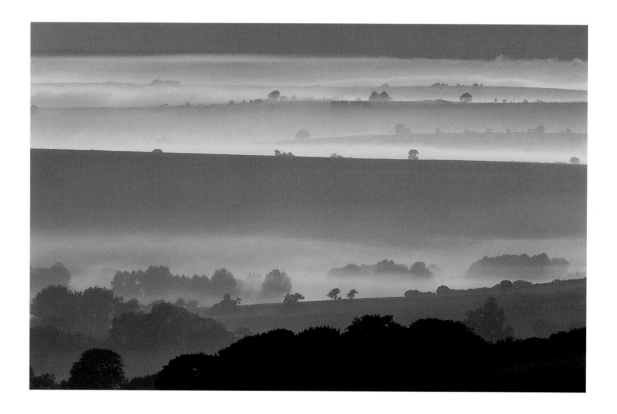

Distant ridges

In misty or foggy conditions, shooting into the light can be particularly effective as the contrast between sunlit mist and shaded trees and hillsides is very dramatic and any rays of sunlight will become more prominent. The image here shows a tiny and distant section of the overall scene before me. By using a long telephoto lens, I was able to compose tightly around the area that held most interest – a series of ridges intersected by valley mist. As the sun was very low in the sky, and just out of shot, my lens hood was rendered useless. In order to prevent flare from reducing the contrast of the shot, I held a piece of card above the lens to prevent the sun's rays from striking the front element directly.

Canon EOS 3, 500mm lens, Fujichrome Velvia, 1/125sec at f/11

29 Shoot sunrises and sunsets

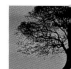

Sunrises and sunsets are popular subjects, and rightly so. It can be tempting to just fire away in order to catch the colours before they fade; however, careful composition remains as important as ever. The best colours are short-lived, so you should be in a suitable location well before they reach their peak. Some of the most spectacular colours appear when you least expect them – often just before or after a storm when a bank of cloud is briefly illuminated by the sun. Don't give up too soon as colours can fade away only to reappear moments later with even more vibrancy. The sky rarely makes a good image on its own, so look for a foreground that will give a base to the image without dominating the composition. In coastal locations and along the shores of lakes and rivers, the water reflects the colour of the sky into the foreground, thus doubling the impact of your shot.

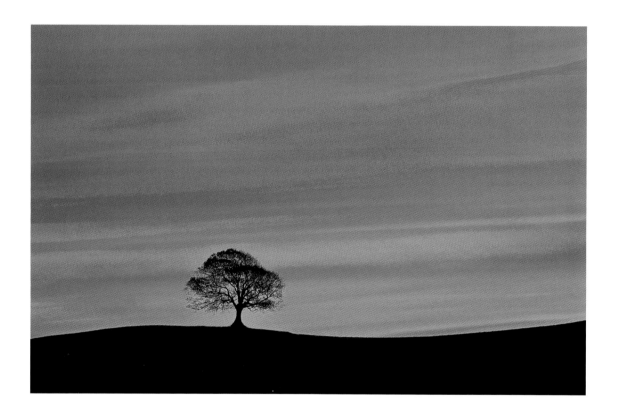

Oak tree

When shooting sunrises and sunsets, simple composition can be the key to a successful image and silhouettes often work well. This hilltop oak tree had attracted my attention on a number of occasions. However, it always seemed to be set against a boring backdrop of blue or white sky. I decided to return early one morning in the hope of shooting it against a colourful sunrise. After a couple of failed attempts, I captured this image as the sun briefly lit up the thin high clouds with glorious red tones. I took a spot-meter reading from the sky itself and increased the suggested exposure by 1 stop so that it recorded as a light tone in the image. I then metered the hillside below the tree to make sure that it was at least 3 stops darker and would therefore record as a solid silhouette.

Canon EOS 5, 100–400mm lens, Fujichrome Velvia, 1/15sec at f/11

30 Use sidelighting

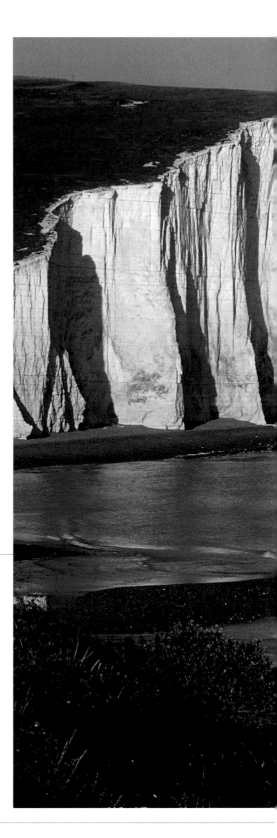

Sidelighting is, in many cases, the most effective lighting for landscape photography. When the sun is behind you, its frontal light flattens perspective and conceals the contours, patterns and textures that give the landscape its character. However, when the sun is shining from right-angles to the camera position, the resulting contrast between sunlit and shaded areas will reveal and enhance the lie of the land. Sidelighting creates a three-dimensional effect that provides modelling light to features in the landscape, such as rock formations and buildings, enhancing their shape and detail. The effect becomes stronger when the shadows lengthen as the sun moves closer to the horizon. Early and late in the day, the contrast will be much lower, enabling you to retain detail in all areas of the image. Make use of shadows when composing your image, but don't let large areas of dense shadow dominate the scene. Polarizing filters have maximum effect when used at 90 degrees to the sun, so can be employed most effectively when shooting a scene with sidelighting.

The Seven Sisters

This view of the impressive Seven Sisters coastline on the south coast of England only works well just before sunset during midsummer. This is the only time at which the sunlight is at the necessary angle to cast shadows across the face of the white chalk cliffs. Without these shadows, the rock face appears quite flat and featureless, but with a little sidelighting, the texture and shape of the cliffs is briefly revealed. Fortunately, the row of coastguard cottages, although not particularly attractive in themselves, are of such a similar tone to the chalk that they fit quite naturally within the scene. I used a polarizing filter, not only to saturate the colours, but also to help cut through the summer haze and reveal more detail in the distant parts of the scene.

Canon EOS 3, 70–200mm lens, polarizer, Fujichrome Velvia, 1/15sec at f/16

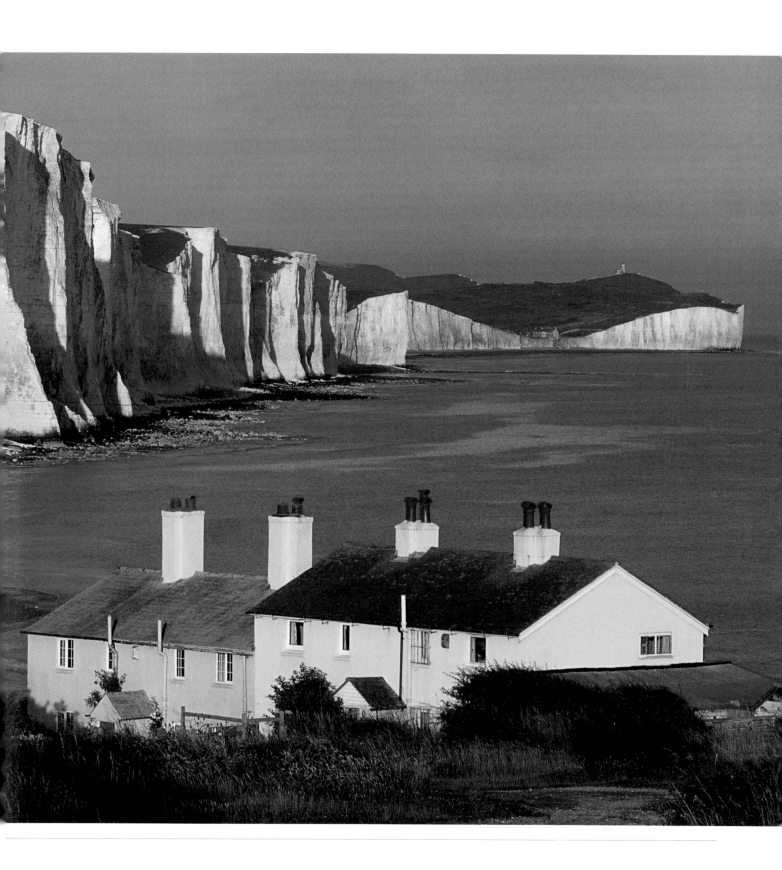

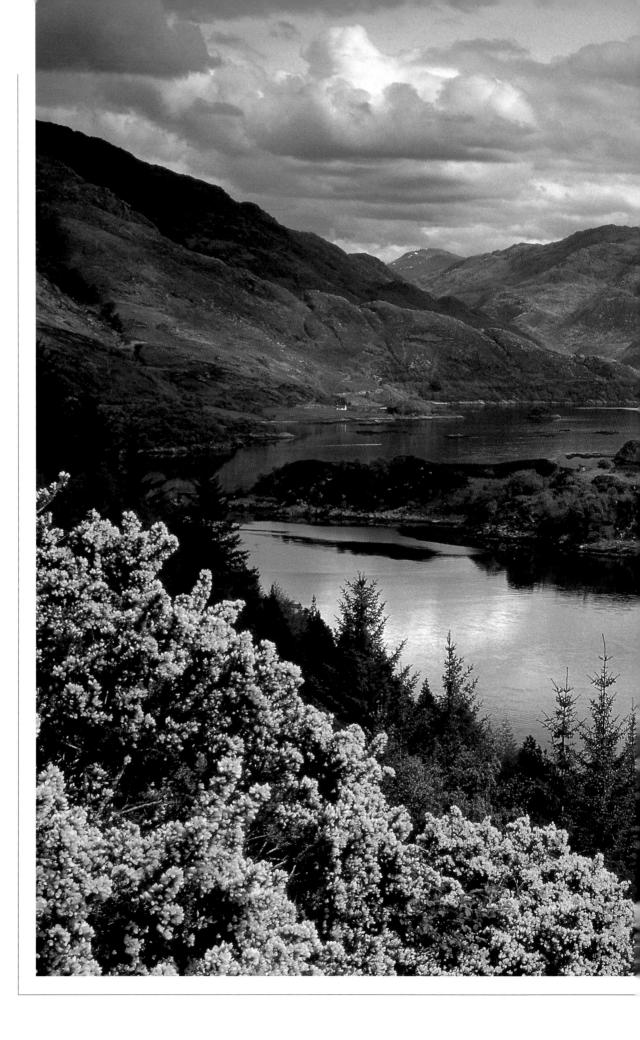

The wider landscape

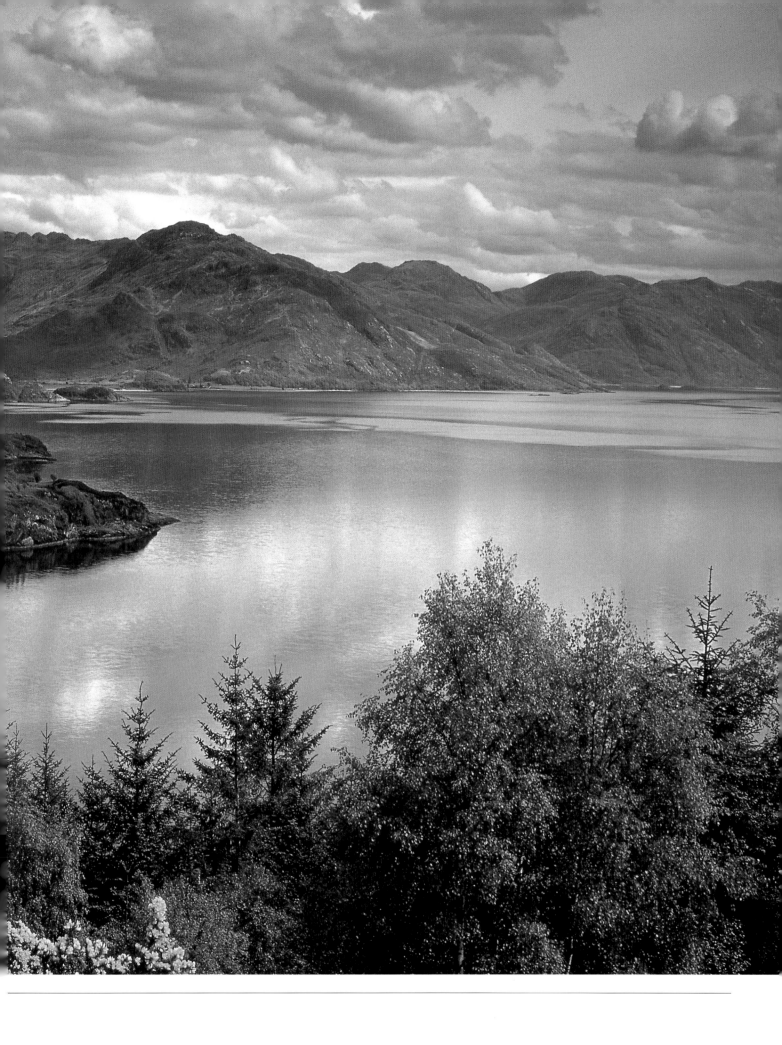

31 Fine-tune composition

Mounting your camera on a tripod will allow you to carefully fine-tune your chosen composition. Small horizontal or vertical shifts can often improve the look of your shot by removing distracting features from the edges of the frame or by placing greater emphasis on other elements by moving them further into the composition. Take time to check for any unwanted twigs or grasses creeping into the edges of the viewfinder – using your camera's depth-of-field preview button to close the lens down to the shooting aperture will allow you to spot these quite easily. The viewfinders on many camera bodies don't show 100 per cent of the image area, so it can be worthwhile zooming out a little or moving the camera around in order to check for any unwanted elements that are lying just outside the visible area of the viewfinder.

Bodiam Castle

To take this early morning image of Bodiam Castle in Sussex, England, I had to stand on the edge of the moat beneath tall trees. Even though it meant manoeuvring myself into a precarious position, with my tripod legs in the water, I had to make sure that neither the overhanging branches nor their reflections appeared around the edges of the frame. As it was impossible to use the branches to frame the shot, any odd ones that did appear within the image would have been very eye-catching and would have detracted from the clean symmetrical composition that I was trying to achieve. I applied a slight amount of polarization to saturate the colours, without causing an uneven darkening of the sky. Within minutes of this exposure being made the wind had picked up and the reflections were lost for the remainder of the morning.

Canon EOS 3, 24mm lens, polarizer, Fujichrome Velvia, 1/60sec at f/11

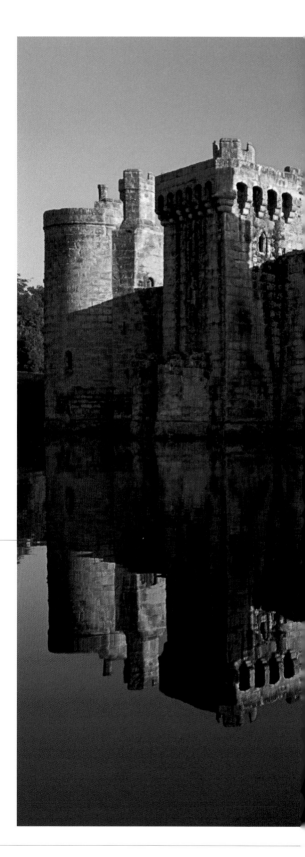

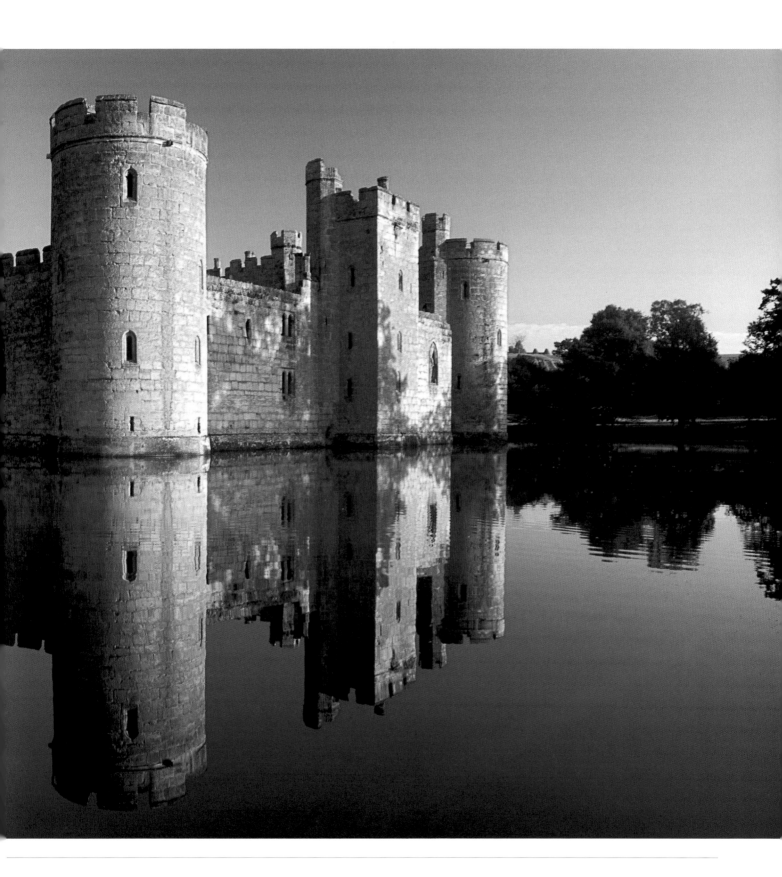

32 Avoid converging verticals

Wide-angle lenses are designed to be able to record both vertical and horizontal lines straight and true when used parallel to the subject. However, if the camera is pointed up or down, even at a slight angle, then vertical lines in the composition will begin to converge into the picture. This can be of benefit when you are attempting to exaggerate the height of certain landscape features or to emphasize the perspective of lines running into the frame. However, it is not desirable to record trees and buildings leaning in from the frame edges when your wish is to record the landscape as naturally as possible. It is possible to counteract the unwanted effects of converging verticals by using either a tilt/shift lens or the movements of a large-format camera body.

Exeter Cathedral

It is possible to avoid converging verticals by ensuring that the back of your camera remains perfectly upright. However, this can result in compositional restrictions, especially when including foreground inter-est close to the camera position. Also, without the ability to tilt the camera forward, you will be forced to position the horizon through the centre of the image. For this shot of Exeter Cathedral, I decided to shoot in portrait format in order to include the foreground cobbles whilst still keeping the camera back vertical. I waited until both the artificial light and the brightness of the sky were roughly balanced before making my exposure. Off-camera flash was used to light the foreground cobbles.

Canon EOS 1Ds, 24mm lens, ISO 50, 30sec at f/11

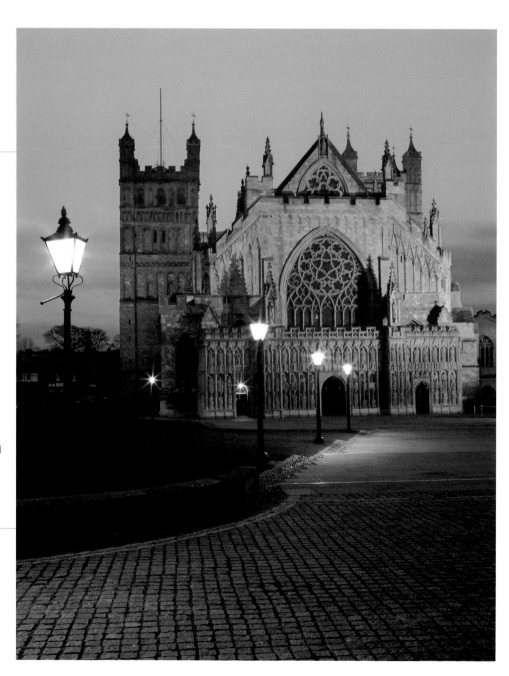

33 Understand depth of field

Depth of field describes how much of a scene can be recorded sharply in front of and behind the actual point of focus. This area of apparent sharpness is affected by the focal length of the lens and the lens aperture used; a smaller aperture results in more depth of field. Wide-angle lenses exhibit far greater depth of field than telephotos. Landscape images taken with a wide-angle lens tend to be made using a small aperture to ensure sufficient depth of field in order to record both foreground and background sharply. However, selecting the smallest aperture on the lens is often unnecessary; you may be able to achieve the required front-to-back sharpness at a more open aperture. Therefore, you should aim to place almost the entire available depth of field within the boundaries of your shot by focusing very accurately.

Frozen river

It was important to set the camera up to ensure that both the foreground ice patterns and the distant trees were recorded sharply in this winter river scene at Kiveskoski in Finland. There's nothing worse than a wide-angle landscape shot where the foreground or background is distinctly unsharp. I used a small aperture of f/16 and focused using the engraved hyperfocal distance scale on the lens barrel to ensure sufficient front-to-back sharpness at that aperture. As the sky was much brighter than the foreground, I had to use a neutral density graduated filter to achieve a balanced result with enough detail throughout the image.

Canon EOS 1Ds, Zeiss 21mm lens,
2-stop neutral density graduated filter,
Fujichrome Velvia, 1sec at f/16

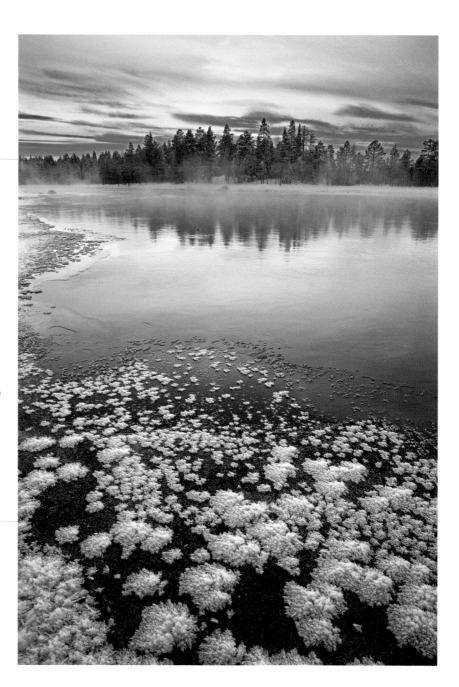

34 Exploit the panoramic format

Landscape photography with a panoramic camera can be very rewarding. The format provides a field of view very similar to what we see with our own eyes. However, composing a panoramic image requires great care and only certain scenes will fit well into the letterbox format. It is essential that there is interest across the entire frame for the shot to be successful. Large areas of dense shadow and featureless blocks of colour should be avoided as they can unbalance the composition. A level horizon is crucial, as any slight angle will be exaggerated by the panoramic format. In order to achieve even exposure across the frame, a centre-spot neutral density filter must be used with most lenses. Another way to achieve high-quality panoramic images is to shoot a series of images with a 35mm camera (either film or digital) and combine the results seamlessly using computer software.

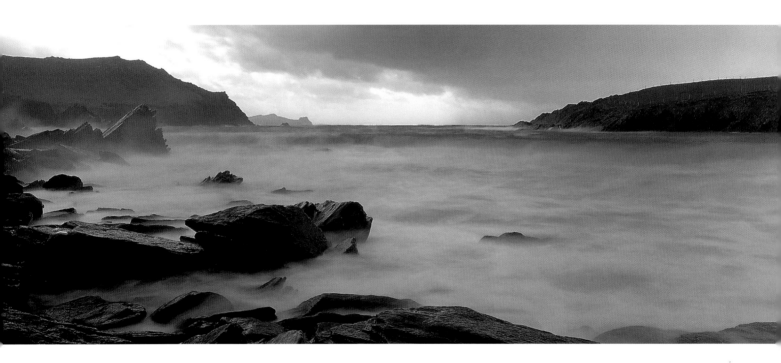

Blasket Sound

Occasionally I come across a location where I find it almost impossible to achieve a successful image without using a panoramic camera. This small bay on the Dingle Peninsula in Ireland was one of those places. I wanted to show the headlands on either side of the bay, whilst including a decent amount of wave-lashed rocky shore on the left of the image. It was also important to exclude as much of the quite featureless sky and dark foreground rocks as possible. Unfortunately, the combination of a small aperture and centre-spot filter resulted in a longer exposure than I would have wished for, smoothing out the huge waves that were sweeping into the bay. The Hasselblad XPan is so small that it can easily be carried in addition to a 35mm or medium-format camera system. Be aware that the rangefinder design of true panoramic camera bodies means that it is difficult, although not impossible, to accurately position neutral density graduated filters in front of the lens.

Hasselblad XPan, 45mm lens, centre-spot filter, Fujichrome Velvia uprated to ISO 100, 8sec at f/16

35 Take care with composition

Simplicity is often the key to composing a successful landscape photograph. However, when using wide-angle lenses, it can be difficult to prevent a landscape view from looking cluttered and confusing to the eye. You must decide which parts of the scene are most important and work hard to exclude any elements that don't have a role to play in the composition of your image. Look for interesting foreground elements and lead-in lines, and compose them so that they draw the viewer's eye into the scene. Try not to include large blocks of solid colour or large areas of dense shadow. As a final check, crank your lens back to its minimum focusing distance whilst looking carefully through the viewfinder – this will show up any potentially distracting grasses or twigs in the foreground that may have gone unnoticed.

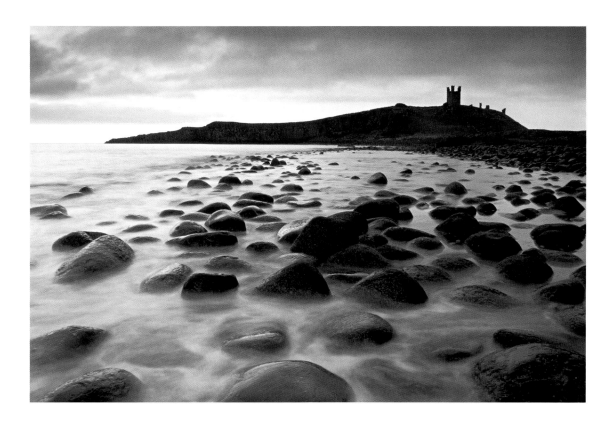

Dunstanburgh Castle

As with many wide-angle shots, it can help to have a focal point to provide the eye with somewhere to rest within the composition. In this image, the distant castle ruins help to illustrate the general scale of the scene. To increase the apparent depth of the shot, I used a wide-angle lens from a low angle so that the effects of perspective were amplified – the size of the foreground boulders diminish the further the eye

travels into the scene. Whilst the lack of colour and the low light levels might not have worked with many landscape images, I feel that they help to convey a feeling of mood and drama that is quite appropriate for this particular location.

Canon EOS 5, 24mm lens, 2-stop neutral density graduated filter, Fujichrome Velvia 50, 1sec at f/16

36 Maintain a level horizon

When composing a landscape photograph, it is important to ensure that the scene is perfectly level, especially when the horizon is included in the frame. Any slight angle will be exaggerated when using a wide-angle lens and will immediately detract from the final image. It is easy to be fooled by slopes and undulations in the landscape, so the effect of a sloping horizon may not become apparent until you look at your processed images. Therefore you should use a spirit level, rather than relying upon the viewfinder image itself. Some tripod heads incorporate a small spirit level, but they can be difficult to see in low light. Hotshoe-mounted spirit levels are a far more practical alternative. Watch out for barrel and pincushion lens distortions, as they can become far more apparent when photographing a perfectly straight horizon. Although more common with zoom lenses, they can also affect cheaper prime optics. Placing the horizon close to the centre of the frame can help to reduce the effects of these distortions, but at the expense of compositional freedom.

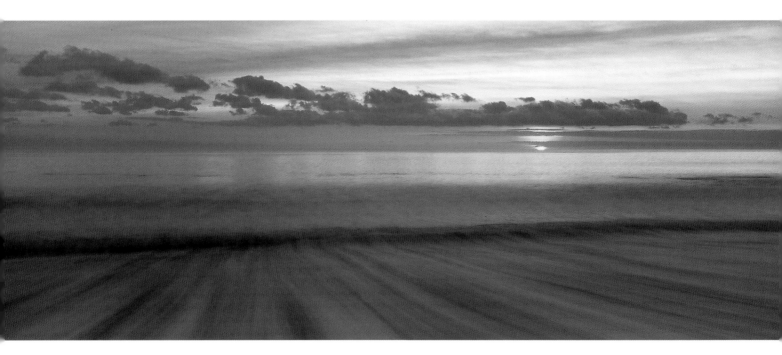

Sunset

When shooting along the coast, the horizon will normally include a distinct straight line over the ocean, so even the slightest slope would be very noticeable. This image illustrates just how important a level horizon can be – the slightest angle here would be very obvious. Waves can easily move your tripod, causing it to slip on rocks or sink into soft sand, so it is essential to check for level before exposing each shot. On this occasion, I set my tripod up just out of reach of the breaking waves to prevent it from being moved as the water dragged pebbles back down the beach. This photograph shows how very simple compositions can be successful. Even though the image consists only of sky and water, the layers of subtle colour and contrasting tone create a serene and inviting scene, whilst the receding wave helps to draw the eye into the shot.

Hasselblad XPan, 45mm lens, centre-spot filter, Fuji-chrome Velvia, 4sec at f/22

37 Use a focal point

A focal point can be an important compositional tool in landscape photography, especially in busy wide angle views, where it can provide the eye with somewhere to rest within the image. Although a focal point needs to be eye-catching, it should never be allowed to dominate the image or detract from the overall composition. You could use something that will help to characterize the area you are photographing, such as a recognizable building or an animal associated with the location. Focal points can be most effective if they are subtle – such as an intersection of shadow and highlight, or a pool of sunlight in an otherwise overcast landscape scene. Unless you are composing a symmetrical image, it is best to position the focal point away from the centre of the image (see page 120).

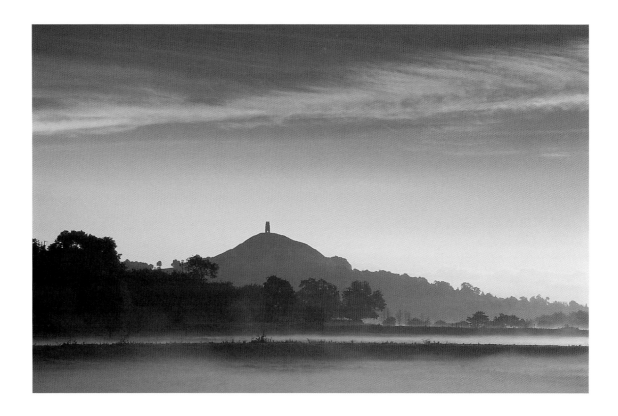

Glastonbury Tor

Here, the tower on Glastonbury Tor, in Somerset, forms a distinct focal point. The eye is drawn to such a prominent feature in the shot and, after exploring the rest of the image, returns to settle upon it, thus maintaining the viewer's interest in the image. It was important to shoot from a position from which I could see clearly through the doorway of the tower – this opening, although very small in the image, provides the tower with a sense of scale and identity. I placed the horizon low in the frame and used the high cirrus cloud to help balance the composition. If the sky had been completely clear, this composition would not have worked.

Canon EOS 5, 35mm lens, 2-stop neutral density graduated filter, Fujichrome Velvia 50, 1/15sec at f/11

38 Use hyperfocal focusing

Hyperfocal focusing can seem quite a daunting topic. However, it simply entails placing your actual point of focus at the optimal position (the hyperfocal point) where you can record the whole scene sharply at your set aperture. Most prime lenses include an engraved depth-of-field scale that can be used to set hyperfocal distance easily. Align the infinity symbol with the right-hand depth-of-field mark for your chosen aperture – you're now focused on the hyperfocal distance for that aperture. The left-hand aperture mark also aligns with the distance scale to show the closest point that will be recorded sharply – a point that is always half the distance between the hyperfocal point and the camera. Unfortunately, most zoom lenses lack this scale, in which case focusing one-third of the way into the scene will give an approximate hyperfocal point. A more precise result will require the use of a depth-of-field chart for the exact lens focal length in use.

Chideock

Once mastered, hyperfocal focusing will ensure that you consistently set your lenses to achieve precisely the right amount of depth of field to record the area in your image sharply from foreground to background. Like many photographers, I prefer to err on the side of caution and calculate hyperfocal distance for an aperture 1 stop open from the one being used – this provides a little extra sharpness back and front, which can be useful when making large prints. For this English landscape, I set my lens (using the engraved hyperfocal distance scale) to ensure sufficient front-to-back sharpness for an aperture of f/11, but used f/16 for the final exposure.

Canon EOS 5, 28mm lens, graduated coral 1 filter, Fujichrome Velvia, 1sec at f/16

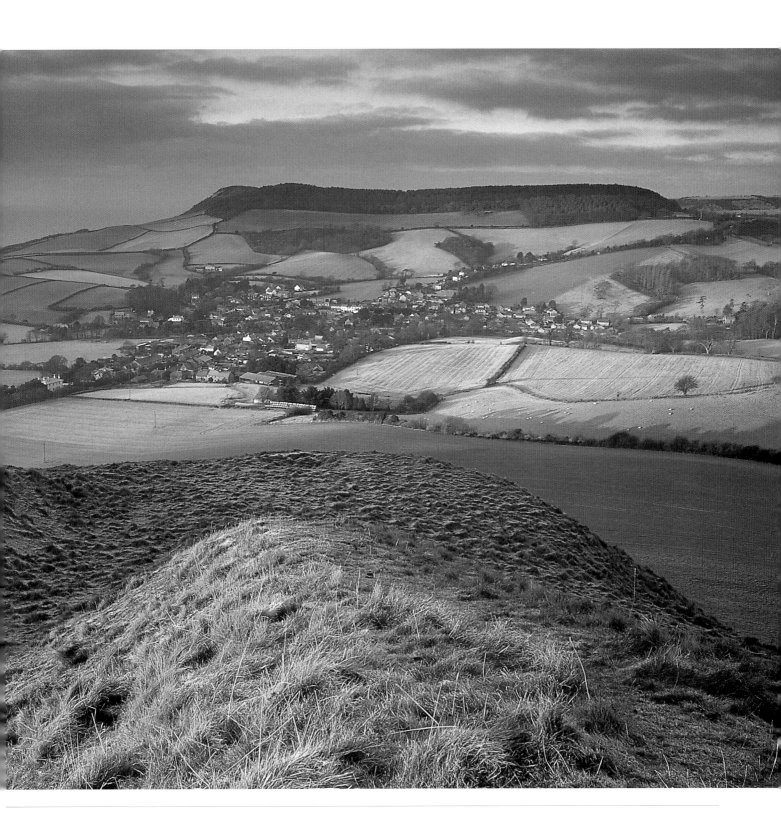

39 Use foreground interest

Try to convey a better sense of depth in your landscapes by including foreground interest to lead the viewer's eye into the scene. A wide-angle lens will usually be required, both to achieve the necessary coverage and to provide sufficient depth of field. The exaggerated perspective of a wide-angle lens also helps to give a more three-dimensional effect, especially when shooting from a low angle. Look for natural lead-in lines and interesting shapes, colours, textures and patterns – nothing too dominant, as you don't want it to overwhelm the image or detract from the main focal point. Although the use of foreground interest is mainly attributed to wide-angle shots, telephoto landscape images can also benefit from a certain amount of foreground to provide a base to the composition and to add depth to the scene.

Mupe Bay

When working close to the limits of depth of field, it is advisable to use hyperfocal focusing to ensure sufficient front-to-back sharpness (see page 53). For this shot of Mupe Bay in Dorset, I used the natural geology of the beach to lead the eye into the scene. Although the effect is quite subtle in this image, the lines of foreground rock add depth to the composition as they recede into the distance. The closer you are to the foreground, the more depth will be conveyed in the image. However, it is important to avoid compositions where the foreground is too distinctly separated from a distant horizon. Include some middle ground as well, so that the viewer's eye can move smoothly through the image.

Mamiya RB67, 50mm lens, 1-stop neutral density graduated filter, Fujichrome Velvia, 1/2sec at f/22

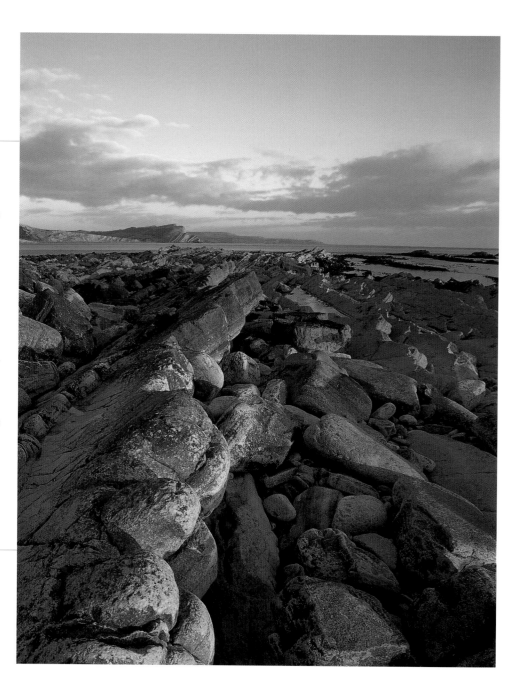

40 Use lead-in lines

Strong lines that are positioned to run from foreground to background can add tremendous depth to a landscape photograph. The effects of perspective help to draw the viewer's eye through the scene and can be amplified with the use of a wide-angle lens. Well-defined lines such as roads, paths, furrows and tracks can be used to add impact but need to be used with caution as they can sometimes lead the eye through the image a little too quickly. Subtle lines can also work well, allowing the viewer's eye to move slowly through the image, studying the detail more closely. If you include the curved or zig-zagged lines of hedgerows, walls, streams and other natural features, these usually provide the eye with several places to rest on its journey through the image.

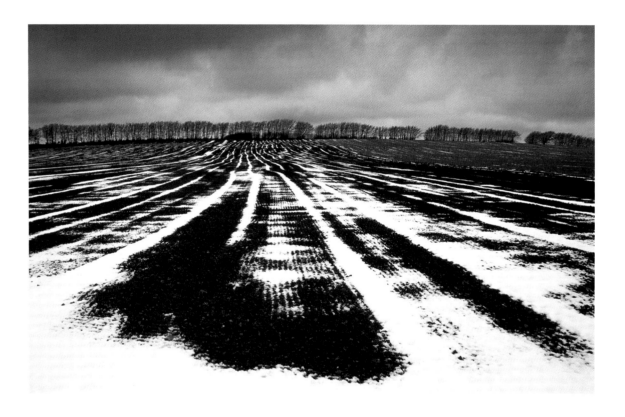

Fields in winter

A series of lines that link together different parts of the image can be effective – perhaps a row of stones in the foreground that link up with the line of a hedge-row further into the composition, which in turn might adjoin a row of trees upon the horizon. The eye will subconsciously link these lines together as a natural trail through the scene. In this image, the patterns amongst the patchy snow in the foreground help to draw the eye towards the distant row of trees on the horizon. The trees are positioned according to the rule of thirds (see page 120) resulting in a well-balanced composition. The strong contrasts and graphic quality of the image, combined with the powerful lead-in lines, provide plenty of impact. Had I taken this image from a few metres either side of this position, the foreground would have consisted of an unbroken blanket of white snow – splitting the image into two distinct sections.

Canon EOS 5, 28mm lens, Fujichrome Velvia, 1/20sec at f/16

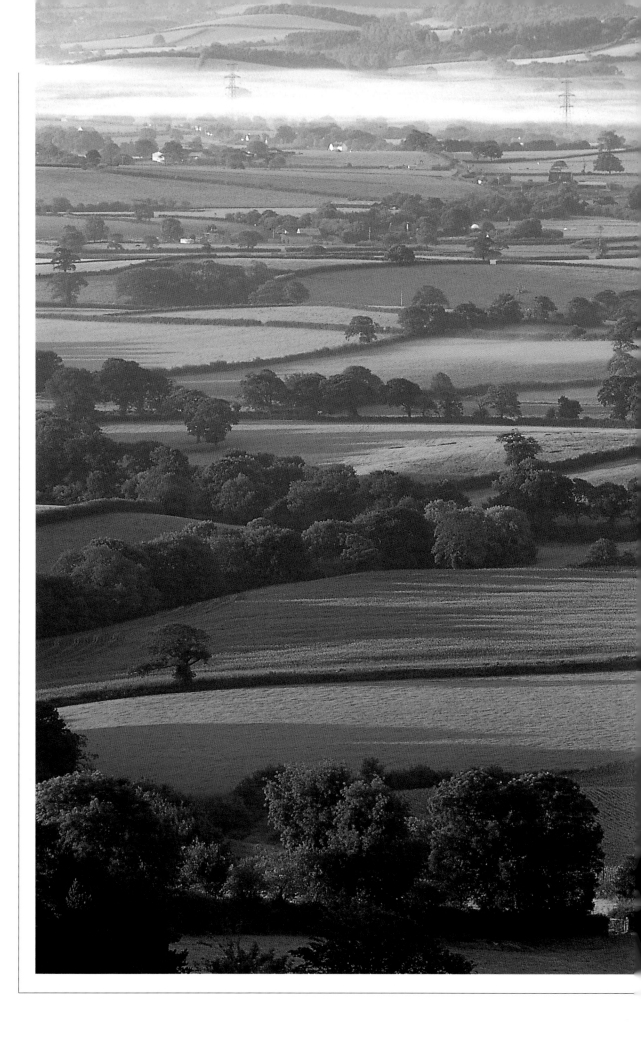

The distant landscape

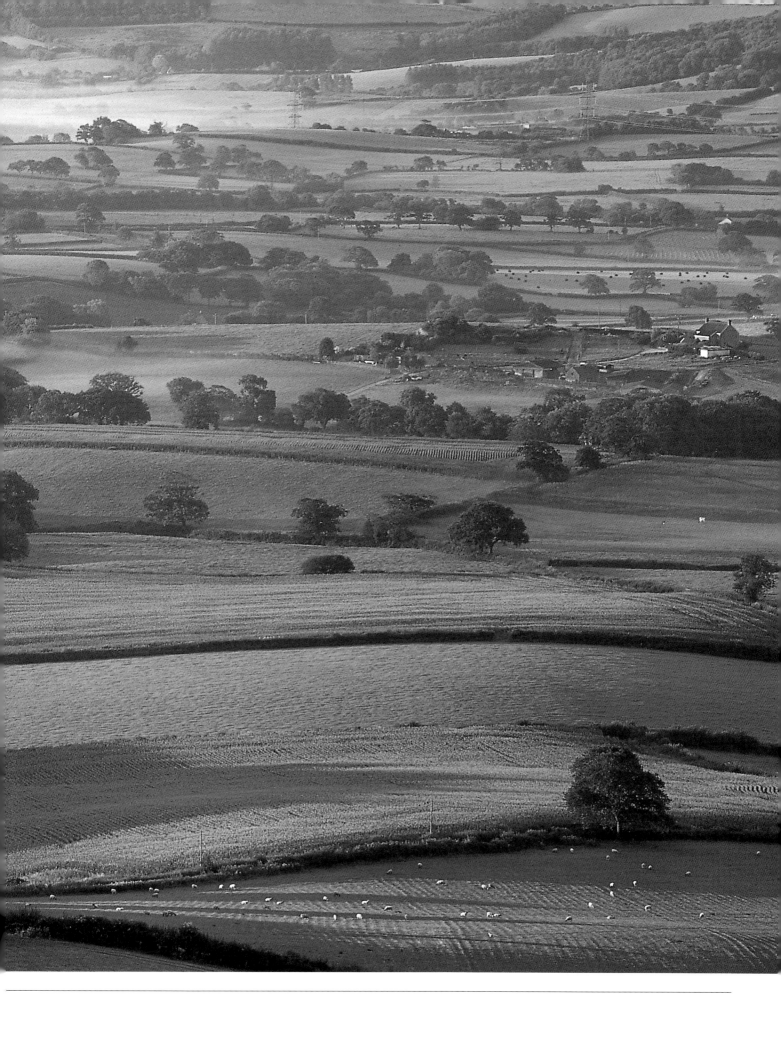

41 Capture aerial perspective

Aerial perspective occurs on hazy days when moisture and dust particles suspended in the air are illuminated against the landscape. In hilly and mountainous regions, the effect of this haze is a contrast in brightness between near and far sections of the landscape. In such conditions, the tone of objects changes according to distance, with far-away mountains, hills and ridges recording as a lighter tone than those nearer to the camera position. This gradual recession of tone provides an enhanced impression of depth and distance that is best recorded with a telephoto lens. The effect can occur at any time of the day and doesn't require direct sunlight. One of the most effective times to capture aerial perspective is just before sunrise and after sunset, when subtle pastel colours enhance the scene.

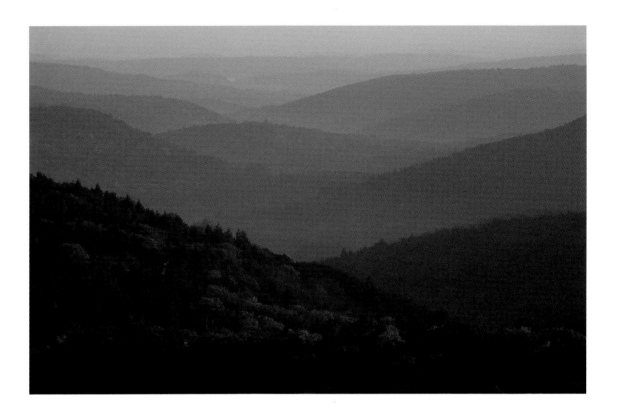

The Berkshires

Images that use aerial perspective generally rely upon a simple graphic composition and often have an abstract feel. Any fine details will be lost in the hazy conditions, so the image needs strong and distinct lines and forms to be successful. This shot, taken shortly after sunrise, shows aerial perspective in a series of intersecting hillsides along a valley in the Berkshires, Massachusetts. I used a 400mm lens to compose tightly around the most graphic section of the scene. The lens had the effect of compressing perspective, which has made the hills appear much closer together than they actually are. Backlighting has enhanced the aerial perspective effect.

Canon EOS 3, 400mm lens, Fujichrome Velvia, 1/60sec at f/16

42 Eliminate all distractions

The most successful telephoto landscape shots tend to have very simple and uncluttered compositions. It is important to avoid including any elements that could potentially distract the viewer's attention away from the main subject or pattern. Make sure that all individual features are wholly included within the composition, rather than being chopped off by the frame edge. Incomplete elements make the viewer wonder what's missing, forcing their attention to the edges of the frame and away from the important components of the image. Achieving front-to-back sharpness isn't always easy with a telephoto lens, but out-of-focus foregrounds and backgrounds can be very distracting in landscape images – so you should do all you can to maximize depth of field.

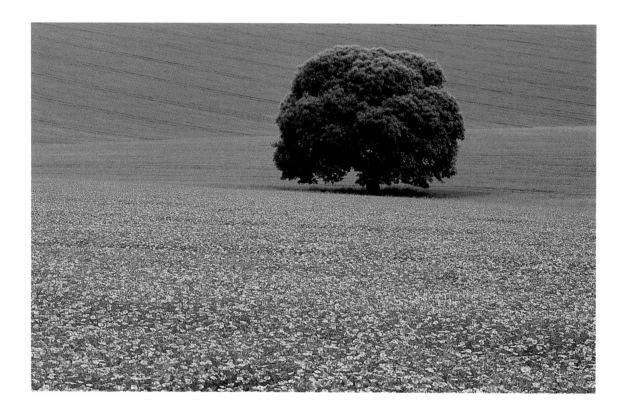

Lone tree

The simple composition of this lone sweet chestnut tree in a field of linseed would not have been possible without a telephoto lens. A combination of a small stepladder and the 200mm end of my zoom lens allowed me to shoot from a high point in the field looking down on the tree, thus avoiding the horizon in the shot. By focusing carefully and selecting a small aperture, I was able to record both the tree and the closest flowers sharply. The image relies upon only two elements: the tree and the mass of blue flowers. Including any other elements in the frame would have altered the feel and balance of the image quite significantly.

Canon EOS 5, 70–200mm lens, polarizer, Fujichrome Velvia, 1/8sec at f/22

43 Choose the right lens

Lenses in the range of 100mm to 1,000mm can all be very useful in landscape photography. However, due to their size and weight, there is the obvious need to restrict the number and weight of lenses carried. There is little point in carrying heavy f/2.8 lenses when practically all your images will be made at smaller apertures. There are many situations in which the use of very long focal lengths (400–1,000mm) can be helpful. They give an extremely narrow field of view that enables you to select distant details of the landscape and compose an image that could easily go unnoticed by the naked eye – opening up new possibilities in your favourite landscape locations. These lenses also have the effect of compressing perspective, which can be very useful in making simple graphic images of the landscape in misty or hazy conditions.

Dry-stone walls

Telephoto zoom lenses can be beneficial for several reasons. Not only do they replace several prime optics, thus saving weight and cost, but they also permit far more precise composition. There is very little difference in optical quality between very good quality zoom lenses and the equivalent prime optics, although zooms can be more prone to flare and lens distortions. However, it is worth bearing in mind that you are able to fine-tune your composition in-camera to exclude any unwanted elements from the scene, so there should rarely be a need for cropping the image later. A further advantage when using cameras that don't show 100 per cent of the image in the viewfinder is the ability to zoom out a little to check for objects encroaching into the edges of your composition. For this shot, I used my versatile 100–400mm lens to carefully compose a distant section of dry-stone walls in the Peak District National Park.

Canon EOS 5, 100–400mm lens, polarizer, Fujichrome Velvia, 1/8sec at f/16

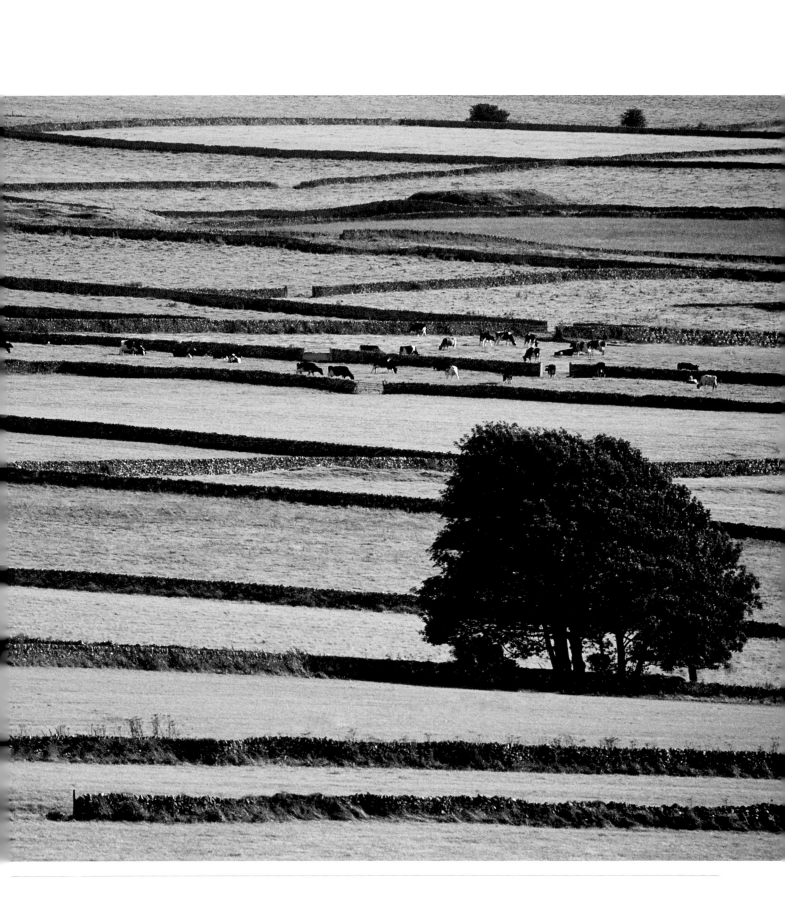

44 Focus with care

To obtain maximum sharpness from your telephoto lenses, it is essential to focus with the utmost care. The very shallow depth of field available with a long telephoto lens means that any slight inaccuracy when focusing will be very apparent in your images. In low light, or at other times when your subject has very little contrast, the accuracy of autofocus lenses cannot always be relied upon, in which case it can be better to focus manually. Alternatively, use autofocus to lock on to a well-defined object at the same distance as your subject, and then recompose. When the whole scene is very distant and includes no close foreground detail, you can use a wide aperture in order to set the fastest shutter speed possible. However, when your composition includes some foreground you must select a smaller aperture to achieve sufficient depth of field.

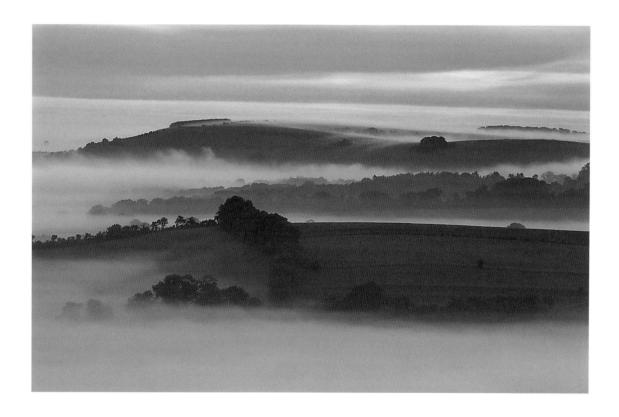

Cranborne Chase

This English scene was taken from a position where it was difficult to set up my tripod. I had to extend the legs to their full height in order to gain a clear view over a roadside hedge. This left my lens prone to the effects of the shutter and mirror-induced vibrations and buffeting by the breeze. As the composition includes only distant elements, I was able to set a wide aperture in order to achieve the fastest shutter speed possible without having to worry about depth of field. Never simply focus at the maximum distance your lens allows assuming that this will record distant detail sharply, as this focus point can be well beyond infinity on some lenses! At a wide-open aperture, accurate focusing is absolutely critical to image sharpness.

Canon EOS 5, 500mm lens, Fujichrome Provia, 1/250sec at f/4

45 Include the sun

Including the sun in an image can add drama to a shot; it acts as a focal point in the image and the backlighting effect adds atmosphere. Including the sun is best when its brightness is muted by mist, haze or thin cloud, otherwise flare could severely reduce the contrast in the image. Filters are best avoided in this situation; however, if a neutral density graduated filter is necessary, its angle in the filter holder must be fine-tuned to prevent a double image of the sun. Metering can be tricky, as the brightness of the sun will fool any automated exposure meter into underexposing the shot. You must decide whether to retain detail in the foreground or allow it to record as a silhouette. It is possible to include the sun even when it is high in the sky, in which case a small aperture can be used to give a starburst effect. However, the chances of flare occurring will be greatly increased. Never look directly at the sun through your viewfinder.

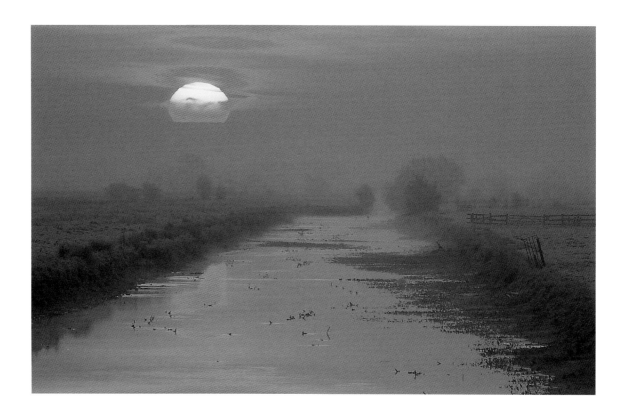

Somerset Levels

For this shot, I decided to use a telephoto lens to record the sun quite large in the frame. The frosty ground helped to record detail in the shadow areas, whilst the water reflected the colour of the sky into the foreground of the image. Sunrise and sunset are the best times to include the ball of the sun within your composition, as its rays have to pass through a greater density of airborne particles, thus reducing its brightness considerably. However, you must make sure that you are set up in time to catch the sun right on the horizon; this is when the colours will be at their strongest and the chances of flare occurring are much reduced.

Canon EOS 5, 400mm lens, Fujichrome Velvia, 1/4sec at f/22

46 Make use of sharp light

Atmospheric haze reduces contrast and can lead to images that lack impact and apparent sharpness. This is especially true of distant landscape scenes shot using telephoto lenses. Fine details are often lost altogether and colour saturation can be poor. These conditions can occur at any time of the year, but are most frequent during the summer months, when high pressure allows moisture and dust to become suspended in the air. Be ready to go out after a storm, or as a weather front begins to move away, as the sunlight will be at its sharpest and most intense, allowing you to record fine details in even the most distant views. Heat haze can also ruin telephoto landscape shots. It can occur whenever the sun is above the horizon and at any time of the year. The shimmering effect distorts distant detail, which records as a blur. On showery days a passing cloud can eliminate the shimmering effect for a few seconds, but you need to be quick to catch the scene in a pool of sharp sunlight.

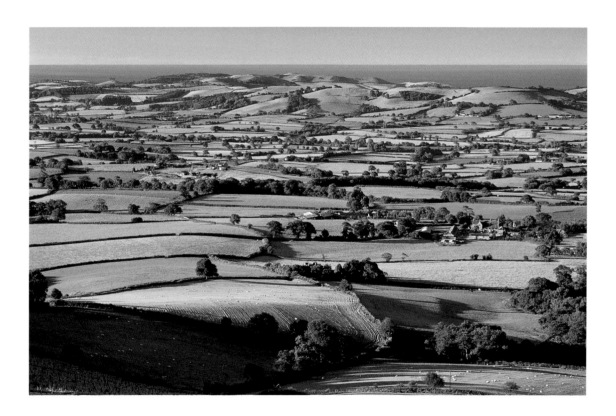

Marshwood Vale

This summertime view across a typical English valley is the type of photograph that benefits greatly from sharp light and clear air. The image was taken late in the afternoon shortly after a weather front had passed away to the east, leaving behind beautifully clear air and crisp sunlight. Any haze would have softened distant detail and reduced the overall impact of the shot. I used a polarizing filter to cut through any remaining haze and to saturate the colours in the scene.

Canon EOS 3, 100–400mm zoom lens, polarizer, Fujichrome Velvia, 1/30sec at f/11

47 Select graphic compositions

Simple graphic compositions often work well in landscape images. Look out for colour, line, form, texture, light and shadow. Search for patterns in the scene that can be used to form graphic or abstract compositions, and exclude any detracting elements. Telephoto lenses can help to isolate details and to concentrate attention on the main subject or pattern. They also compress the effects of perspective, which can further simplify the image. Zoom lenses, especially telephoto zooms, can be useful in fine-tuning composition. Look for a small number of elements that work well together. Use contrasting colours to add impact to the image, or complementary colours for a more subtle effect. This type of image can be appreciated solely for its graphic qualities, but it is still nice to provide a sense of scale where possible.

Layered hills

On a previous visit to this hilltop, I had noticed how a small section of the distant landscape fitted well into the 35mm format through a 400mm telephoto lens. I decided to return early one morning when the hills would be backlit to attempt a more graphic image than would have been possible in direct sunlight. As luck would have it, the valleys in between were hidden beneath a blanket of thick fog, causing the succession of hilltops to stand out even more ef-fectively than I had envisaged. It was almost an hour after sunrise before I was able to cast a shadow over the front element of my lens without my hand appearing in the frame. The wait was worthwhile, as flare would have reduced the overall contrast of the image. Some landscape photographs, particularly graphic images where the composition depends upon the lines and forms of the landscape, can benefit from the sharper and more intense light that occurs when the sun is well above the horizon. I was quite pleased with the monochrome tones that resulted from shooting a little later in the day, free from the warmth of first light.

Canon EOS 5, 100–400mm zoom lens, Fujichrome Velvia, 1/60sec at f/11

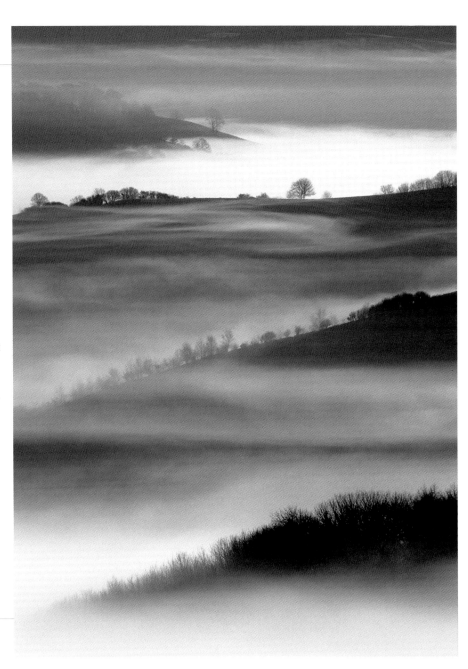

48 Spot potential scenes

Our eyes naturally tend to see things with a wide-angle perspective, so it can be difficult to spot distant scenes that could potentially offer an effective composition with a telephoto lens. The best way to develop an eye for this type of landscape photography is to go out a few times armed with only a long telephoto lens. Once you become accustomed to the magnification, compressed perspective and tight framing that these lenses provide, you will begin to become aware of distant compositions that would not have attracted your attention before. When contemplating any landscape scene, take the time to consider whether there are any distant details that could be selected from the overall vista in order to make an interesting image in their own right.

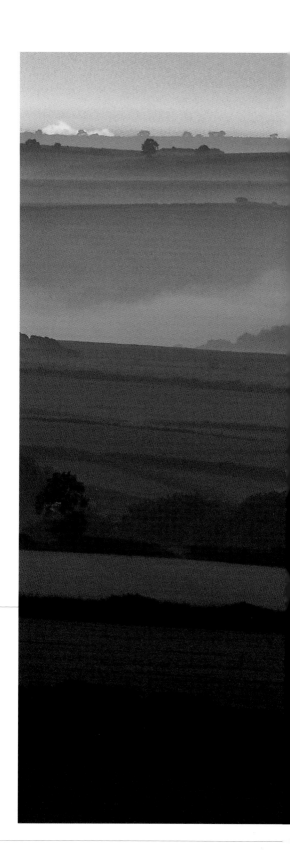

Red mist

This view was many miles away from my actual shooting position. Initially, I used binoculars to scan the distant horizon for possible compositions. Fortunately, I was able to find a large gatepost that made a rock-solid support for my lens, which I placed on top of two beanbags so that the entire length of the lens was well supported. In order to include only those elements that were necessary for the composition to work, I added a 1.4x extender to my 500mm lens – a combination that provides around 14x magnification. The narrow field of view allowed me to compose around the most vibrant colours whilst avoiding the bright area close to the rising sun.

Canon EOS 3, 500mm lens, 1.4x extender, Fujichrome Velvia, 1/250sec at f/11

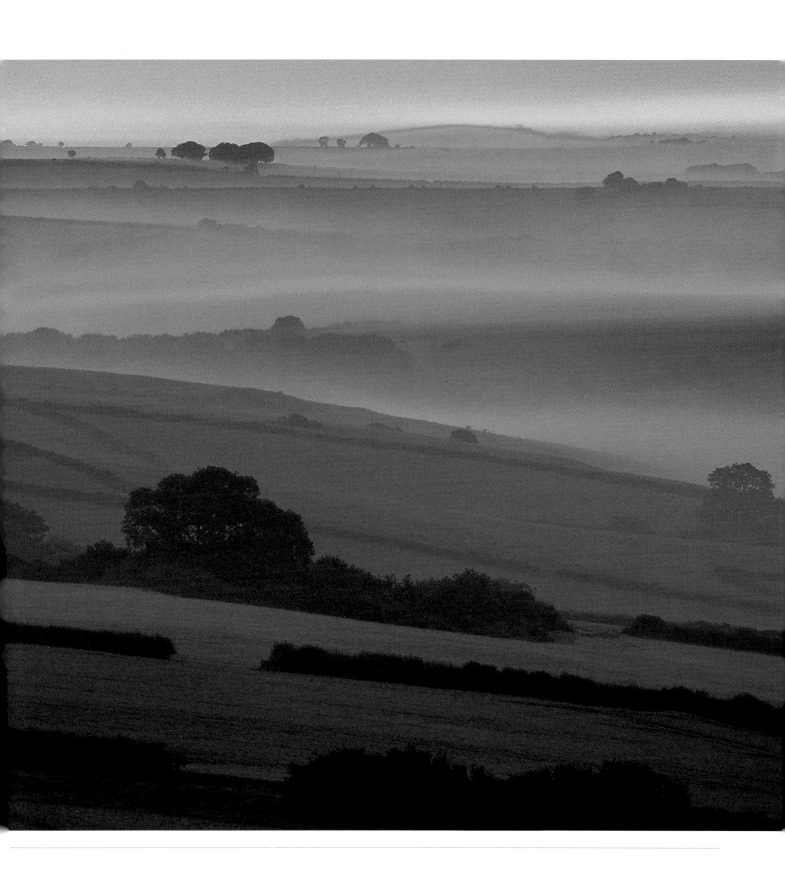

49 Understand long lens technique

It is essential to use support with heavy, high-magnification lenses. A beanbag is less sensitive to wind-induced vibration than a tripod. It also absorbs vibrations caused by the camera shutter, which can affect the image sharpness when using a big telephoto lens. In situations where a beanbag cannot be used, a heavy tripod is the next best option. This can be made more stable by placing a beanbag on top of the lens. In breezy conditions, it can be worthwhile attaching a second tripod or a monopod under the camera body – although this makes fine compositional adjustments awkward. It is best to avoid shutter speeds between 1/2 and 1/60sec, as these are the ones most prone to exhibit the effects of camera shake and vibrations. Always use your camera's mirror lock-up function (if it has one), together with a cable release or self-timer.

A distant dawn

The advent of image-stabilized lenses has made obtaining sharp images from large telephoto lenses much easier. I often make use of image stabilization in blustery conditions to help minimize the effects of the wind buffeting the camera. However, you shouldn't allow this technology to make you a lazy photographer – continue to use your tripod religiously; in the majority of situations there is no substitute! This image was taken with a 700mm lens, which provided around 14x magnification. This is a very small and distant section of the view I was looking at, and without such high magnification I would never have been able to achieve this layered effect. I supported my lens on two beanbags, which were placed upon the roof of my car, and used mirror lock-up and a remote release to ensure a sharp result.

Canon EOS 1Ds, 500mm lens, 1.4x extender, ISO 100, 1/125sec at f/16

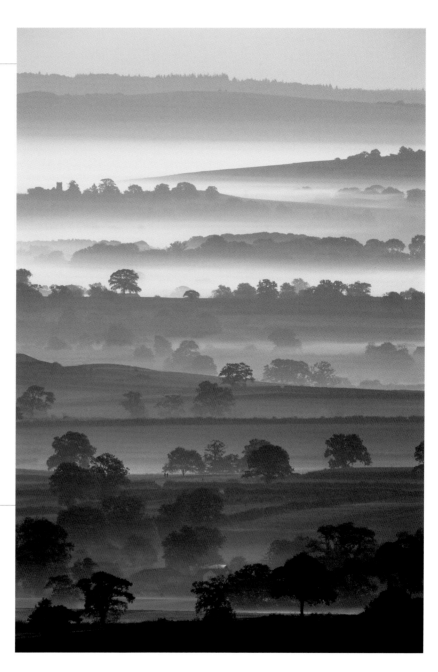

50 Use filters with caution

Filters and telephoto lenses don't always work well together. The optical quality of most plastic and optical resin filters is fine for wide-angle and normal lenses, but often not for longer glass. Neutral density graduated filters should only be used when absolutely necessary and even then you must use the very finest quality filters available. The poor optical quality of many filters is hugely magnified by telephoto lenses, and in some cases it can be impossible even to focus the lens with the filter in place. One exception is a glass polarizing filter, which can be used successfully to cut through haze and saturate colour, albeit at the expense of 2 stops of light. Many larger telephoto lenses have a built-in filter drawer at the back of the lens that takes both a purpose-made polarizing filter and very thin gel filters, which can be used very effectively in landscape photography.

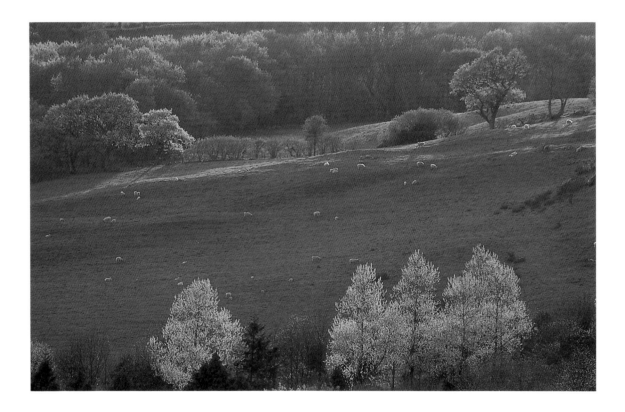

Backlit trees

The narrow field of view of a telephoto lens means that neutral density graduated filters are rarely required, as it is relatively easy to prevent areas of high contrast such as the sky appearing within your com-position. In this image, the last rays of the sun have provided a golden tint, negating the need for a warm-up filter and providing the scene with an autumnal feel – even though this particular image was taken in springtime! Had I been tempted to use a warm-up filter in this backlit situation, the chances of flare occurring would have been greatly increased and overall image quality would have been compromized as a result.

Canon EOS 5, 400mm lens, Fujichrome Velvia, 1/8sec at f/16

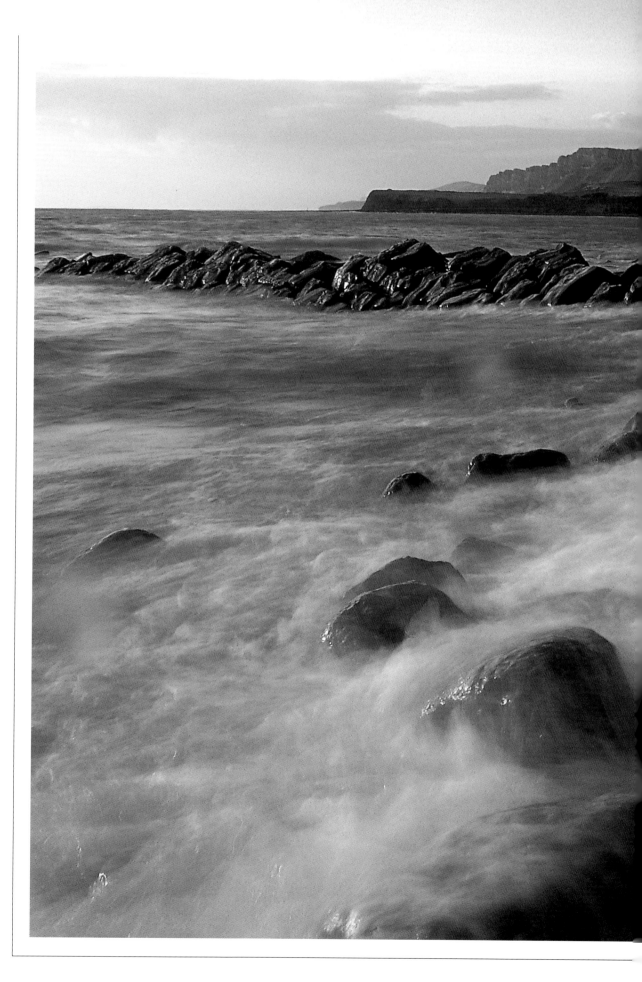

Coastal landscapes

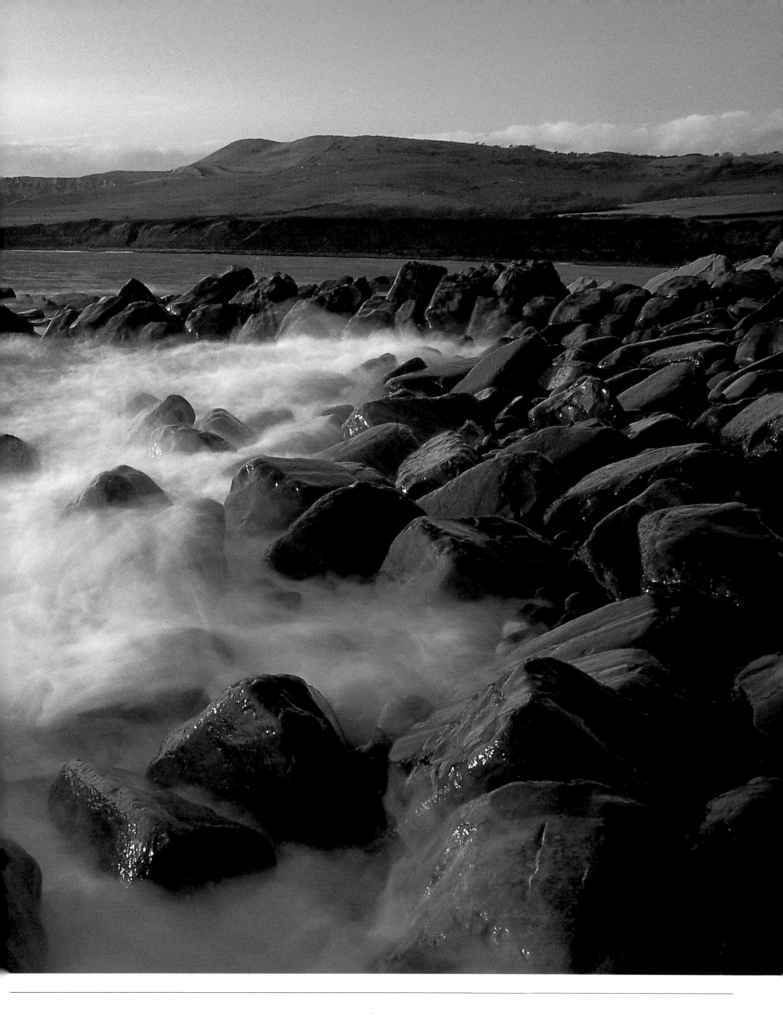

51 Avoid flotsam and jetsam

It can be surprisingly easy to miss small pieces of litter and debris when shooting a coastal landscape scene. Often such items are concealed in the shadows or temporarily hidden by the surf. However, they become all too evident when you first see your processed images! The smallest piece of litter can spoil an image of an otherwise unspoiled coastline. Most litter gets deposited along a natural strandline – the position of which varies depending upon the height of the tide and the state of the sea. Even natural material can look unsightly, as a small piece of dry seaweed on a pristine beach can be a major distraction. Occasionally though, the tide will bring in a more attractive item, such as driftwood or an interesting shell, which can be successfully incorporated into your image.

St Alban's Head

Even though this particular section of coastline is almost inaccessible on foot, its west-facing aspect means that, unfortunately, litter will normally be present. Before taking this shot, I had to spend time removing various pieces of marine refuse that had been carelessly thrown overboard somewhere out in the Atlantic and that had been deposited here by the prevailing winds and ocean currents. It is a good idea to carry a pair of disposable gloves for this task. The light on this occasion was quite spectacular, retaining contrast even when the sun was upon the horizon. I used a polarizing filter to saturate the colours and increase the exposure time to allow me to record motion in the waves and so add further atmosphere to the photograph.

Canon EOS 3, 20mm lens, polarizer, 1-stop neutral density graduated filter, Fujichrome Velvia, 3sec at f/22

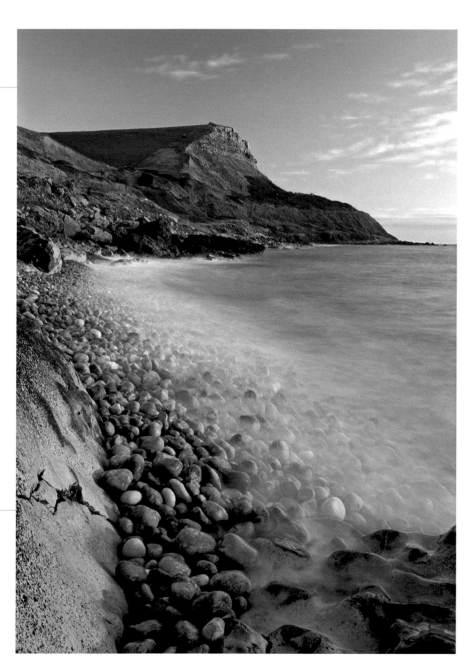

52 Check the tides

When working on the coast, a knowledge of the tides is vital, both for photography and for safety. Make sure that you have accurate tidal information for the location that you plan to visit. Keep an eye on an incoming tide: it is easy to get cut off when a headland is unexpectedly surrounded by water. Plan your photography according to the tidal conditions. Some locations look best at low tide, when rock pools, pristine sand and interesting geology are exposed. Other sites can look better at high tide, when beach debris, litter and other unwanted elements are concealed in the surf. A falling tide exposes clean, unmarked sand and shiny wet pebbles and boulders that reflect the colours of sunrise or sunset. A rising tide can be less productive, as the sand is often marked and unattractive and any boulders are dry and unreflective.

Lyme Bay

Tidal conditions can vary from one beach or cove to the next – even if they are not very far apart. Therefore, it is essential to find a tide table for the exact locality you're heading for. By scouting locations in advance, you will be able to work out the best tidal conditions for each particular place. The small area of sandy beach in this image is only ever exposed during the lowest tides. A previous visit had told me that sunrise would offer the best photographic opportunities here, so I returned when a low tide coincided with both sunrise and favourable weather conditions. By shooting from a low angle, I was able to record some of the colourful clouds reflected in the waterlogged sand.

Canon EOS 3, 24mm lens, 2-stop neutral density graduated filter, Fujichrome Velvia, 1/8sec f/16

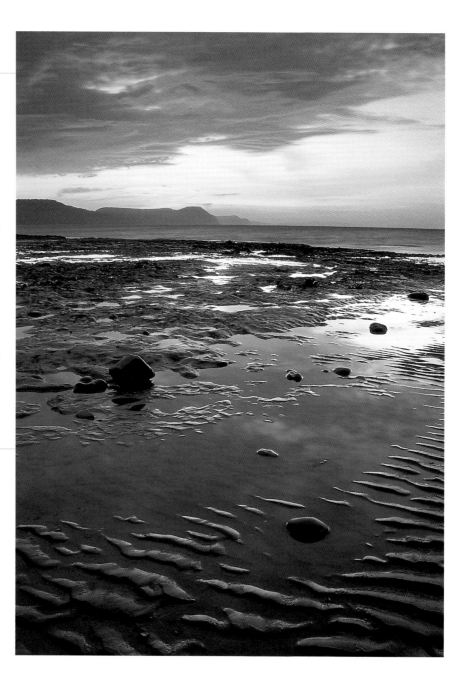

53 Go with the flow

Recording the movement of the sea in your images can be very effective. Different effects can be achieved depending upon the speed and power of the incoming waves, and the shutter speed used to take the photograph. Exposures of over 10 seconds result in very little detail being recorded in the water, and can flatten a rough sea into a seemingly tranquil state. This can help to simplify a composition by isolating and emphasizing features such as rocks and sea stacks. However, in order to record a proper feeling of movement in the water, you will need to use a slightly shorter exposure time. Again, results will depend upon the state of the sea, but exposure times of between 1/15 and 4sec are generally very effective. Shoot when the waves are receding; this has a more predictable result and reduces the chances of large areas of bright foam or breaking waves dominating the foreground.

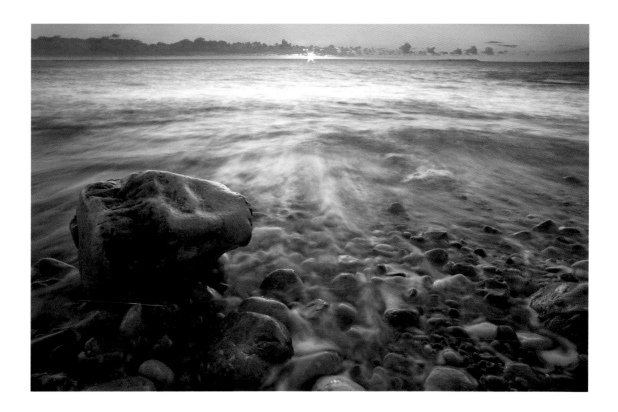

Purbeck Coast

For this shot, I used a wide-angle lens to exaggerate the perspective of the receding water – providing a tunnelling effect that implies movement and also helps to lead the eye into the scene. I set my tripod very low, allowing the foreground pebbles to add depth to the composition. The sky was virtually cloudless and would have added nothing to the image. Therefore, I excluded all but a thin strip of sky above the horizon, where the setting sun provides a focal point. I used a remote release to ensure that I captured a sharp image and weighted the legs of my tripod down with heavy boulders to prevent them from being moved during the exposure by the action of the incoming waves.

Canon EOS 1Ds, Zeiss 21mm lens, 2-stop graduated neutral density filter, ISO 50, 2sec at f/22

54 Include foreground colour

Where the predominant geology of the landscape is dark-coloured rocks or dark sand, look for additional or contrasting elements of colour that you can include in the foreground of your image. Bright-coloured shells, vibrant seaweeds, pale driftwood or even sea creatures such as starfish or sea urchins that have been washed on to the beach can all be used to inject a little more colour into the scene. Try using a polarizing filter to increase the impact of the colours by removing unwanted reflections (see page 16). When working near ports and harbours, consider including colourful boats, lobster pots and fishing nets that could be successfully incorporated into your image. These items not only add colour to the image but can also help to illustrate the character of the area and the important role that the sea plays in the livelihoods of local people.

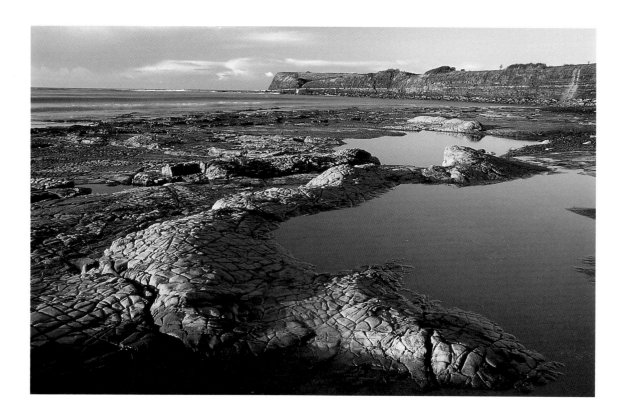

Kimmeridge Ledges

The fascinating and varied geology around Kimmeridge Bay Marine Nature Reserve in Dorset, England, provides endless opportunities for coastal landscape photography. The colour of the dry rock has been enhanced by the warm low-angled sunlight, which has also helped to reveal the latticed texture of the stone. Notice also how the wet rock remains relatively dark and colourless, even though it consists of exactly the same material. The contrast between yellow and blue helps to add impact to the image, whilst the low shooting angle has increased the apparent depth of the shot.

Canon EOS 5, 28mm lens, polarizer, Fujichrome Velvia, 1/8sec at f/16

55 Look for interesting patterns

Coastlines are forever changing due to relentless erosion by the sea. This process exposes fresh cliff faces and creates both permanent and temporary geological formations. Cliffs and rocky shores can display a great variety of patterns, the scale of which can vary tremendously from miles of layered sedimentary rock to a minute ammonite fossil preserved in a shoreline boulder. Sandy beaches are refreshed by each high tide and, depending upon weather conditions, fascinating patterns can be left in the sand as the tide recedes. Most patterns are best photographed in low-angled sunlight, which helps to reveal their texture. Compose tightly for a detailed study or an abstract effect, taking care to avoid any distracting elements. Alternatively, use the pattern as a foreground element in a wider shot of the coastline.

Oil shale

This image shows a slab of oil shale that has been scoured by the ebb and flow of the tides. The soft back-lighting has helped to reveal the texture upon the surface of the rock by increasing the contrast between the flat sections and the dividing channels. The slab was being washed by waves as the tide retreated and the wet surface has highlighted the mottled effect by reflecting light from the sky. I used a telephoto lens to frame a tight composition of the most detailed section, using a small aperture to ensure sufficient front-to-back sharpness.

Canon EOS 5, 300mm lens, Fujichrome Velvia, 1sec at f/22

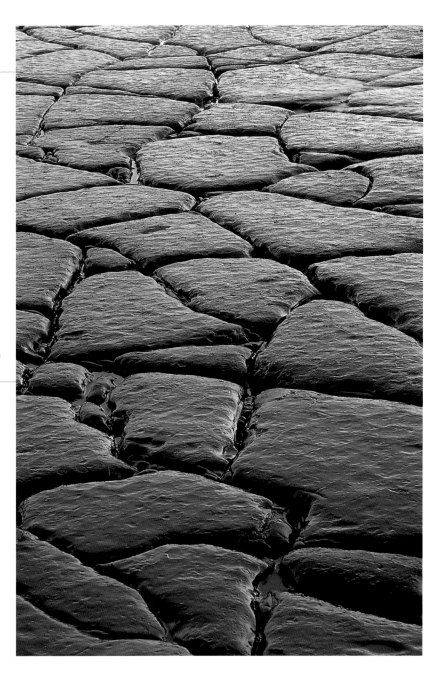

56 Research lighting angles

The confines of a narrow strip of landscape where the land meets the sea means that lighting angles are all important. In the northern hemisphere, south-facing coasts are great in winter when the sun rises and sets out to sea but less good during the summer, when sunrise and sunset occur inland, and you miss the best light because much of the shoreline is in shadow early and late in the day. Conversely, north-facing coasts are better in the summer when the sun rises and sets in its northernmost position, briefly casting warm light along the shore at either end of the day. East-facing coasts are generally best early in the morning, whilst west-facing coasts are better at sunset. The irregular nature of many coastlines means that good lighting conditions depend upon the topography of the specific location; low-lying coastal plains and beaches can offer photographic opportunities at either end of the day.

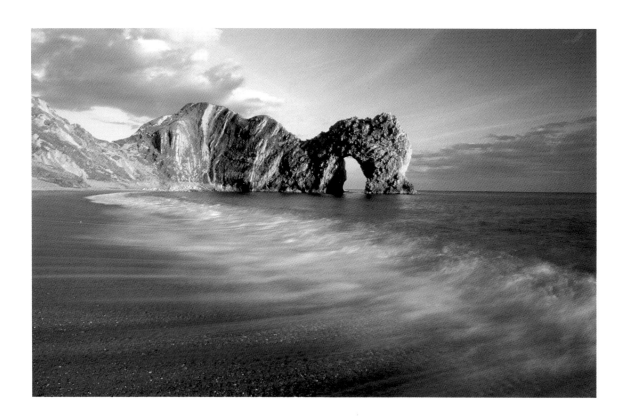

Durdle Door

Past experience has taught me that the face of this limestone rock arch in Dorset is only bathed in warm, low-angled light at sunset during a two-week period in April and in September. At other times, the sun sets either behind tall cliffs to the west, or out to sea. In order to capture it at just the right time, I have made a permanent note in my photographic diary. In order to convey the movement of the sea, I used a slow shutter speed to record the motion of the incoming waves and made my exposure just as a breaking wave began to recede down the beach. A polarizing filter was used to provide more contrast by darkening the blue water, although only a half turn was applied so as to avoid uneven darkening of the sky with my wide-angle lens. The naturally golden colour of the cliffs and pebbles in this light meant that a warm-up filter was unnecessary.

Canon EOS 3, 24mm lens, polarizer, Fujichrome Velvia, 1sec at f/16

57 Shoot breaking waves

Dramatic coastal landscape images can be taken when large waves are rolling in and breaking along the shoreline. Waves will smash into cliffs and headlands far more impressively during high tide; at low tide, much of their energy is absorbed by beaches and offshore reefs. Different effects can be obtained by using a fast or a slow shutter speed. Shorter exposures will freeze the movement of waves, which can be very effective, but should never be used at the expense of depth of field. As always, good composition is vital. Work out where the waves are breaking so that the resulting highlight is in the appropriate place within the image – neither too central, nor at the very edge of the frame. Once you have found a composition you like, wait for the decisive moment before tripping the shutter. Even small waves can add significant impact; use a wide-angle lens to catch them breaking over boulders in the foreground of your image.

Portland Bill Lighthouse

I had explored the area around this lighthouse on a previous occasion. I returned at high tide and when the wind was blowing from the right direction to make the waves break against the slab of rock in the foreground of the image. By finding the composition in advance and deciding exactly when I should return for the best possible result, I was able to make the very most of this opportunity by shooting a series of images within the hour that provided the best lighting and tidal conditions. I chose a shutter speed just slow enough to record some movement in the wave as it burst against the rock. A polarizing filter helped to provide more contrast by darkening the sky and the blue water. The exposure was set manually and the focus locked so that I could concentrate on catching the breaking waves at just the right moment.

Canon EOS 3, 28–70mm lens, polarizer, Fujichrome Provia, 1/60sec at f/11

58 Shoot contrasting colours

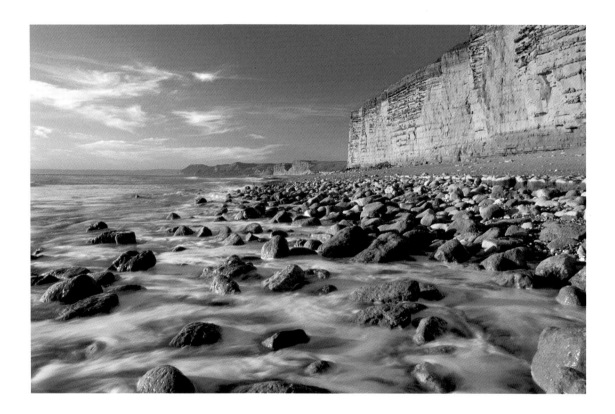

Although the contrasting colours of the landscape can help to add impact to any composition, they are especially effective when photographing coastal scenes. In sunlight, coastal locations can be particularly vibrant places, with golden sands, colourful rock pools, pebbles of assorted colours, varied geology and a backdrop of vivid blue sea. Primary colours offer the greatest contrast, so a combination of yellow and blue or blue and red will provide maximum impact. Fortunately, these are colours frequently encountered – both in nature and the presence of man – along many shorelines when the cliffs, sand dunes and fishing boats are lit with warm sunlight. The contrasting colours don't have to be included in equal amounts – even a small element in the photograph can add sufficient impact if the colour contrast is strong enough.

Sandstone cliffs

Yellow and blue comprise perhaps the most striking combination of natural colours. These sandstone cliffs on the Dorset coast look great when their bright yellow tone contrasts with a deep blue sky. Fortunately on this occasion there was just enough high cloud to provide some detail in the sky. I used a polarizing filter to saturate the colours in this shot – a half-turn of the filter was all that was necessary to accentuate the colours and make the clouds stand out. The receding wave not only adds interest and movement to the composition, but also helps to conceal much of the dense shadow that would have appeared between the foreground boulders.

Canon EOS 3, 28mm lens, polarizer, Fujichrome Velvia, 1/2sec at f/22

59 Shoot lighthouses

Lighthouses are very popular subjects for photographers. The lighthouse itself doesn't have to take up a large portion of the image; it can be used very successfully as a distant focal point in a wider view of the coastline. Weather conditions will have a significant effect upon the type of photograph you will be able to achieve and upon the general atmosphere of the shot. It is important to take into account lighting angles, tidal conditions, wind speed, wind direction and, perhaps most importantly, the state of the sea. You can choose whether to capture the power of the sea in your images by shooting breaking waves with a fast shutter speed, or opt for a more tranquil effect by blurring the motion of the sea during a long exposure. The latter can work particularly well at dawn and dusk, when the lighthouse lamp is illuminated.

Hook Head Lighthouse

This medieval lighthouse is situated at the end of a narrow peninsula on the coast of County Wexford in Ireland. Dating back to the 13th century, it is one of the oldest operational lighthouses in the world. This image was taken late in the afternoon when the light was soft enough to illuminate the white lighthouse tower, whilst still allowing me to retain detail in all other areas of the image. By using a telephoto lens, I was able to compose tightly around the lighthouse and the lighthouse keepers' cottages whilst avoiding nearby telephone lines and parked cars. The rocky shoreline provides context whilst the dark sky adds drama to the scene.

Canon EOS 3, 100–400mm lens, polarizer, Fujichrome Velvia, 1/4sec at f/16

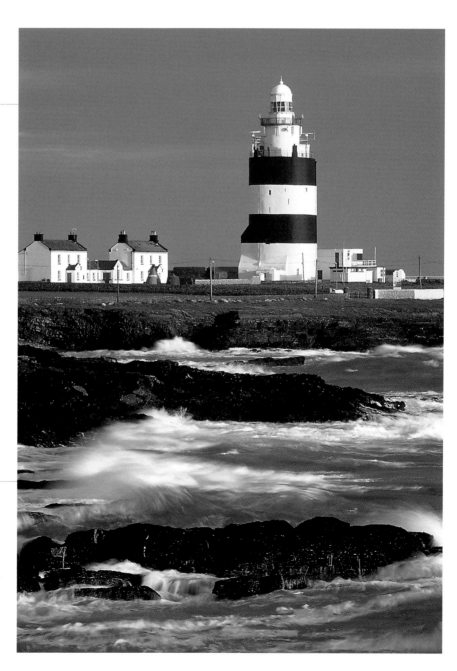

60 Tread with care

If you've made the effort to visit a sandy beach early in the morning, or as the tide is falling, in order to catch it in pristine condition, the last thing you want is to leave a trail of your own footprints on the sand. It is very hard to smooth out footprints once they're made and, although digital shooters can clone out such mistakes, it is better to get it right on location! Take care not to walk through areas that you might include in your shot. Before marching across the beach, consider where you will be taking your shots from, and in which direction you will be looking. If possible, walk along the edge of the water so that your footprints are swept away as you go, or walk along the back of the beach, if it's safe to do so. It is equally important not to leave wet sandy footprints upon rocks that you might want to include in your shot.

Constantine Bay

This image of a Cornish beach was taken late in the afternoon. Fortunately, strong winds during the day had smothered most of the footprints on the beach, but even so I decided to search for an attractive foreground up in the dunes where the sand remained pristine. When using a wide-angle lens, I like to gradually work my way towards the best composition by moving slowly forwards whilst looking through the viewfinder. That way, I never disturb any foreground elements that I might want to include in my composition. In a photograph like this, it is vital that both the immediate foreground and the distant peninsula are recorded sharply. I used the engraved depth-of-field scale on my lens to ensure that this was the case.

Canon EOS 3, 24mm lens, polarizer, graduated coral 1 filter, Fujichrome Velvia, 1/15sec at f/16

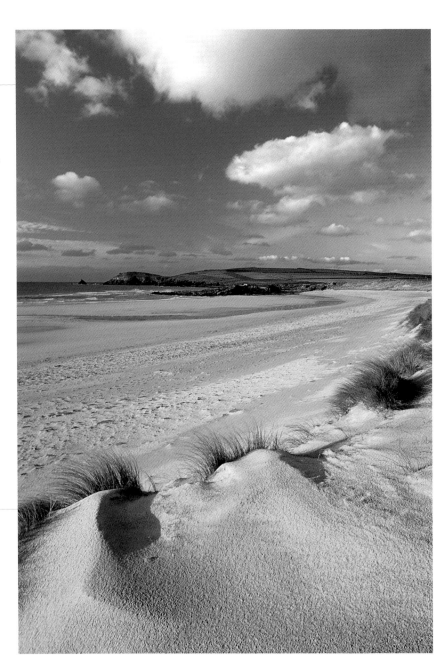

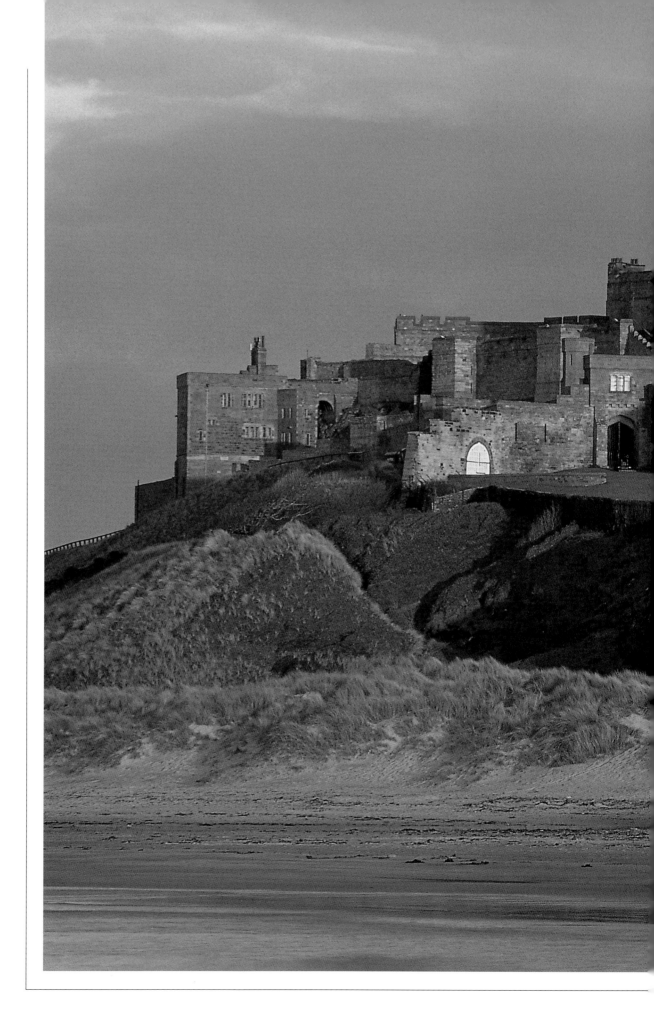

Town and country

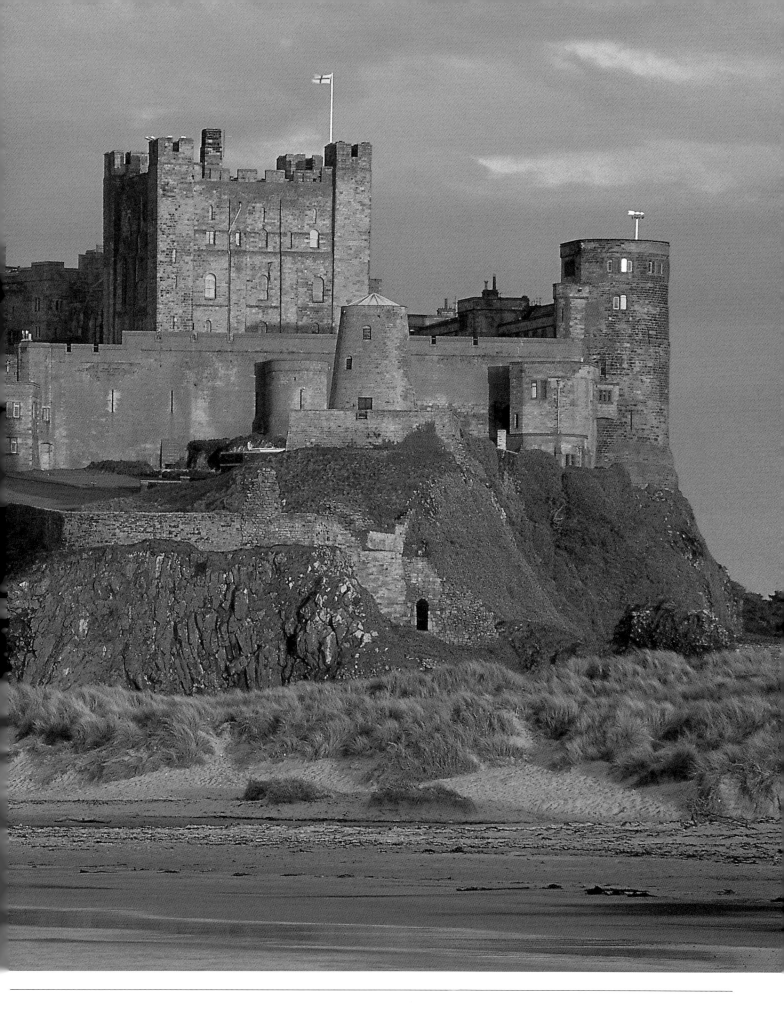

61 Explore woodlands

Woodlands can be difficult to photograph well; the natural clutter of the habitat makes it tricky to compose clean and simple images. Shoot in overcast light to avoid harsh shadows and bright highlights; the lower contrast will reveal more fine detail. A polarizing filter is an essential piece of kit when photographing woodlands from spring to early autumn, as it removes reflections from foliage and saturates colour. Backlighting can work well early and late in the day, when it produces long shadows that can be exaggerated with a wide-angle lens. During the winter, try to capture the bleak nature of deciduous woodland when mist and fog add atmosphere to the tangle of bare trunks and branches. Try to exclude distracting patches of bright sky, as such highlights will drag the viewer's attention away from more important areas of the image.

Forest deadwood

When composing an image in a woodland environment, try to avoid surrounding clutter, such as fallen branches or scrubby bushes. Look for things that typify the type of woodland, such as fallen leaves under deciduous trees or pine cones in coniferous forests. This shot of an ancient oak stump was taken in the New Forest in southern England. The heartwood has been exposed to reveal an intricate natural pattern. I chose to photograph it with a wide-angle lens in order to include a little of the surrounding environment.

Canon EOS 1Ds, 24mm lens, polarizer, ISO 100, 1/4sec at f/11

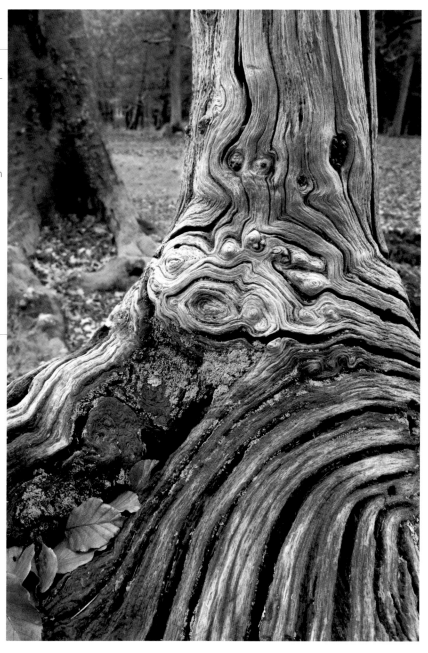

62 Find subjects that characterize a place

Very often, there are distinguishing features in the landscape that can help to make a specific location easily recognizable in a photograph. These might include geological formations, identifiable hills and mountains, monuments, bridges, regional building styles, the type of vegetation cover or the general lie of the land. Such features can be included in your image to help identify a location, but don't need to dominate the composition in order to be effective. They can be included either in part, or as a small element within the image. Using characteristic features to define a location can be particularly effective where a tight composition would otherwise prevent it from being recognizable. Obviously, if you want a more generic image, the same features are best excluded.

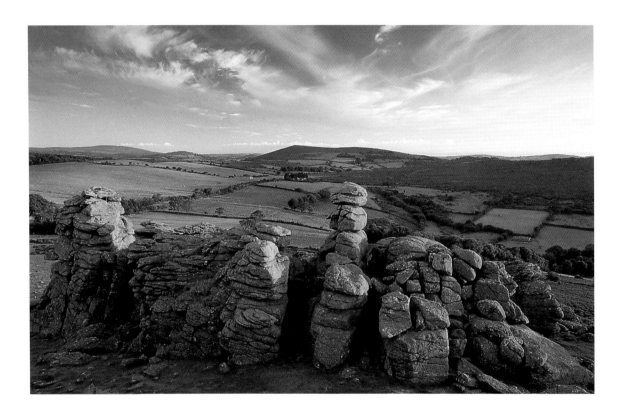

Hound Tor

The weathered granite tors of Dartmoor in Devon are characteristic of this part of the English landscape. Including the tors in a landscape photograph immediately identifies the location. This image was taken just after dawn from the top of Hound Tor. I wanted to include both the weathered rocks and the sky which, at the time, held enough colour and detail to add interest to the composition. As the sun had yet to reach the immediate foreground, I used a neutral density graduated filter to help reduce the contrast and retain detail in the darker areas of the image.

Canon EOS 3, 28–70mm lens, polarizer, 2-stop neutral density graduated filter, Fujichrome Velvia, 1/8sec at f/16

63 Shoot castles

Castles make great subjects for photography. Their ancient fortifications have a feeling of permanence that seems to have blended into the landscape over time. This is especially true of ruined castles, which appear to be part of the natural geology rather than the man-made constructions that they are. A great many castles are sited in spectacular locations and are often surrounded by water. These qualities provide a great opportunity to shoot dramatic landscape compositions using the castle either as the main subject or as a focal point in the wider landscape. When photographing castles, it is important to capture atmosphere in the shot. This may be in the form of dramatic light with threatening storm clouds, misty conditions when modern distractions are easily concealed, or even at night if the ramparts are lit with artificial light.

Eilean Donan Castle

One of the most attractive castles in the British Isles is Eilean Donan. This much photographed 13th-century castle is situated on a small island in Loch Duich, in the heart of the Scottish Highlands. Even though the castle has been photographed from every angle and at every time of the day and year, as well as appearing in several feature films, I find it impossible to resist taking one more shot whenever I pass by. This image was taken on a winter evening long after the sun had set. The afterglow that remained upon the horizon provides a useful contrast to the artificial lighting on the castle walls. Metering for this scene was easy; I took a spot-meter reading from an evenly illuminated section of the castle walls and opened up 1 full stop to place it as a light tone in the shot.

Canon EOS 5, 28–105mm lens, Fujichrome Velvia, 8sec at f/8

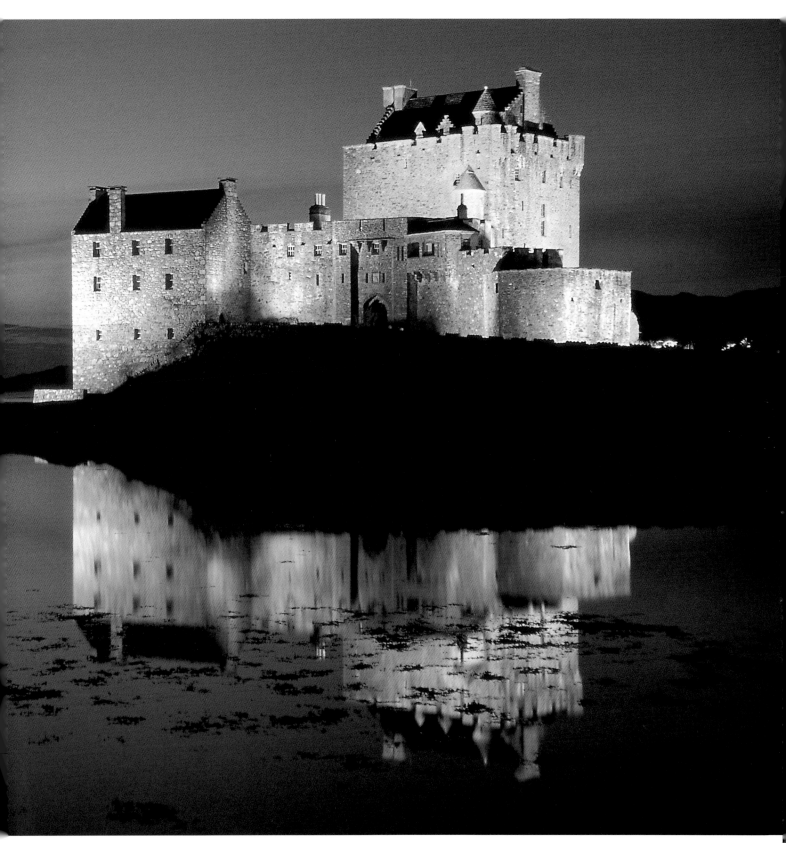

64 Shoot agricultural landscapes

Farming has had a great effect upon the appearance of the landscape in many areas of the world. Seasonal changes provide endless opportunities for landscape photography throughout the year. In arable regions, a variety of crops provide ever-changing colour to the fields from spring until late summer. Use a wide-angle lens to fill the foreground with individual plants, allowing them to recede gradually into the distance. 'Tram lines' created by farm machinery can often be used to lead the viewer's eye into the composition. Harvest time adds even more interest to the agricultural landscape. Bales of straw and silage can be used either as foreground interest in wider views, or as a pattern when viewed from a distance. In upland areas, livestock farming is more common and the setting of small fields set amongst rolling hills and lush valleys is ideal for landscape photography.

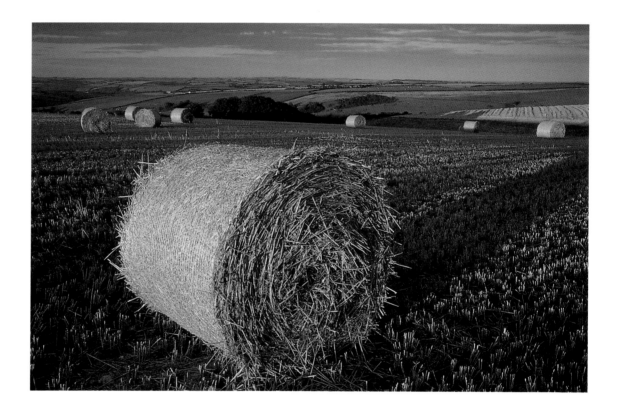

Harvest time

Scour the field margins for arable weeds such as poppies and daisies, as their bright colours will add impact to any shot. Try not to restrict yourself to all-encompassing views – use a telephoto lens to compose repetitive patterns, such as rows of crops, lines of straw bales and the furrows in ploughed fields. A stepladder can be a useful accessory, allowing you to gain a clear view over taller crops. On windy days, don't restrict your depth of field in order to freeze the motion of swaying crops; instead, allow the movement to record on film during a long exposure. This shot of straw bales was taken shortly after they had emerged from the baler. With the farmer's permission, I entered the field and composed this frame just before the sun went down.

Canon EOS 5, 28mm lens, polarizer, 1-stop neutral density graduated filter, Fujichrome Velvia, 1/2sec at f/16

65 Photograph mountains

Mountain areas provide some of the most impressive landscape scenery; however, it is easy to be overcome by the wealth of photographic opportunities on offer. Good mountain photography is all about lighting. Sidelighting works best, as it reveals essential texture in gorges, crevasses and rock detail. Shoot with the sun low in the sky as the warmth of the light will increase the atmosphere in your image. An unfortunate side effect of shooting early and late in the day is that valleys are in shadow; however, foreground detail can be retained with the use of neutral density graduated filters. Mountains also naturally attract a lot of cloud. Such overcast light is bad for mountain photography, as the resulting images will lack texture. Use these days to find good locations to return to when the weather improves. Be prepared for a sudden break in the cloud; this is when the most memorable mountain images can be made.

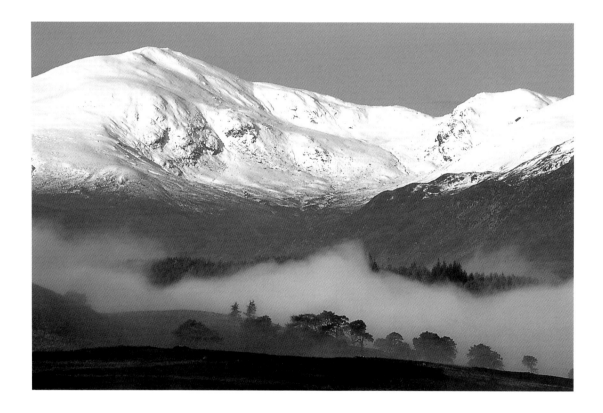

Perthshire mountains

The elevation at which you take a photograph can have a marked effect upon the feel of the image. When shooting from the valley floor, you can show lush pastures and meandering rivers juxtaposed against a backdrop of mountain scenery. Mountain-tops, on the other hand, provide panoramic views but need perfect weather conditions. Longer focal length lenses can be used to shoot images of distant mountain ridges and to compose interesting patterns on the valley floor. Some of the most impressive images can be made from the sides of mountains, where it is possible to show both the depth of the valley and the towering mountains above. This image was taken from a high moorland road in the Scottish Highlands using a telephoto lens to compose tightly around the four main elements of mountains, trees, mist and blue sky.

Canon EOS 3, 100–400mm lens, polarizer, Fujichrome Velvia, 1/45sec at f/11

66 Shoot cityscapes

Towns and cities can be seen to be as much a part of the landscape as farmland, forests and villages. Many large towns and cities are built around major rivers or ports, so you can try to convey this relationship in your photograph by emphasizing the natural elements in the scene. Parks and gardens provide plenty of opportunities to include natural elements against a backdrop of urban life. They also offer the chance to record seasonal changes in the form of spring blossom or colourful autumn foliage. Recognizable skylines tend to characterize many cities. Find a location from which all the major buildings appear well defined – preferably from a vantage point that allows you to include a backdrop of hills, or reflections upon the still water of a river or harbour.

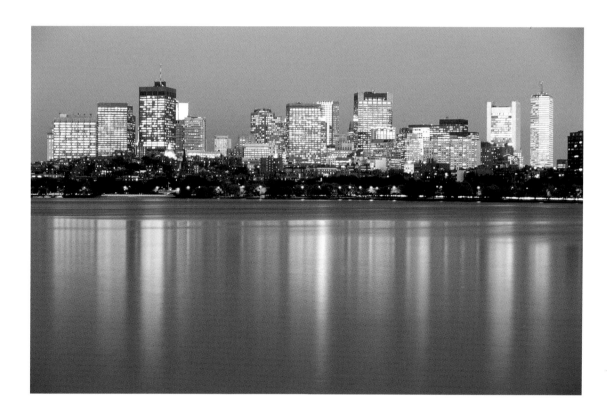

Boston skyline

Shooting at dawn and dusk allows a mix of both natural and artificial light, which can be very effective. It is important to get the lighting balance just right, so aim to make your exposure when the brightness of each light source is equal – a point often referred to as 'cross-over light'. Another advantage to shooting in low light is that moving cars and people become blurred by the long exposure and don't record in the final image. For this shot of the Boston skyline viewed across the Charles River, I used a polarizing filter combined with a small aperture in order for the exposure time to be long enough to blur the rippled water and thus emphasize the reflections. The light on the buildings is a reflection of the afterglow behind me.

Canon EOS 5, 70–200mm, polarizer, Fujichrome Velvia, 15sec at f/16

67 Shoot lakes and waterways

Water is an attractive element in a landscape photograph, whether it be a lake, river, canal or simply a puddle. Reflections can double the impact of your image; landscape images that feature ponds and lakes often benefit from calm conditions. Still water tends to coincide with the best light at either end of the day. When the breeze picks up, search for shallow sheltered areas of water that are less prone to disturbance. Rivers and lakes are prone to the formation of overnight mist and fog, which can add atmosphere to a shot. Use waterside features such as boats and jetties to provide a sense of place, and consider framing your composition with waterside reeds or shoreline boulders. The movement of flowing water can be recorded by using a long exposure allowing the direction of flow to lead the viewer's eye into the scene.

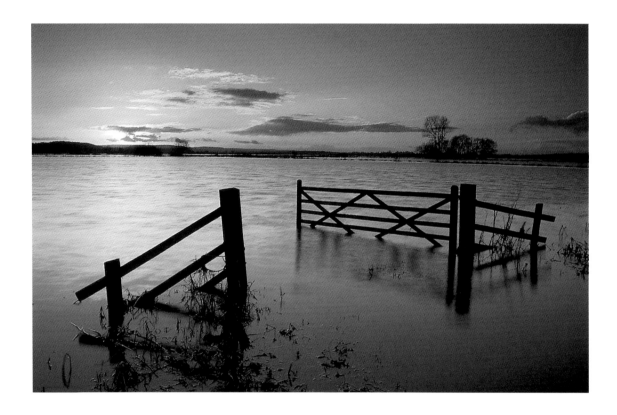

West Sedgemoor

This image of flooded water meadows was taken on a breezy winter afternoon just before sunset. The rippled water caused a busy background against which the outline of the gate wasn't particularly clear. Therefore I used a neutral density filter to reduce the exposure time to three seconds – long enough for the ripples to be smoothed out during the exposure and allow the gate to stand out against the blue water. In order to access your camera gear easily and safely when shooting from the water's edge or, as in this case, from in the water, it is advisable to carry your kit in a shoulder bag or waistcoat rather than a rucksack.

Canon EOS 5, 24mm lens, 2-stop neutral density graduated filter, 2-stop neutral density filter, Fujichrome Velvia, 3sec at f/22

68 Shoot rural villages

Town and country

Attractive rural villages and hamlets, with their idyllic cottages and well-manicured gardens often set against a backdrop of rolling hills and fields, can fit quite naturally into a landscape photograph. Many rural buildings are traditionally constructed of locally sourced materials and are of a design that helps to characterize a region or country. In most cases, the village church will be the most prominent building in the area and, as such, will often act as a natural focal point in your photograph. The biggest problem when photographing villages tends to be the presence of parked cars, which not only detract from the scene but also destroy the timeless quality that helps to make many villages so photogenic. Try to lose such unwanted elements in shadow areas, or hide them behind trees or buildings.

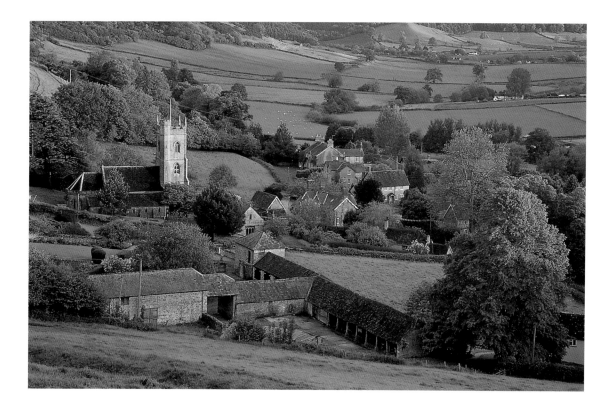

Corton Denham

This photograph of the small Somerset village of Corton Denham was taken on an early summer evening moments before sunset. I wanted to shoot this scene with the last rays of sunlight illuminating the church tower whilst the rest of the landscape was in shadow. One potential problem with this was that the blue sky above would make the shaded areas record with a cool blue colour cast. To counteract this, I used an 81B warm-up filter. This filter covered the entire image, which didn't matter as no sky was included in the composition. The soft light allowed me to expose for the pale sunlit stone of the church tower whilst still maintaining plenty of detail in the surrounding landscape.

Canon EOS 5, 70–200mm lens, polarizer, 81B warm-up filter, Fujichrome Velvia, 1/2sec at f/11

98

69 Shoot waterfalls

When shooting a waterfall, it is important to consider how it may be affected by seasonal changes and lighting conditions. In dry weather, ugly exposed rocks and river debris may be difficult to avoid; in wet conditions, the spray and surge of water may conceal features that you want to include. Somewhere in between tends to be best, but much depends upon the character of the individual waterfall. It is generally best to shoot waterfalls in overcast conditions to avoid excessive contrast. Selection of shutter speed depends upon the flow rate and turbulence of the water, but a good starting point is somewhere between 1/15 and 1/2sec if you wish to record movement. It is important to maintain detail in the whitest parts of the water. A polarizing filter can remove reflections from wet rocks and increase exposure times where necessary.

New Hampshire cascade

Waterfalls are great subjects to shoot when the lighting conditions aren't suitable for general landscape scenes. Choosing the perfect shutter speed is rather subjective, so experiment to see which effect you like best. My personal preference is to maintain a feeling of movement in the water whilst avoiding the milky effect that results from exposures of more than about four seconds. Whatever effect you are looking to achieve, it is vital to retain detail in the brightest areas of water – so avoid overexposing the image at all costs! This section of a small waterfall in New Hampshire, USA, has acquired a blue tint from the clear sky above. I composed tightly on this area of the fall to avoid surrounding debris and the sunlit riverbank beyond.

Canon EOS 5, 70–200mm lens, Fujichrome Velvia, 1/2sec at f/16

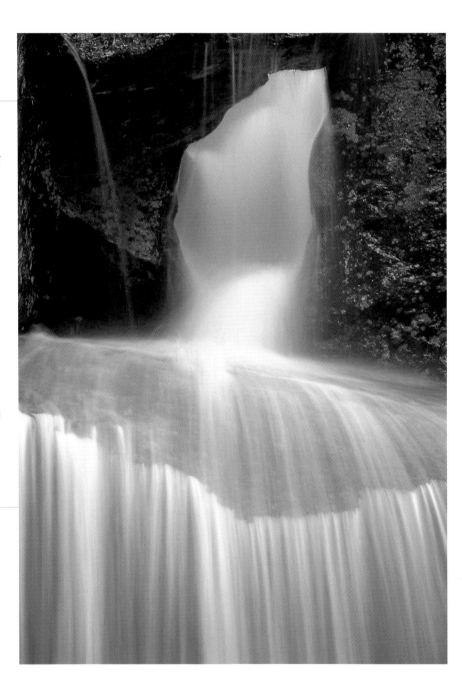

70 Show the hand of man

Many photographers strive to exclude unnatural manmade elements from their landscape photographs in order to create or preserve a feeling of wildness. However, in many areas this is simply not possible, as man's presence has had such an obvious and sometimes dramatic effect on the appearance of the land. It can sometimes be good to show what the modern landscape looks like in reality, rather than trying to convey an untrue representation of wilderness. Man's effects upon the land are not always unattractive – many historic sites seem entwined with the landscape itself, while the modern agricultural landscape can offer endless opportunities for photography. Manmade elements can be included either as the main subject, as you might photograph a castle for example, or in more subtle form such as a path or track leading into a woodland scene.

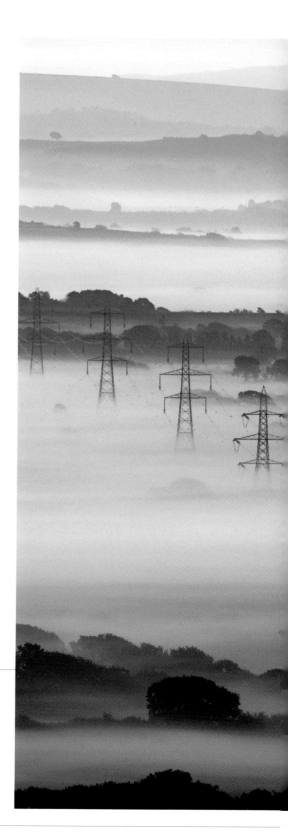

Pylons

It can be very effective to show manmade and natural features of the landscape in juxtaposition. This image shows electricity pylons running through picturesque countryside in southern England. Although the mist has concealed many of the finer details of the landscape, to create quite a graphic composition, the contrast between natural and man-made elements remains very apparent.

Canon EOS 1Ds, 500mm lens, ISO 100, 1/125sec at f/11

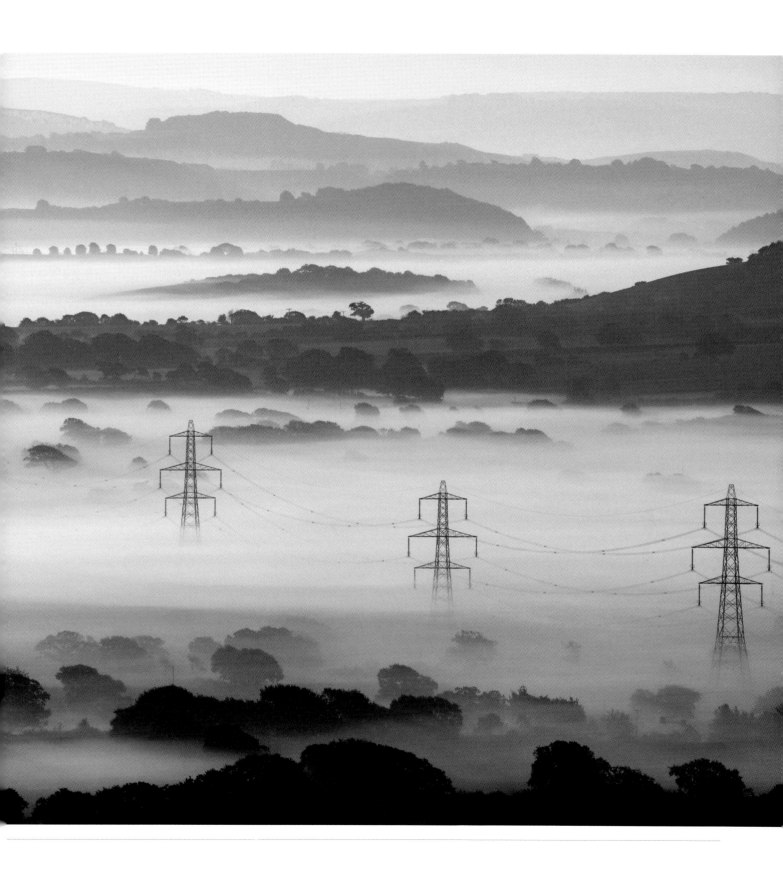

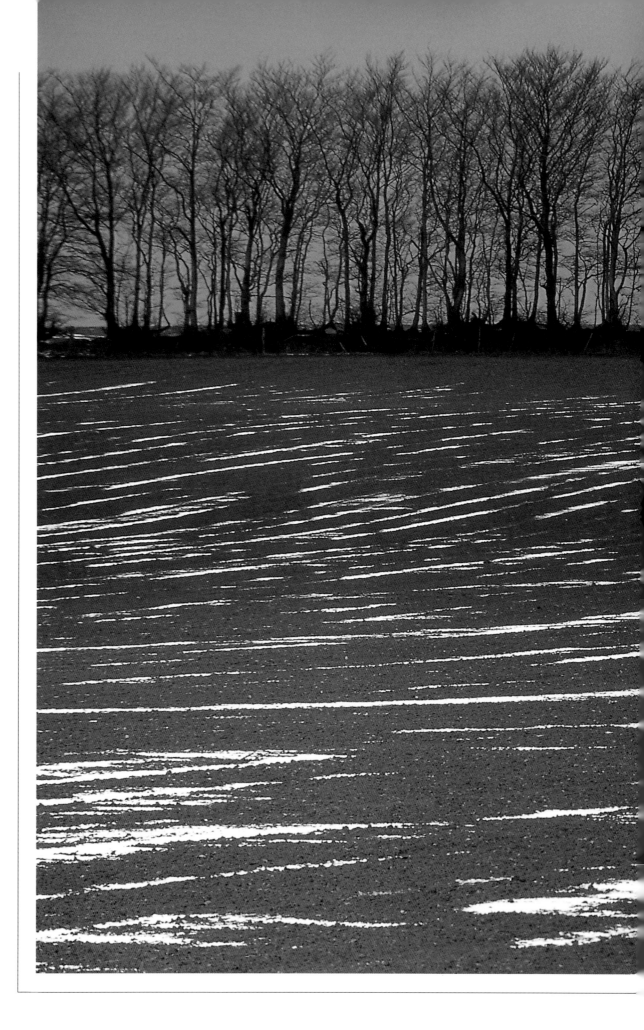

The seasons

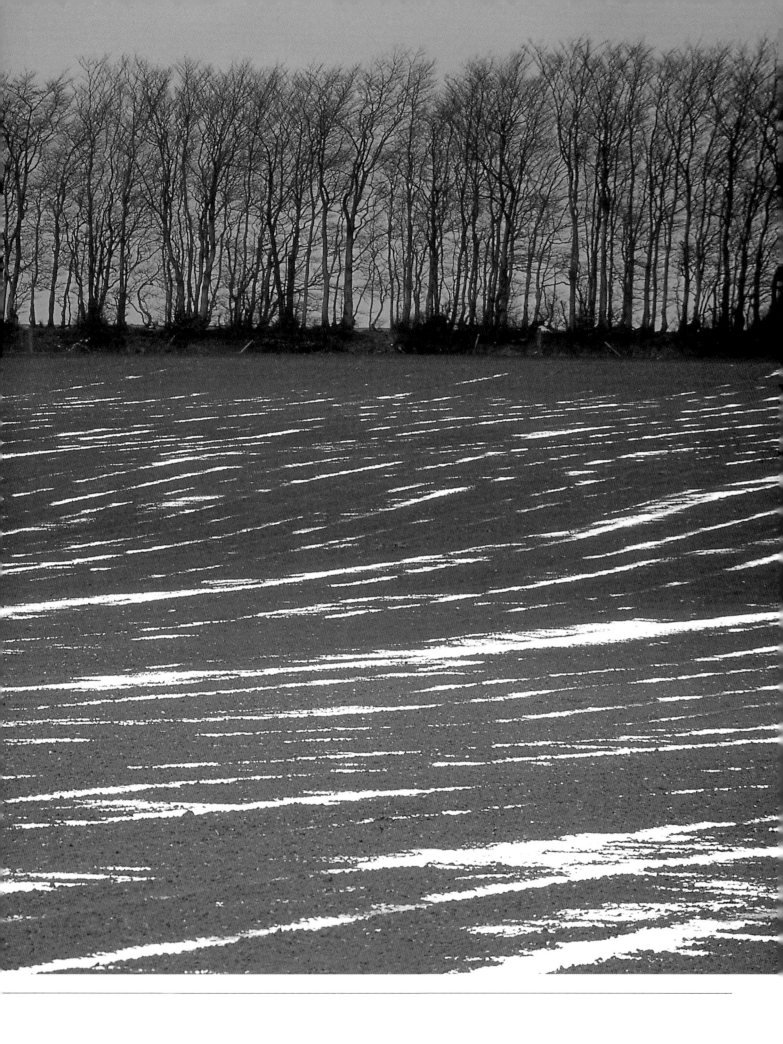

The seasons

71 Be in the right place at the right time

Some locations offer their best photographic potential at a very specific time of the year. This may be due to a number of factors such as the necessary lighting angle, seasonal colour or characteristic weather conditions. It is important to consider which locations are going to be worth visiting and when – timing is often critical if you are to coincide your photography with short-lived seasonal events such as peak autumn foliage. It helps to have at least a basic understanding of the natural world and the ecology of different habitats. Some locations, such as wildflower meadows, are obviously best photographed during the spring or summer months, and the timing of your visit can be further narrowed down according to the specific wildflower species that bloom there.

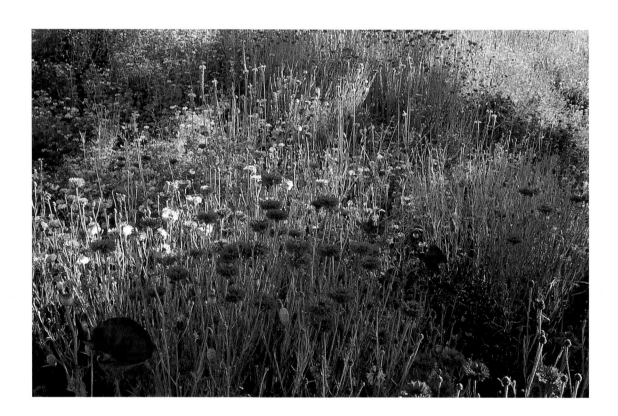

Roadside wildflowers

When a new road was being constructed through farmland close to my home, I knew that the disturbance was likely to cause dormant seeds to germinate the following spring. I visited the site in early June and found a great variety of wildflowers in bud on the roadside verges. I returned again three weeks later when the flowers were in bloom and found several scarce species amongst the common poppies, corn-flowers, knapweeds and daisies. I took this image early in the morning, using the dappled light under a tree to retain detail in the flowers. The rest of the scene is backlit, which helped increase the shot's atmosphere.

Canon EOS 5, 28–105mm, polarizer, Fujichrome Velvia, 1/8sec at f/16

72 Capture the atmosphere of autumn

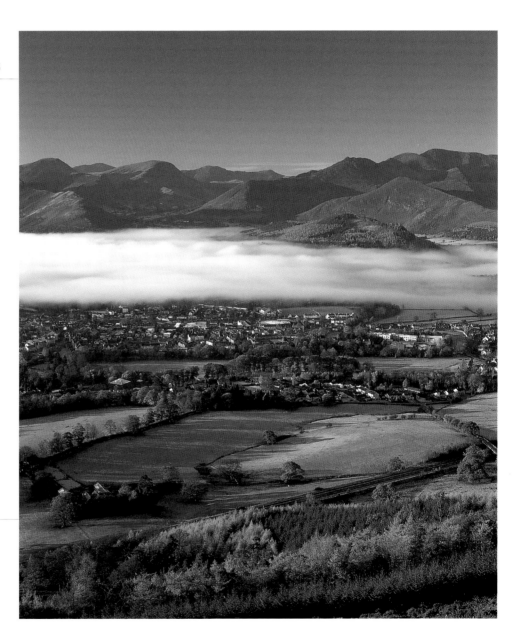

Changeable autumn weather can result in some of the most dramatic landscape images. At either end of the day, the warm light will help to accentuate the golden tones of the landscape. Sunny days followed by cool clear nights frequently result in the formation of radiation mist by dawn, adding a great deal of atmosphere to early morning landscape scenes. Get to know where mist has a habit of forming in your local area. River valleys, lakes and damp ground tend to be most prone, so search for a high vantage point that will give you a clear view. Set your alarm clock early so that you're in position before sunrise. Try not to restrict yourself to wide sweeping views, though – look for colourful details in the landscape such as fallen leaves and woodland fungi.

The Lake District

This image of the Cumbrian town of Keswick, in England, and the surrounding fells was taken from Latrigg – an insignificant foothill below the taller peak of Skiddaw. The particularly clear and crisp autumn morning was perfect for photographing wide landscape scenes like this, as distant detail could be rendered very clearly. The mist that had formed across the lakes overnight lasted well into the morning and provided a welcome injection of atmosphere into my images. As my chosen composition included no close foreground detail, it was unnecessary to use a small aperture, as extensive depth of field was not required. Therefore I used a mid-range aperture of f/8, a point around which most lenses perform at their best in terms of resolution and contrast.

Mamiya RB67 ProSD, 90mm lens, polarizer, Fujichrome Velvia, 1/30sec at f/8

73 Get your bluebells blue

Bluebells have long been a popular subject for photographers, but recording their colour accurately is hard, as most films render the subtle tones as anything but blue! To achieve accurate colours, shoot on a blue-sky day in open shade when none of the blooms are lit by direct sunlight. This usually means working early and late in the day when the sun is very low in the sky. The reflected blue light from the sky counteracts films' tendency to record bluebells as warmer than they appear in reality. Use a polarizer filter to remove reflections from the shiny bluebell foliage. Atmospheric images can be made in woodlands lit by low-angled sunlight, albeit at the expense of accurate colour. To maximize the impact of the massed blooms consider carefully both your lens choice and your shooting angle – the longer the focal length of the lens and the lower your shooting angle, the more compressed the blooms will appear.

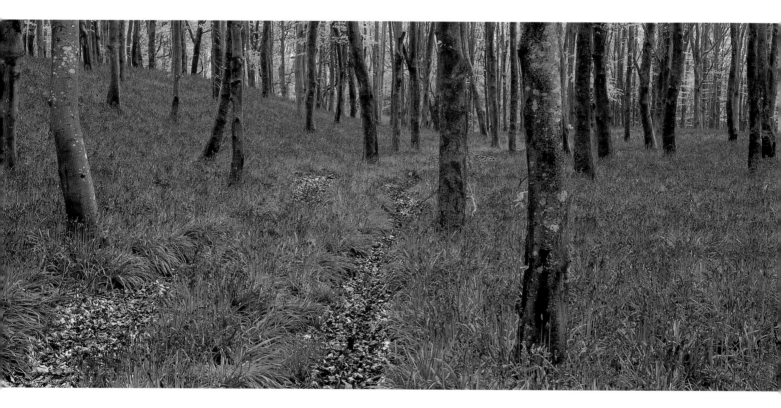

Bluebell woods

Although generally regarded as a warm film, I find that Fujichrome Velvia records the colour of the bluebell very accurately in open shade, whilst still providing bright, well-saturated greens. However, when working in overcast conditions or in sunlight, Fujichrome Provia 100F tends to give the best results. This is one landscape subject for which digital photographers have a distinct advantage, as digital cameras seem to have no problem in recording the colour of bluebells accurately. The image shown here was taken in the early evening when the sun was low enough not to cast any direct light on to the woodland floor. I positioned my camera at a height of about one metre to gain a shooting angle that compressed the blooms into a more solid mass.

Mamiya RB 67 ProSD, 90mm lens, 6x8cm back, polarizer, Fujichrome Velvia, 3sec at f/22

74 Make the most of winter

Short winter days mean that sunrise doesn't occur too early. This makes it much easier to get out before dawn in order to find some good compositions before the sun breaks the horizon. At this time of the year, the sun regularly provides perfect lighting conditions for landscape photography. So long as the weather remains favourable, the effects will also last longer than they do through the rest of the year, as the sun follows a shallow arc across the horizon. Winter lasts longer at higher altitudes, so venture into the hills and mountains to capture spectacular winter landscapes. At lower altitudes, head for river valleys, where winter floodwater can provide colourful reflections at either end of the day. When the temperature drops below freezing, keep an eye out for mist, as one of nature's most spectacular displays, hoar frost, may result.

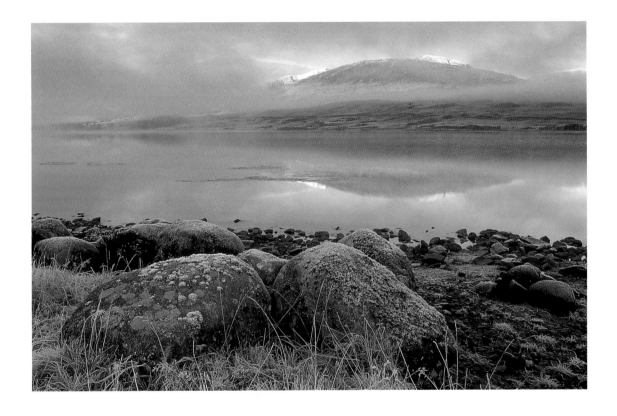

Loch Tulla

This image was taken just before Christmas. I arrived beside this small Scottish loch just before sunrise, hoping to photograph a scene that I had found on a previous visit. Thick fog had enveloped the valley overnight and my chances of making the image that I wanted seemed unlikely. However, just before I decided to move on, the mist began to break and I noticed the outline of a hill across the water – in the opposite direction to the view I was aiming for. The colour contrast between the sunlit hillside, mist-shrouded lake and frosty shoreline was striking. I quickly moved my camera and recomposed, using the same foreground boulder as I had planned for my intended composition. I much prefer this image to the scene I had previously envisaged!

Canon EOS 3, 24mm lens, 2-stop neutral density graduated filter, Fujichrome Velvia, 1sec at f/22

75 Record seasonal changes

Most seasonal changes are quite subtle and occur gradually throughout the year. It can be interesting to record these changes by shooting the same scene in each season. A set of images taken at key times throughout the year will show seasonal transitions in a far more dramatic fashion. Choose a simple composition where seasonal transformations are likely to be most obvious, such as a broadleaved woodland or arable farmland. Make sure you leave a marker or shoot from an easily recognizable position to enable you to set up in the same position each time. Use the same lens and film and try to avoid using filters, as their effects can be difficult to replicate exactly each time. It is also important to take each photograph at the same time of day – taking into account the changing day length.

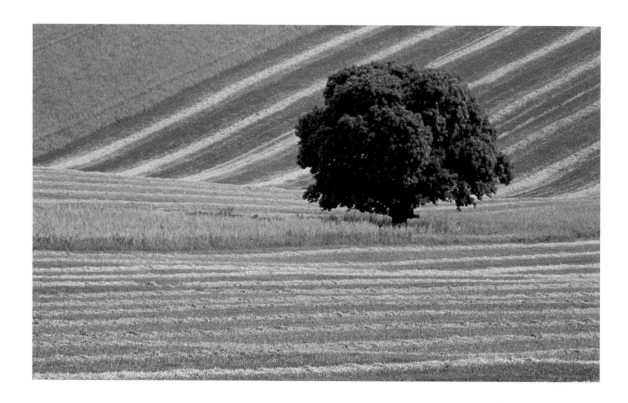

Lone tree

These images show just a few of the seasonal changes that occur to one arable field on Salisbury Plain. All the images were taken from roughly the same position and with the same equipment. You don't need to limit a project like this to a single year; the time-scale could be longer, or shorter. The rotation system employed by arable farmers means that this one field was planted with a variety of crops over a set rotation. The single sweet chestnut tree provides a vital permanent link between the images, as well as adding to the seasonal changes that are recorded.

Canon EOS 5, 70–200mm lens, polarizer, Fujichrome Velvia, variable exposures at f/16

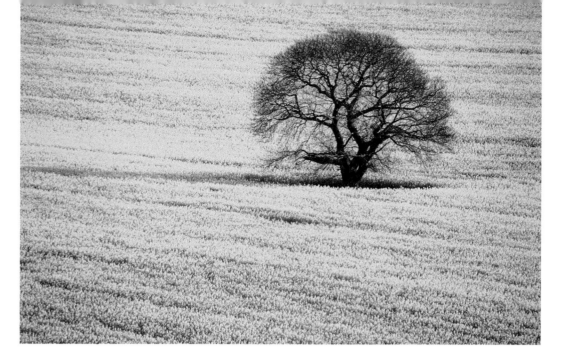

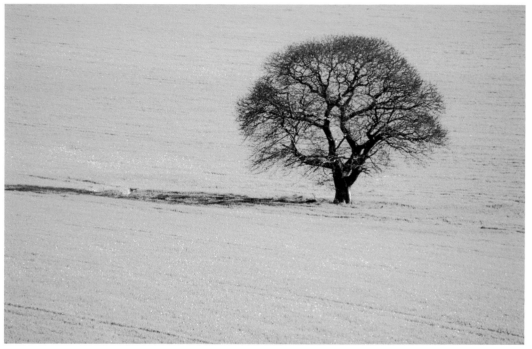

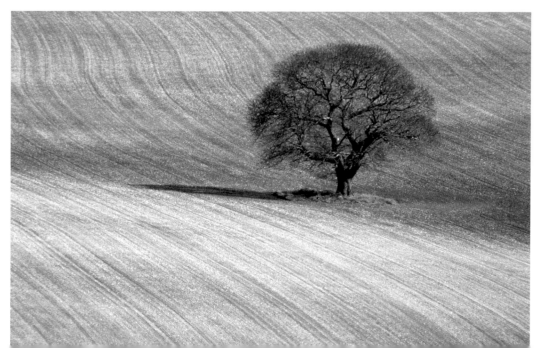

76 Search for subjects in summer

With the best light occurring very early in the morning and later in the evening, summer can be a demanding time for the landscape photographer. The upside of these unsocial hours is a general absence of people and cars. In many areas, the monotonous green tones of summer can be overwhelming. Overcome this by shooting early and late in the day and allowing the resulting long shadows to break up any large areas of grass or foliage. Around midsummer's day, the sun rises and sets in its most northerly position of the year – make use of this to light north-facing coves, corries and valleys that remain in deep shadow at other times of the year. Hazy conditions occur frequently in the summer, which can create a chance to shoot scenes that exhibit aerial perspective (see page 64). Alternatively, concentrate on views that don't depend upon distant detail, such as lush river scenes or picturesque villages.

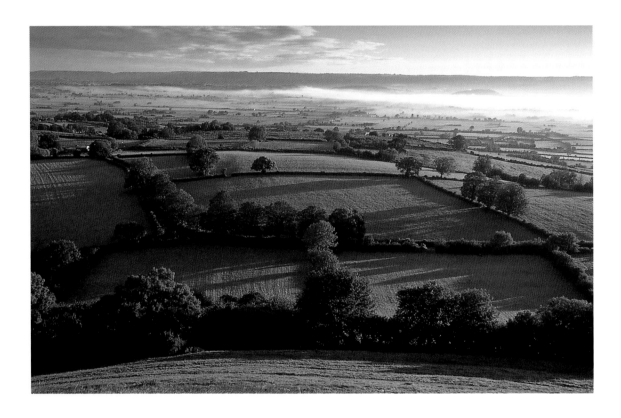

The Somerset Levels

On clear days, try to make the most of the vibrant colours, before the landscape begins to take on the more monotonous tones of late summer and early autumn. I photographed this scene from the top of Glastonbury Tor in Somerset at 5.30 on an early summer morning. Later in the day, this view would have included little more than a uniform swathe of green fields and hedgerows, but here the combination of low-angled sunlight and long shadows has provided a variety of contrasting tones. The band of mist in the distance has injected a little extra atmosphere into the shot and also helps to draw the eye into the scene.

Canon EOS 3, 28mm lens, polarizer, 2-stop neutral density graduated filter, Fujichrome Velvia, 1/15sec at f/11

77 Shoot autumn colour

Autumn's short season of colour is a productive time for landscape photography. When foliage colour is at its height, there are photo opportunities in all weather conditions. Backlighting early or late in the day, when the sun is low in the sky, can create atmospheric images. However, one of the best times to shoot autumn colour, especially in a woodland situation, is under a heavily overcast sky, when the colours will appear far more saturated and you'll avoid problems with excessive contrast. Even under these conditions, use a polarizer to remove reflections from foliage and saturate colours further. When autumn colour has passed its best, concentrate on close-up details, such as fallen leaves, and more abstract shots where it isn't necessary for the trees to be in perfect condition. You don't have to travel far; local parks and gardens can provide great opportunities for shooting the colours of autumn on a smaller scale.

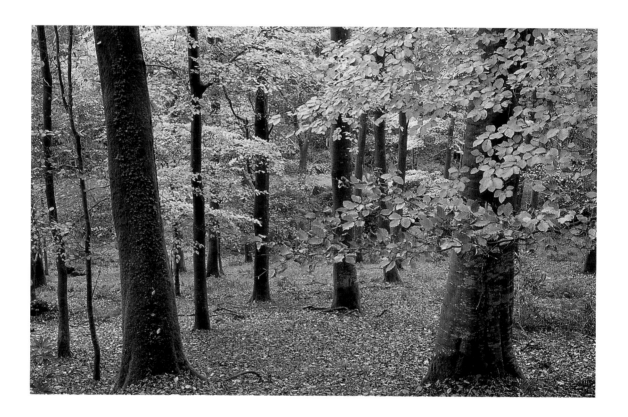

Beech woodland

Whilst all the seasons have something special to offer, I have always felt that autumn is the most spectacular time for landscape photography, and I anticipate this short burst of intense colour throughout the rest of the year. This normally leads to three or four weeks' frantic photography as I attempt to capture some of the scenes that I previously thought would benefit from some colourful autumnal hues, like this image of broadleaved woodland in the Quantock Hills, Somerset. It is a good idea to mark the weeks of best autumn colour in your photographic diary so that you can refer to these notes and make the best of the limited time. I make a note of potential scenes spotted in previous years and have an ever-growing list of locations to head for when the colours reach their peak. It's essential to be prepared and act swiftly, as a strong wind can sweep away your chances overnight.

Canon EOS 5, 24mm lens, polarizer, 81B warm-up filter, Fujichrome Velvia, 1/2sec at f/16

78 Shoot snow and ice

Always try to be prepared for snow, as its effects can be very short-lived. Make a list of suitable locations to head for in your local area, and get out early to capture the landscape in its pristine white blanket. Once the snow begins to melt from twigs, branches and vegetation, the landscape will begin to look untidy and finding an uncluttered composition will become difficult. In mountainous regions, superb winter lighting can often be captured on the high tops, along with fascinating ice and snow formations. It's important to work hard at getting one or two perfect shots, rather than rushing around trying to shoot everything. Concentrate on composition and careful exposure in what are likely to be difficult working conditions.

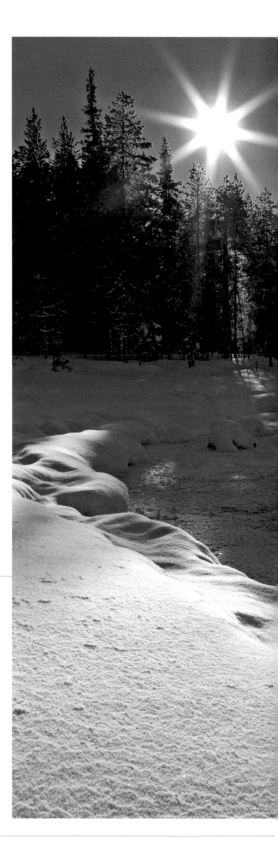

Kuusamo

Even the most sophisticated automatic exposure system will need help to correctly expose frosty or snowy landscape scenes like this one in Finland. It is essential to expose for the highlights, even if this is at the expense of shadow detail. For this shot, I took a spot-meter reading from the sunlit snow in the foreground and added 1 1/2 stops to the suggested reading so that the snow recorded as a very light tone in the photograph. However, I still needed to use a neutral density graduated filter positioned over the sky to balance the range of brightness in the scene. The digital camera provided me with instant feedback to confirm that sufficient detail had been recorded throughout the image.

Canon EOS 1Ds, 24mm lens, 2-stop neutral density graduated filter, ISO 100, 1/125sec at f/22

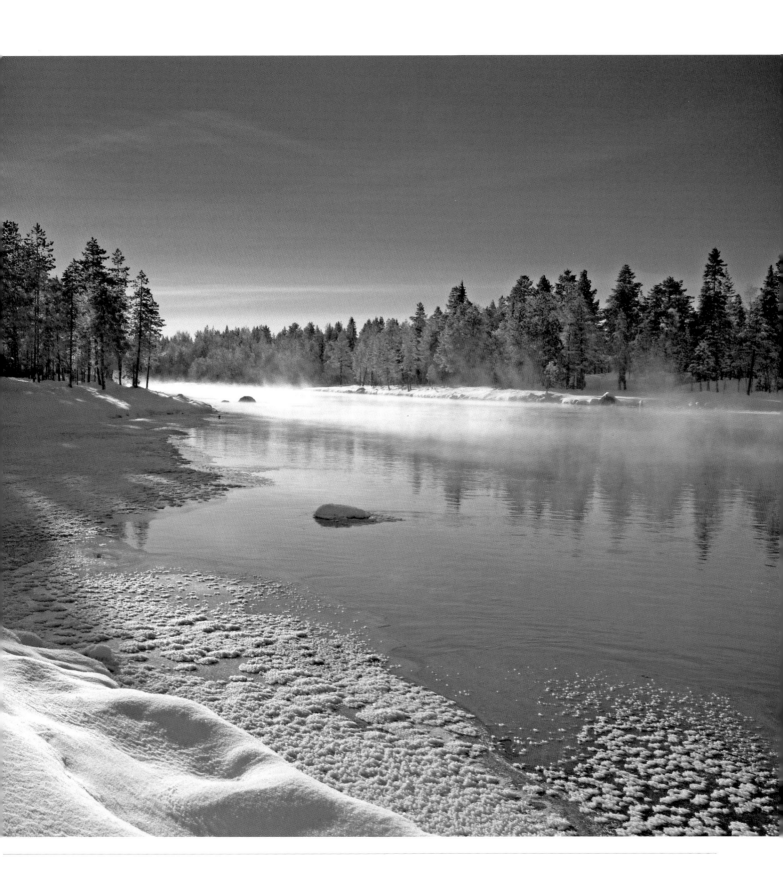

79 Shoot the harvest

Farmland provides a perfect environment for landscape photography, enabling you to capture various aspects of man's relationship with the countryside in your landscape images. The annual harvest of crops produces a range of interesting subjects to photograph, from lines of round straw bales to the regimental furrows of freshly ploughed fields. Combine harvesters create lines of discarded straw that make perfect lead-in lines when photographed with a wide-angle lens. Alternatively, use a telephoto lens to hone in on interesting patterns from a distance. Many harvest scenes can be photographed from roadsides or public footpaths. However, if you need to enter private farmland in order to achieve your desired composition, always ask permission first.

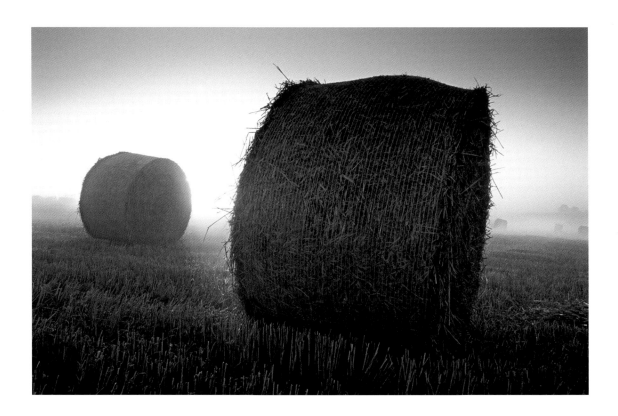

Straw bales

Round straw bales make ideal foreground interest in harvest scenes. They also make good subjects in isolation, as their familiar shape is characteristic of the harvest landscape. Due to the high contrast in this scene, I needed to use a neutral density graduated filter to help record detail and colour throughout the image. By using a soft-edged filter, with a relatively open aperture, I ensured that the transition line wouldn't be apparent in the photograph. By concealing the sun just behind one of the straw bales, I prevented flare from reducing the contrast in the image, whilst maintaining the atmosphere created by the backlighting effect.

Canon EOS 5, 24mm lens, 2-stop neutral density graduated filter, Fujichrome Velvia, 1/60sec at f/8

80 Utilize spring colour

Try to capture signs of early spring in your compositions by making use of splashes of natural colour within the otherwise colourless winter landscape. The monochrome tones of winter are gradually overcome by an eruption of spring colour. With trees and hedges leafing up and crops beginning to grow, the familiar patchwork of green tones returns to the countryside. Spring is a great time to photograph woodland interiors, as a profusion of wildflowers rush to make use of the available light before the canopy closes in. Head for the coast to photograph cliff tops and shorelines carpeted in colourful thrift and other maritime flora. Spring is a time of changeable weather and, quite often, exceptionally clear light created as bands of fast-moving weather fronts pass by – perfect for photographing sweeping vistas where you wish to capture distant detail clearly. Spring is also a good time to photograph waterfalls, especially where they are located in wooded gorges. Pick an overcast day to avoid excess contrast and to record the delicate greens of the surrounding trees.

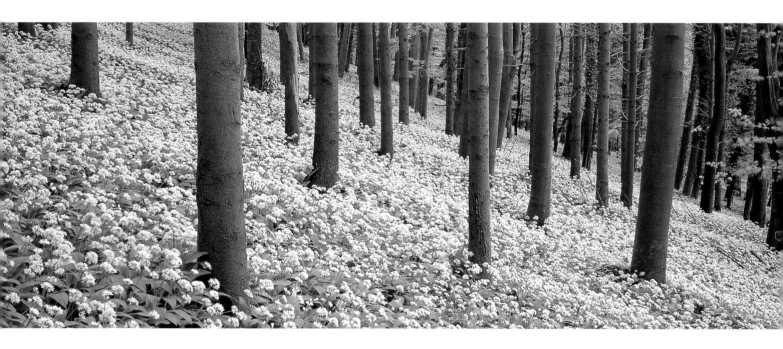

Woodland flora

This small beech woodland comes into leaf towards the beginning of summer, before which time the woodland floor is carpeted with an impressive display of wild ramsons. The mass of white blooms is complemented by the lime-green beech leaves beginning to unfurl above. It was important to time my visit just right, as the flowers don't last long and must be photographed in perfect condition in order to convey the freshness of spring woodland. By shooting this scene in panoramic format, I emphasized the scale of the display whilst avoiding any areas of bright sky that would have caused distracting highlights at the top of the image.

Hasselblad XPan, 45mm lens, polarizer, Fujichrome Velvia, 3sec at f/16

Landscape details

81 Compose around interesting patterns

Patterns, either natural or manmade, can be found everywhere in the landscape. Some can be short-lived, such as ice patterns on a pond, whilst some are seasonal, such as fallen leaves under a maple tree. Others, such as coastal rock formations, are more permanent features of the landscape. Some patterns can be created in-camera, like a mass of shimmering leaves blurred by a long exposure. Equipment choice will vary with each composition, and some lenses are more suited to photoographing particular patterns than others. A telephoto lens will help to pull up distant patterns from within a wider landscape scene, whilst a zoom lens can be used to compose carefully around the main area of interest. This can be a very creative area of landscape photography, and will require a good eye to spot a potential image. Keep compositions simple and exclude any non-essential elements that may distract from the pattern itself.

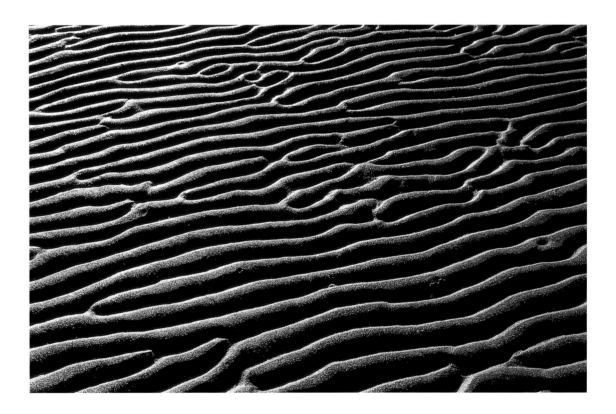

Sand patterns

This is an example of a temporary pattern in the landscape, as the effect would have been washed away during the next high tide. Ripples often form upon the surface of sandy beaches as the tide begins to recede. The depth and definition of the pattern will depend upon the state of the sea as the tide falls back, with the best patterns forming when the sea is relatively calm. The image shown here was taken late in the morning when the light was quite harsh. The resulting contrast between light and shade has helped to define the pattern, making it more abstract, and the effect has been amplified by shooting into the light.

Canon EOS 5, 100–400mm lens, Fujichrome Velvia, 1/30sec at f/22

82 Emphasize symmetry and repetition

Finding simple graphic compositions in the landscape is much easier when there is some symmetry or repetition to exploit. Look for layers or repeating elements such as the overlapping ridges of distant hills, a series of hillsides defined by light and shadow, or natural bands of colour, tone or texture. Telephoto lenses can be used to compress the perspective of such scenes, making repeating elements appear much closer together than they actually are, which can often add impact to the shot. Reflections in ponds and lakes can be a particularly good source of symmetrical and repetitive patterns. After you have photographed the perfect reflection of an impressive landscape scene in the mirror-calm waters of a lake, take time to consider other options, such as creating ripples in which the reflection will be broken into repeating bands of colour for an abstract shot with a telephoto lens.

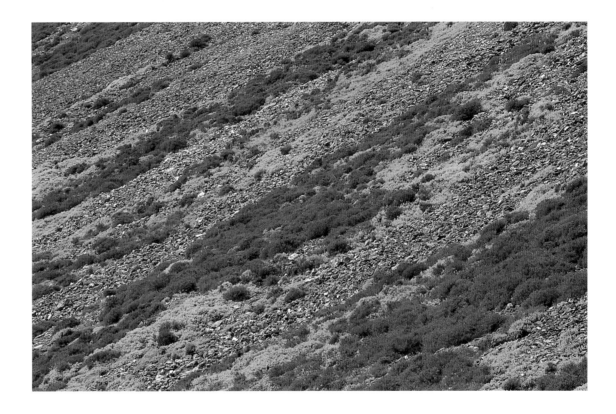

Scree slopes

This image was taken in the Whinlatter Pass in the Lake District National Park. The scree on the mountainside extended all the way down to the road, where the rock fragments were separated by bands of heather and bilberry, creating a repetitive pattern across the slope. It was important to simplify the composition to emphasize the pattern. I walked around to find a position from which the natural stripes of colour looked most symmetrical, and used the 200mm end of my zoom lens to frame the most striking section.

Canon EOS 5, 70–200mm lens, polarizer, Fujichrome Velvia, 1sec at f/22

83 Consider the rule of thirds

Composing an image within the restrictions of a rectangular frame is one of the most demanding aspects of landscape photography. The rule of thirds is a reliable way of arranging the elements of your picture to result in the strongest possible composition. If lines were drawn to split the frame into nine equal parts, the focal point (or the most dominant element) of the image should be placed upon one of four points at which the lines cross. These intersections are sometimes called 'power points'. They are areas within the rectangle where the eye tends to fall naturally. Similarly, if the scene includes a horizontal division, such as the distant horizon or the shoreline of a lake, it is often best placed along one of the dividing lines, emphasizing either the sky or the land – whichever is more important to the image.

Walls and barns

Finding a composition for this image of barns and dry-stone walls in the Yorkshire Dales wasn't difficult. The three barns were nicely spaced; I chose to place the closest barn according to the rule of thirds as it seemed the most dominant element in the composition. Even though one wall runs through the centre of the image, this doesn't unbalance the composition as the whole scene is divided into natural layers. The rule of thirds isn't always the best approach – for example, symmetrical scenes tend to work better with a 50/50 split. As you develop an eye for composition, you will begin to get an intuitive feeling of when the composition feels right and then the rule of thirds will just be a guideline to consider when composing an image. Rules can be broken, and some of the most unique landscape images owe their success to the fact that the photographer chose to do just that!

Canon EOS 5, 100–400mm, polarizer, Fujichrome Velvia, 1/15sec at f/16

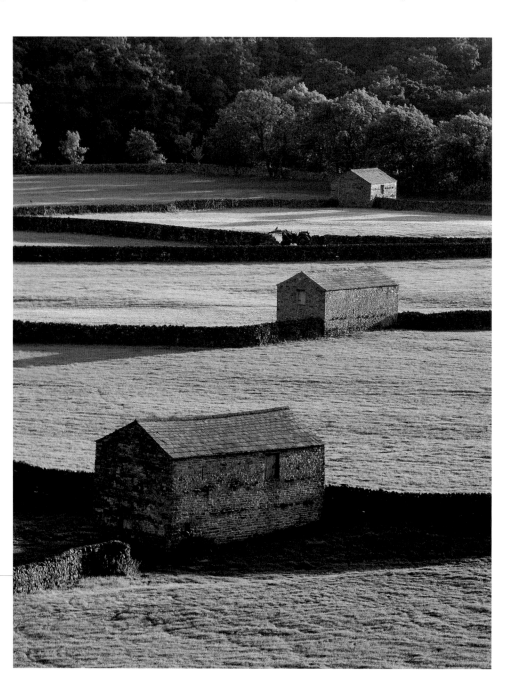

84 Shoot elements of the wider landscape

The term 'Landscape Photography' tends to conjure up an image of wide, sweeping views with distant hills, rivers, valleys and expansive skies. This type of scene can certainly be very dramatic in perfect lighting conditions, but it can also be worth searching for more intimate views of the landscape when we have the chance. Very often, smaller details of the landscape are swamped by the grandeur of what surrounds them. Composing an image within the set boundaries of a camera viewfinder allows us to consider such individual elements in isolation, allowing us to appreciate them more fully. In fact, it can be possible to paint a virtual picture of the wider landscape by shooting a series of intimate details. Compose around the main area of interest and don't allow any extraneous elements to encroach into your composition. The fewer elements included in your image, the more emphasis will be placed upon the subject itself – whether it is a pattern or a prominent individual feature.

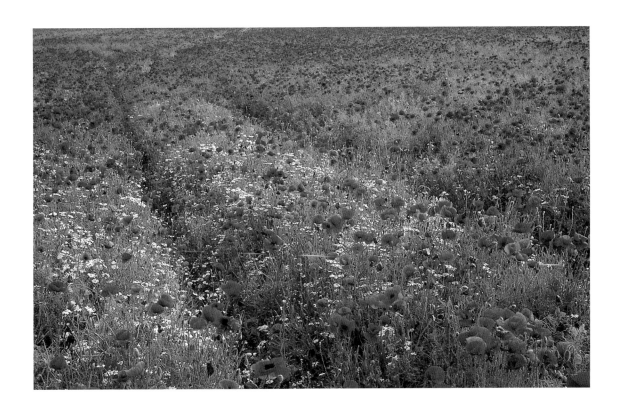

Poppies

When I first entered this field of poppies, the impact of the massed red blooms was overwhelming. Had there been a contrasting blue sky then a wide-angle lens would have been the obvious choice to show the entire display in all its glory. However, as the light was very flat, I decided that a more intimate shot would be more appropriate – showing the finer detail amongst the blooms, and excluding the featureless sky. I used a small stepladder to gain a higher viewpoint. This not only provided a better shooting angle from which to include the faint 'tram line' through the field, but also helped me to achieve greater front-to-back sharpness.

Canon EOS 5, 70–200mm lens, polarizer, Fujichrome Velvia, 1/2sec at f/22

85 Go for an abstract view

Images that challenge the viewer to identify the subject can be very successful, provided they conform to basic compositional considerations and hold enough interest to maintain attention. Again, simplicity is the key, as complex subjects can be off-putting. Particular attention needs to be paid to line and form, shadow and highlight, and colour and tone when composing minimalistic landscape studies of an abstract nature. Concentrate hard upon the image in your viewfinder and try to disassociate it from the landscape around you. This should enable you to place greater emphasis upon its graphic qualities when you are deciding on a final composition.

Honeycomb rock formation

This unusual rock formation (caused by calcareous cement leaching out of the limestone rock) occurs in the coastal cliffs close to the village of Elgol on the Isle of Skye, Scotland. I composed tightly on the pattern and excluded the cliff edges or any other recognizable elements in order to achieve a simple abstract image. It is, quite clearly, a geological formation, but the unique pattern creates an interest that will hopefully hold the viewer's attention for longer than a wider view where the location and subject is clearly apparent. In the lower left corner of the image, there is a small rock inside one of the honeycomb segments. I deliberately included this as it gives the eye a subtle point on which to rest within the composition.

Canon EOS 5, 70–200mm lens, Fujichrome Velvia, 1/15sec at f/16

86 Exploit the benefits of a zoom lens

Zoom lenses are ideal for composing landscape details as they provide precise compositional freedom. When using a fixed focal length lens, you will often be forced to alter your envisaged composition in order to exclude distracting elements nearby, or to crop the image before printing. This can often result in an unbalanced composition. Zoom lenses enable you to achieve very precise composition by cropping out unwanted elements in-camera. A zoom also allows you to experiment with slight changes in focal length, which can have a marked effect upon the final image. If your chosen composition demands a non-standard focal length such as 95mm or 112mm, then a zoom lens is the only option. Examine the scene initially at the short end of the zoom and gradually work towards your desired composition.

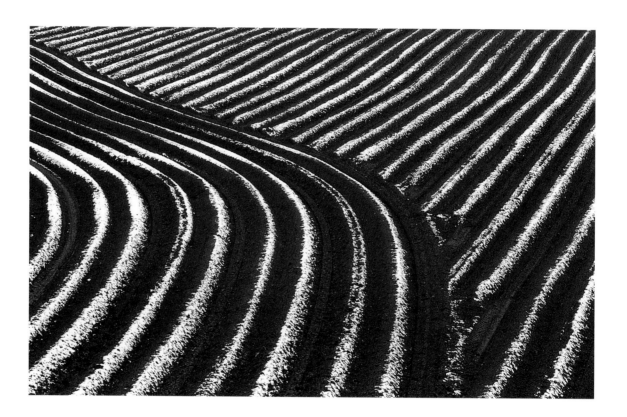

Potato furrows

I noticed these potato furrows following a late spring snowfall in Holland. By midday, most of the snow had melted, but the ridges remained capped in snow, creating an eye-catching pattern in the roadside fields. My shooting position was restricted by the bank of the dyke upon which the road was built – but it also provided the elevated position that was necessary for the pattern to show clearly. Had I taken the shot from lower down, the lines in the field would have merged, losing the pattern. Therefore, my zoom lens was invaluable in allowing me to compose the image precisely from the roadside. I worked my way towards this composition, beginning at the shorter end of my zoom and ending up with this image shot at about 150mm.

Canon EOS 3, 70–200mm lens, Fujichrome Velvia, 1/2sec at f/22

87 Include recognizable elements

Photographing the smaller details of the landscape often results in capturing images that are of an abstract nature. It can help to include an easily recognizable feature in order to provide a sense of place, or scale, or to identify the subject. The feature that you include could either act as the focal point within the composition, or it could be included more subtly so that it doesn't detract from the overall pattern that may form the central focus of the composition. In non-abstract, including a recognizable element may also help to provide evidence of a specific environment. For example, a particular species of tree, like a rowan, might characterize an upland environment, whilst an acorn could provide evidence that the image was taken in an oak wood.

Tulips

The Dutch bulb fields are spectacular in late April. I found this patch of on a roadside near Den Helder. In overcast conditions, the colour of the blooms was amazing, but the strong wind prevented me from recording the whole scene sharply as the flowers were constantly moving. I decided to opt for an abstract image using a 400mm lens on a fluid-action tripod head. I set a long exposure and moved the camera smoothly whilst the exposure was made. I experimented with this technique until I was confident that I had achieved an abstract image that was, nevertheless, easily identifiable as flowering tulips. By allowing part of the exposure to be made whilst the camera was still, I have retained sufficient detail in parts of the scene for the flower heads to be quite clearly visible.

Canon EOS 1Ds, 100–400mm lens, polarizer, ISO 100, 1sec at f/22

88 Pay attention to composition

Composition plays a key role when shooting landscape details. It is very important to ensure that any unnecessary elements that might cause a distraction or draw attention away from the basic composition or pattern are excluded. Pay particular attention to the edges of the frame, as the viewfinders in many camera bodies don't show 100 per cent of the image. Mentally dissect the scene into line, form, colour and tone and consider how each of these might affect the overall balance of the composition. Poorly placed highlights and shadows can cause just as much distraction as an out-of-focus branch, so consider where to place them in the image, or whether to include them at all. Never chop individual elements off at the edge of the frame – it is important to keep all such elements well contained within the composition if the viewer's eye is not to be drawn to the frame edges and away from the main subject or pattern.

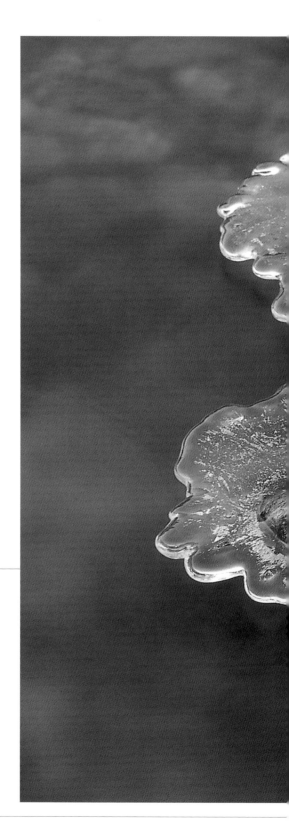

Frozen boulders

When working in the Lake District in early January, many of the rivers were partially frozen. Thin rims of ice had formed on boulders that projected from the river bed. After much searching, I found a group of three stones that formed a pleasing composition in a fairly isolated position in the middle of a stream. I wanted to concentrate on this group alone, so I used a telephoto lens to compose quite tightly around them, taking care to avoid neighbouring stones and patches of ice. Had I inadvertently included the edge of another boulder within my composition, it would have caused the viewer's eye to jump between the two distinct elements. By containing the main subject within a frame of clear water, the eye naturally falls upon the composition that I aimed to show.

Canon EOS 5, 70–200mm lens, Fujichrome Velvia, 1sec at f/16

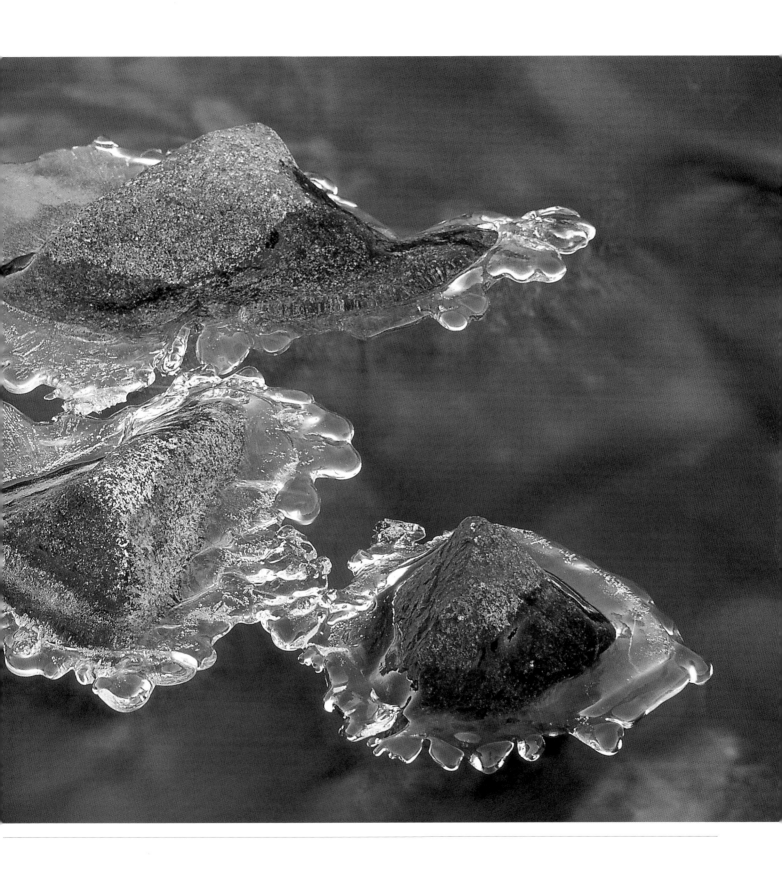

89 Shoot details

There can be a vast multitude of potential images to be found right under our feet, which should not be overlooked simply because they are a less obvious subject for landscape photography. These smaller elements, when combined, help to make up the wider landscape around us. Therefore, the scale of the subject should not matter if it forms part of the environment as a whole. Suitable subjects might include pebbles, shells, small geological formations and intricate patterns in sand, ice and snow. Detailed studies can produce abstract results as there is no visual reference for scale (see page 122). Macro lenses are ideal for shooting close-up small-scale details of the landscape, and their versatile design means that they can be used equally as effectively when focused on more distant scenes.

Lichen-covered rock

I found this lichen-encrusted rock on my way to photograph a waterfall in a Norwegian valley near Stryn. The area shown in this image measured about six centimetres across. Given its small size, some might question its relevance as a subject for land-scape photography. However, its intricate pattern stood out amongst the wider landscape of dramatic lakes and mountains and instantly attracted my eye. It is, basically, a rock covered in lichen, the species of which is typical of the habitat in which it was growing. Although on a much smaller scale, I feel that this is as much a legitimate subject for landscape photography as a moun-tain covered in forest.

Canon EOS 3, 90mm macro lens, Fujichrome Velvia, 2sec at f/11

90 Shoot silhouettes

Silhouettes can make very striking photographs, but it's not always easy to achieve a successful result. The most difficult part is finding a suitable subject to use as a silhouette. Look for simple graphic elements and easily recognizable shapes, and shoot into the light to maximize contrast. Patterns can also work well, such as a frame-filling shot of tree branches against a colourful sunset sky. Composition plays a vital role. Try to balance the composition, never allowing more than half the image to be made up of dense shadow. For this reason, open structures such as trees tend to make successful silhouettes. Meter from a bright area of the sky, but not too close to the sun. Decide how bright you would like this area to be in your image and adjust the exposure reading accordingly (see page 32). To make sure that the silhouette appears as a featureless black tone on film, take a meter reading directly from it – if it's at least 3 stops darker than your shooting exposure, you're okay.

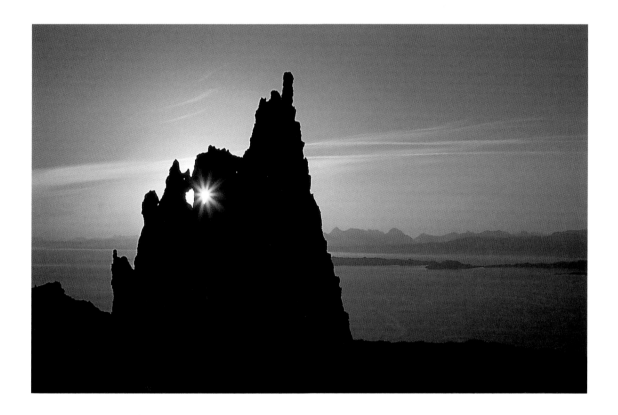

The Isle of Skye

When I took this shot, the light from the midsummer sun was becoming quite harsh, so rather than struggle to control the contrast in a sidelit situation, I decided to utilize the conditions to capture a silhouette. I took a spot-meter reading of 1/250sec at f/11 from an area of sky to one side of the rock. I wanted this area to appear as a light tone, so I increased the suggested exposure by 1 stop to 1/125sec at f/11. I then metered the rock itself, which gave a reading of 1/4sec at f/11. This 5-stop difference confirmed that the rock would appear as a solid silhouette in my photograph.

Canon EOS 3, 28-70mm lens, Fujichrome Velvia, 1/125th at f11

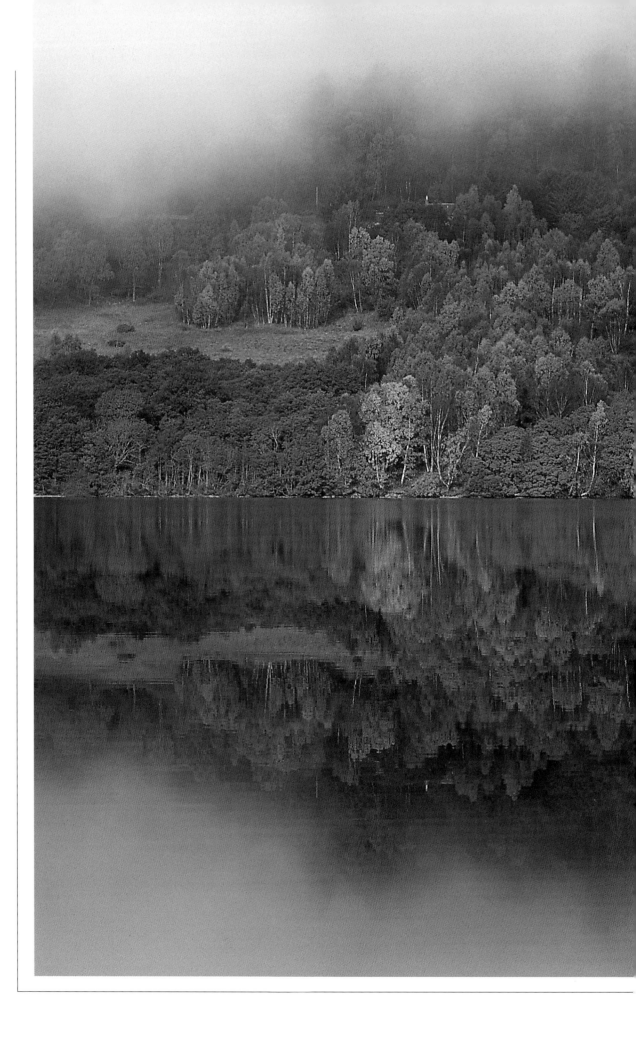

Creative landscape photography

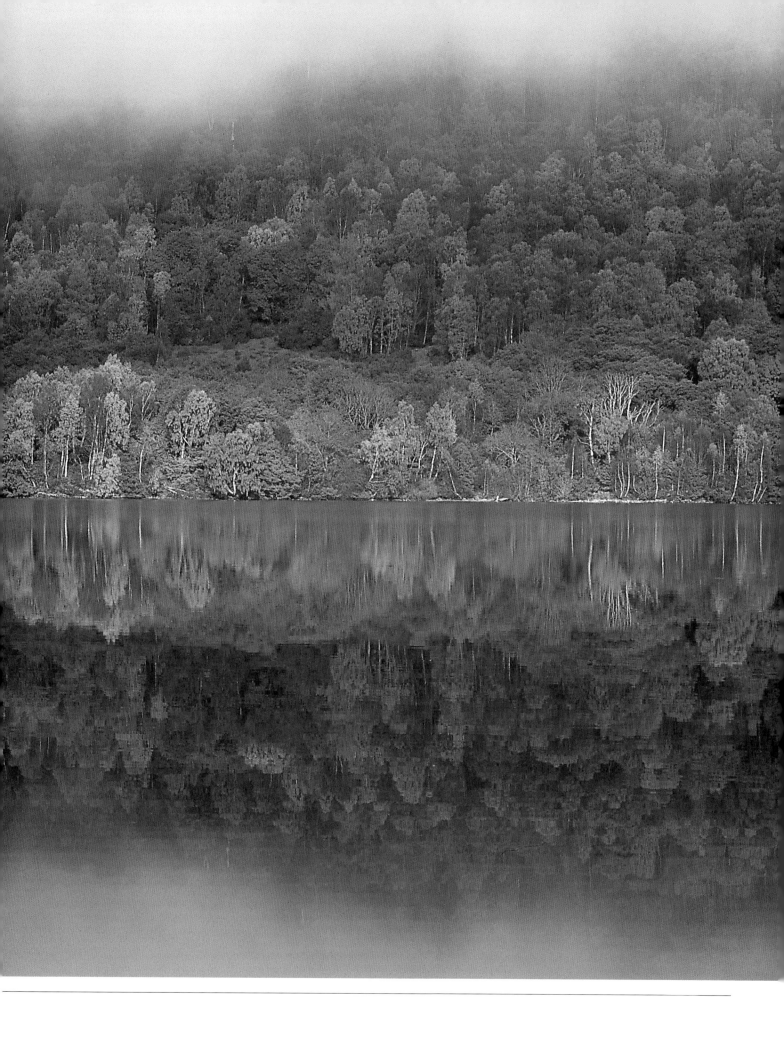

91 Create abstract images

Many photographers shy away from recording the landscape in anything but its natural state. However, abstract images can be very successful, allowing you to concentrate on the elements that appeal to you most, be they colours, shapes or textures. Techniques such as multiple exposures, subject movement, camera movement, filtration and computer manipulation can all be employed to achieve specific effects. Recording a personal impression of the landscape in this way should not be seen as tampering with nature, but as creating or expressing your own vision. It places emphasis on your own artistic talent rather than simply recording the landscape as everybody else sees it. Nevertheless, even when recording a distorted view of the landscape, the image should still contain enough information to allow the viewer to understand the image and recognize the subject or location.

Autumn foliage

For this shot, I used a telephoto lens on a fluid-effect tripod head. When half the exposure time had elapsed, I allowed the lens to fall slowly forward under its own weight, creating a painterly scene that has retained just enough sharp detail to depict the subject. A straightforward shot of the same scene would have made a colourful autumnal image, but wouldn't have retained the viewer's interest for very long. By record- ing the scene in an unexpected way, the image provides more interest, allowing the natural colours and textures to be appreciated to a much greater degree. Sometimes it is worth reminding yourself that the term photography translates as 'painting with light'.

Canon EOS 3, 100–400mm lens, polarizer, Fujichrome Velvia, 2sec at f/22

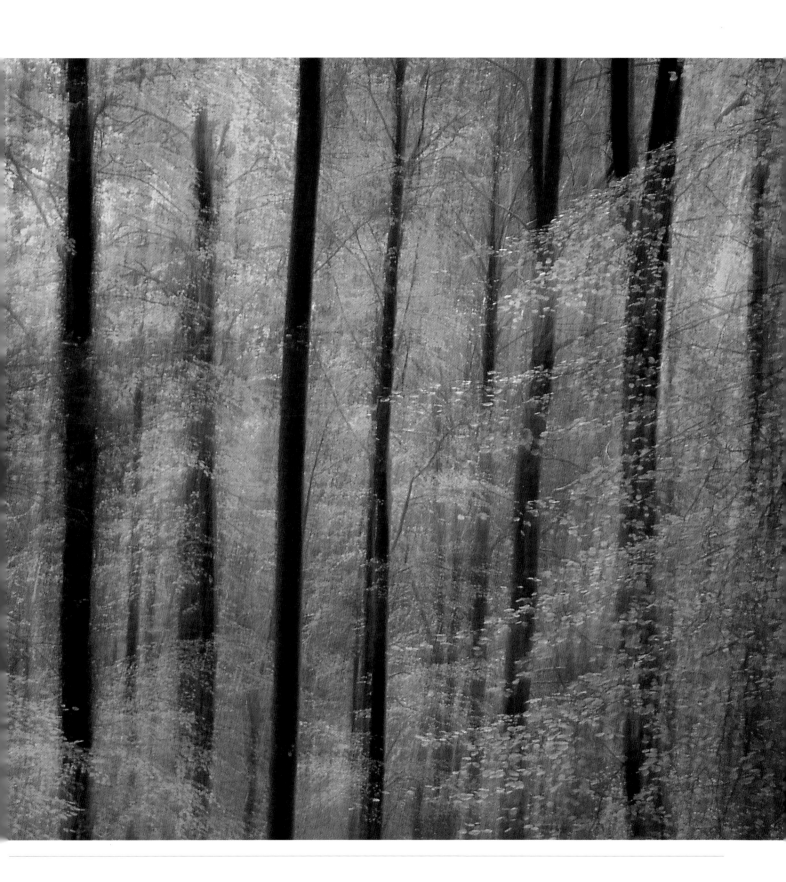

92 Include an additional light source

Just because the sun has set doesn't mean that it's time to pack your camera away. With a powerful torch, or even your car headlights, you can record some very creative images with artificial light. Try to highlight a particular feature rather than illuminate the entire scene. Geological formations, isolated trees, buildings and other recognizable features can work well. A high-powered torch is the most practical source of illumination, and the colour contrast between ambient and tungsten light will create impact. You can use the tourch to create shadows that will give the image a more natural feel. Digital shooters have an advantage here, as they can judge the effect of the torchlight from their first shot. Film users should bracket their exposures and vary the amount of torchlight applied to ensure a correct result.

Pulpit Rock

This photograph of Pulpit Rock on the Isle of Portland in Dorset was taken a full hour after sunset. It was almost dark to the naked eye, but there was sufficient colour left in the sky to prevent it recording as solid black. I took a spot-meter reading from the sky, and added 1 stop more exposure so that it recorded as a light tone (as I was shooting with a digital camera I didn't need to compensate for reciprocity failure). This gave a suggested exposure of 5min at f/8. I set the bulb function on my camera and released the shutter (beginning a five-minute countdown timer on my stopwatch at the same time). I then moved 10 metres to the right of the camera and began painting the rock stack with torchlight. This lighting angle created shadows that helped to reveal the texture of the rock. After illuminating the rock as evenly as possible for about three minutes, I returned to my camera in time to close the shutter when the five-minute exposure was up.

Canon EOS 1Ds, 28–70mm lens, ISO 50, 2 million candle-power torch, 5min at f/8

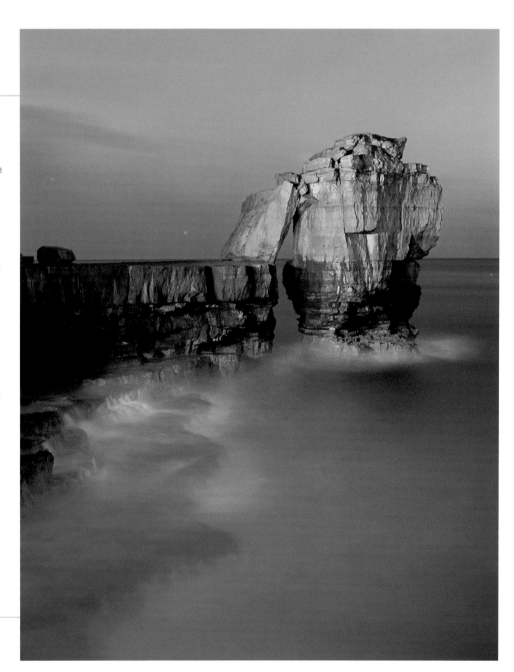

93 Keep a photographic diary

Keep a continually updated diary of what you shoot and when. Include useful information about each site that you visit as a source of reference for the future. Include information such as the peak autumn foliage colour in different parts of the country, and the best time to photograph bluebells in a certain wood. A consistent record like this will enable you to plan ahead in following years. You can look up several weeks in advance to remind yourself when potential subjects will be at their best. Record details of techniques that you've found useful at different sites, and details of metering and exposure methods that have worked in unusual situations. An undated diary will allow you to record events day-by-day, including seasonal changes as and when you notice them.

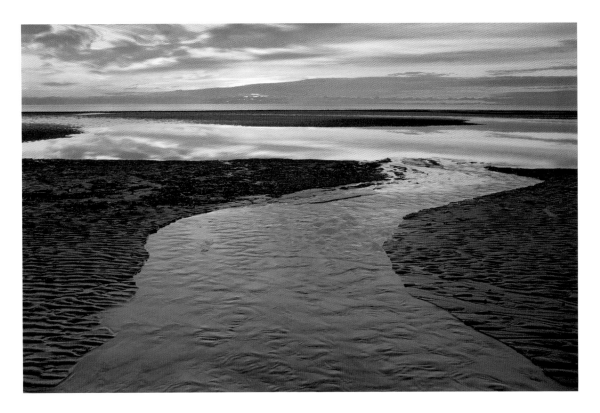

Isle of Walney

This shot was not planned. I was returning home from Scotland when I realized that a colourful sunset might well develop later in the day due to high cirrus cloud. My best chances of getting a good shot meant a diversion to the west coast, so I headed towards Barrow-in-Furness in the north-east of England. A quick consultation with the photographic diary that I keep on my laptop showed up a location that I had visited once before and that I'd noted as a potentially good site at sunset. Unfortunately, I reached the beach only to find the sun being slowly obscured by thicker cloud close to the horizon, so the vibrant colours that I had hoped for never materialized. Well, that was before I attached my blue-gold polarizing filter! The filter amplified the subtle colours that were present, providing me with a colourful, if not entirely natural, sunset.

Canon EOS 1Ds, 24mm lens, 2-stop neutral density graduated filter, Singh-Ray blue-gold polarizer, ISO 100, 1/2sec at f/16

94 Photograph a theme

Don't get stuck in a photographic rut by continually shooting with your favourite lens always from roughly the same angle. A good way to try something new is to set yourself an annual theme – for example, reflected colour, pebble beaches or the colour red. This way you'll be constantly on the look-out for new ways of recording basically the same subject wherever you go. Experiment with different lenses, photographic techniques and shooting angles, and shoot in different lighting situations, seasons and weather conditions in order to come up with yet another take on the same subject. By the end of the year, you will have built up a collection of images that thoroughly illustrate your chosen theme, and the project will have expanded your photographic vision with ideas and skills that can be applied to all your future images.

The river in winter

The images here were all taken along a six-mile stretch of the River Derwent in the Lake District. My aim was to build a collection of images that illustrated an upland river in winter. If I had travelled throughout the Lake District to the spots where I knew there were impressive waterfalls and rapids, I would have made some striking images but they would probably have all been very similar in composition and content. By restricting my photography to one small area, I was forced to look at the river from all pos-sible angles and to work hard at making a good number of images to illustrate my theme. I managed to capture the essence of the river in winter far more effectively than with half-a-dozen dramatic water-fall shots. I also ended up with a much greater variety of useful images.

(This page) Canon EOS 3, 100–400mm lens, Fujichrome Velvia, 1sec at f/16
(Top right) Canon EOS 5, 70–200mm lens, polarizer, Fujichrome Velvia, 1/30sec at f/11
(Centre right) Canon EOS 3, 70–200mm lens, Fujichrome Velvia, 4sec at f/22
(Below right) Canon EOS 5, 90mm macro lens, Fujichrome Velvia, 1sec at f/11

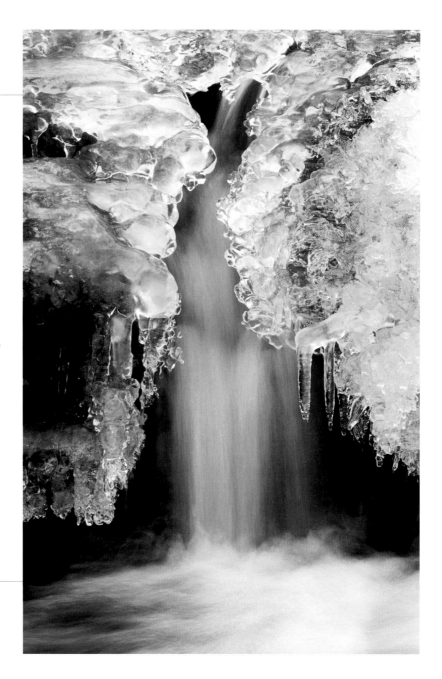

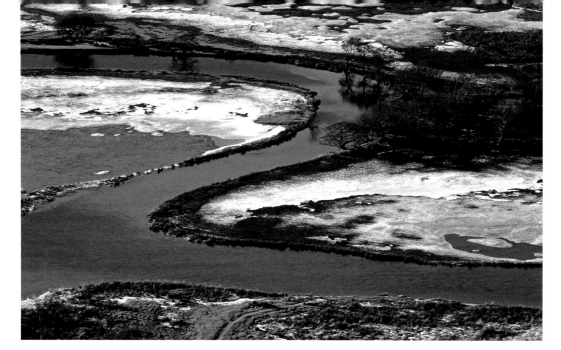

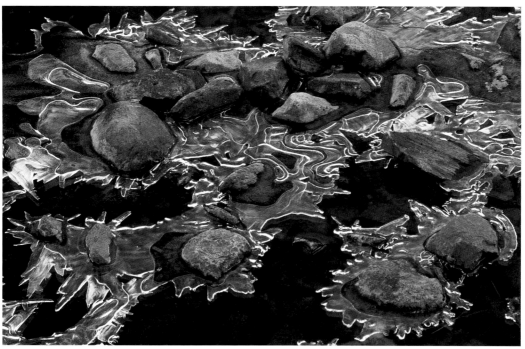

95 Keep on shooting

When you find a good location, try to get as much out of it as possible – the more photographs you take, the more creative you become, so your final images are likely to be your best. Get the standard views in the bag and then consider carefully what else you could do. What have you done in the past that might also work here? Stay at the same location and photograph the changing light, rather than dashing from place to place. Explore the locality thoroughly, searching for framing devices, interesting foreground elements and close-up details. Try different lenses, filters and shooting angles. There are always more shots to be had – it's just a matter of finding them. Don't pack up until you're sure that you've exhausted all potential from the location, or until there is no light left to expose an image.

Autumn tundra

Norway's mountainsides are host to a vibrant display of colour in early autumn, when the ground flora turns various shades of reds and yellows – a sight that can rival fall foliage in New England. This image was taken by the side of a mountain road near Geiranger. Dense fog provided perfect lighting conditions for recording such a highly detailed and colourful subject. My attention was drawn towards a lone birch sapling surrounded by crimson bearberry and various other colourful alpine plants and lichens. I began by shooting the tree with a wide-angle lens in order to include plenty of the colourful ground flora around it. I spent over an hour experimenting with different angles, but my final image was taken with a 90mm macro lens. This reduced the scene to the two key elements that had first attracted my attention.

Canon EOS 5, 90mm macro lens, polarizer; Fujichrome Velvia, 1sec at f/16

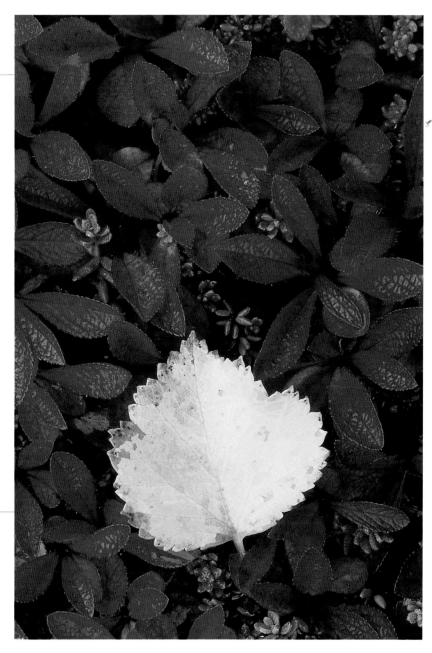

96 Shoot close to home

Many photographers don't exploit the full potential of the area in which they live. Locations are overlooked simply because they are familiar. Remember that this is the area that is easiest for you to access; when the conditions are right you are on the spot to catch an image by making the most of extraordinary light. If your local landscape lacks sweeping vistas or an attractive coastline, concentrate on characteristic details. In towns and cities, head for parks and gardens where the seasons can be recorded in landscape details. Build up a list of locations within easy reach and visit them often to record the changing seasons. If you photograph your local area on a regular basis, you will have to become more creative in order to create fresh images, helping you to develop your landscape photography skills and benefiting all your future work.

Foxgloves

It isn't necessary to travel to exotic locations in order to shoot good landscape photographs. Many of my most successful images have been taken within a few miles of my home. This is an area that I know like the back of my hand, so when good light or interesting weather occurs, I know exactly where to head to make the most of it. Also, by talking to local people, I am often made aware of things that I might otherwise have missed, such as a field of poppies or a blossoming orchard. This image was taken a few hundred metres from my home. A large patch of coniferous woodland had been cleared – an operation that often causes the dormant seeds of foxgloves to germinate. By early summer, the area was covered in foxglove foliage, so I knew that there was the prospect of a fine display the following year. Repeated visits ensured that I captured the blooms at their best.

Canon EOS 5, 24mm lens, polarizer, Fujichrome Velvia, 1/8sec at f/11

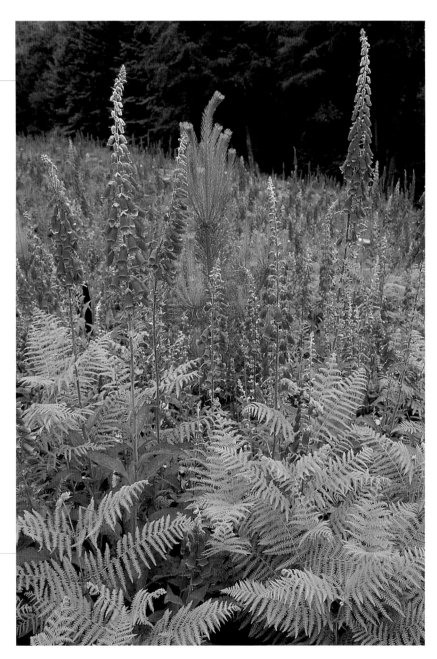

97 Shoot multiple exposures

The term multiple exposure refers to exposing more than one image on to a single frame of film. This can be done on a manual camera by not winding the film on after the first shot. Modern cameras with motordrives require a special function to be set. The results achieved by this method can vary from subtle soft-focus effects to radical changes, such as adding a full moon to a twilight landscape shot. One use of multiple exposures in landscape photography is to shoot simple abstract compositions whilst varying the point of focus or camera position between each shot. This allows us to create images with a painterly quality, whilst maintaining enough detail for the subject to be recognizable. On film, these effects are achieved in-camera. Computer software allows digital shooters to achieve the same effects in post-production.

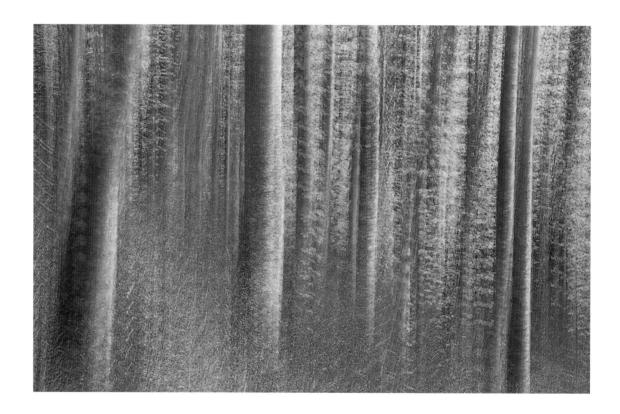

Bluebell abstract

This image of a bluebell wood in spring is the result of an eight-frame multiple exposure. The camera was set on a fluid-effect video tripod head. After composing the image, I locked the panning base and tilted the camera up until the top of my chosen shot appeared at the bottom of the viewfinder. I then released the tilt mechanism, which allowed the camera to tilt smoothly down under its own weight. I simultaneously hit the shutter button on the remote release – causing eight consecutive frames to be exposed (with the aid of a motordrive) as the camera moved down. I had determined the correct exposure to be 1/30sec at f/11, and I allowed one more stop in order to compensate for the slight fall-off in brightness that occurs with most multiple exposures (I calculated that, for the same amount of light to reach the film during eight separate exposures, each would need to be 1/125sec at the same aperture). The result is an impressionistic image.

Canon EOS 5, 28–105mm lens, Fujichrome Velvia, 8 exposures of 1/125sec at f/11

98 Shoot vertical panoramics

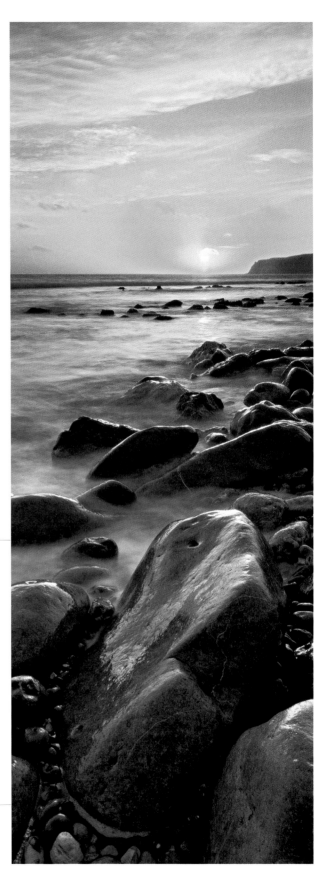

Using a panoramic camera vertically can provide yet another take on many of your favourite landscape scenes, enabling you to discover compositions that you might never have considered. Obviously, subject matter will dictate whether a vertical panoramic image will work, or be appropriate. Foreground interest is absolutely essential, and needs to lead the eye well into the frame to provide the image with sufficient depth. Depth of field will always be at a premium, and for this reason most vertical panoramic images will be taken at minimum aperture in order to achieve sufficient front-to-back sharpness. You may only come across a suitable scene once in a while, but the resulting images will certainly add to the diversity of your portfolio.

Axmouth

Most vertical panoramic images require the use of a neutral density graduated filter due to the considerable brightness range between the sky and the immediate foreground. This is especially true when shooting into the light around dawn and dusk. Unfortunately, all dedicated panoramic cameras are of the rangefinder design, so accurately positioning these filters is difficult as the effect cannot be judged through the viewfinder. I have managed to devise a way of accurately positioning graduated filters by marking out a rough scale on the filter holder after examining test shots taken with the filter in various positions. This image of Seaton Bay at Axmouth in Devon required stacked 2- and 3-stop neutral density graduated filters in order to reduce the contrast between the bright sky and the dark foreground boulders.

Hasselblad XPan, 45mm lens, 2- and 3-stop neutral density graduated filters, Fujichrome Velvia, 4sec at f/22

99 Show animals in the landscape

Including animals and birds in your landscape images can help to provide a sense of scale, as well as giving some detail about the landscape and its inhabitants. Even when used very small in the composition, animals can bring life to an image. Living creatures are always eye-catching in a photograph and will immediately grab the attention. Consider what sort of shot you want to achieve – an environmental portrait with the emphasis on the animal, or a wild landscape using the animal as a subtle focal point. When the subject is small in the frame, position it carefully in the composition – keeping it away from the centre of the image (see page 120). As an alternative, try to include more subtle signs of the native fauna, such as footprints in snow or a discarded antler.

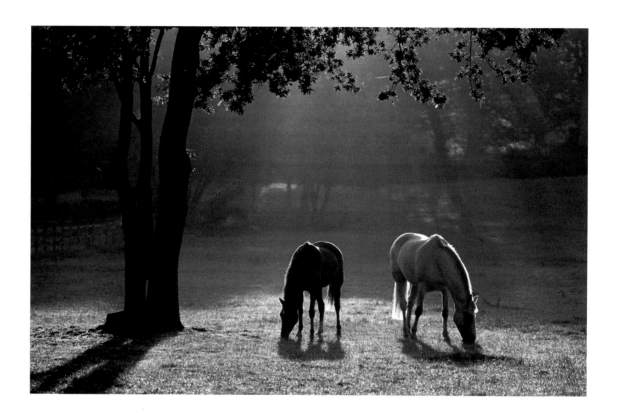

New Forest ponies

Some animals are indicative of the landscape in which they live. New Forest ponies are characteristic symbols of the New Forest in Hampshire, England. The ponies roam freely throughout the year. The grazing of ponies and deer has created, and helps to maintain, a balance of woodland, open heath and other habitats that are vital for a great variety of wildlife. This shot was taken early one morning, using backlighting to add atmosphere to the scene. I waited until the ponies moved into a position under the tree that would result in a well-balanced composition. As always, attention to detail was vital. The ponies were constantly on the move, so I took several consecutive images to make sure that all eight legs were visible on at least one frame!

Canon EOS 5, 70–200mm lens, Fujichrome Velvia, beanbag, 1/60sec at f/8

100 Use unconventional filters

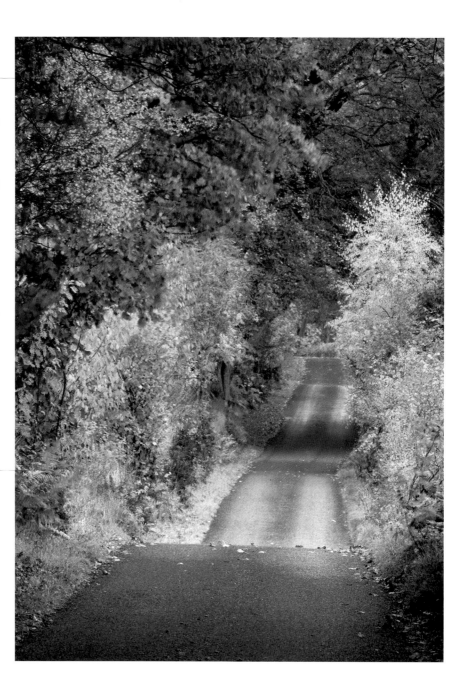

Although the use of filters is generally best kept to a minimum in landscape photography, there is one special filter that can be quite useful. Both Cokin and Singh-Ray produce a blue-gold (or, in Cokin's case, blue-yellow) polarizing filter. The effects of this filter can often look false or gimmicky, but there are occasions when it produces very pleasing results. The filter imparts an overall warm colour tone as well as colouring highlights either blue or gold (depending on how far you turn it in its mount). It is most useful on wet, overcast days when shooting landscape details, where the results can sometimes be spectacular. It can also produce interesting results in foggy and misty conditions. Used sparingly, it can help you to produce striking and sometimes unique images in weather conditions that might otherwise prevent any worthwhile photography.

Autumn road

This image was taken on a dark, wet autumn afternoon along a back road through the Scottish Highlands. Even though the autumn foliage was colourful, the scene as a whole looked dull and lifeless due to the poor light. Therefore, I reached for my blue-gold polarizer to see what effect it might have upon the scene. By looking through the viewfinder, I was able to adjust its effect upon the image by turning the filter in its mount. My main aim was to emphasize the blue tone of the wet road. This was greatly amplified by the filter, thus increasing its contrast in relation to the golden autumn foliage. The filter's effect is relatively subtle here, but it helped me to make a successful image in terrible weather conditions.

Canon EOS 1Ds, 100–400mm lens, Singh-Ray blue/gold polarizer, ISO 50, 1sec at f/22

Index